The Mission of Art

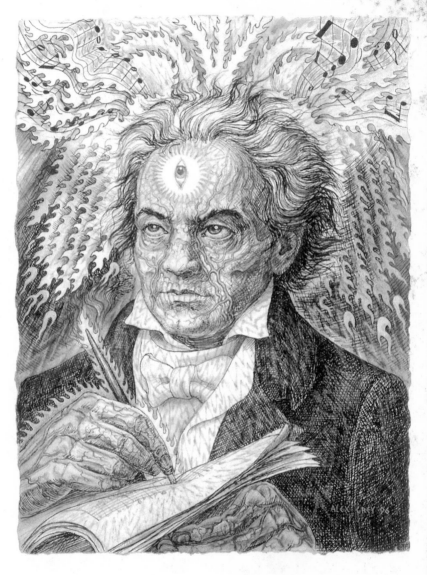

"There is no loftier mission than to approach the Godhead nearer than other people, and to disseminate the divine rays among humanity."

—Beethoven

The
MISSION *of* ART

ALEX GREY

Foreword by
Ken Wilber

SHAMBHALA
Boston & London
2001

Shambhala Publications, Inc.
Horticultural Hall
300 Massachusetts Avenue
Boston, Massachusetts 02115
www.shambhala.com

16 15 14 13 12 11 10 9

Printed in the United States of America

⊗ This edition is printed on acid-free paper that meets the
American National Standards Institute z39.48 Standard.
♻ Shambhala Publications makes every effort to print on
recycled paper. For more information please visit us at
www.shambhala.com.
Distributed in the United States by Random House, Inc.,
and in Canada by Random House of Canada Ltd

Library of Congress Cataloging-in-Publication Data
Grey, Alex.
The mission of art/by Alex Grey; foreword by Ken
Wilber.—1st ed.
p. cm.
ISBN 978-1-57062-396-7 (cloth)
ISBN 978-1-57062-545-9 (pbk.)
1. Grey, Alex—Philosophy. 2. Grey, Alex—Criticism and
interpretation.
I. Title.
N6537.G718A4 1998 98-16930
759.13—dc21 CIP

Dedicated to the
Art Spirit in every person

Contents

List of Illustrations ix

Foreword xiii

Artist's Prayer 1

1. Vision and Mission 3

2. To See or Not to See 33

3. Deeply Seeing 71

4. The Mystic Eye 109

5. Illuminating Visions 139

6. Art of Goodwill 177

7. Art as Spiritual Practice 205

Afterword 234

Notes 243

Acknowledgments 249

Index 251

Illustrations

Illustrations are by the author unless otherwise indicated

Frontispiece: *Beethoven*, graphite, ink & gouache on paper, 11″ × 14″, 1996.

Page 2: *Vision & Mission*, charcoal, ink, & gouache on paper, 8″ × 12″, 1996.

Page 4: *Skeleton*, pencil on watercolor on chipboard, 8″ × 12″, 1959.

Page 4: *Grim Reaper*, gouache on paper, 8½″ × 11″, 1964.

Page 5: *Anatomy Study*, watercolor, 9″ × 12″, 1971.

Page 5: *Praying*, oil on linen, 36″ × 48″, 1984.

Page 7: *Dying*, oil on linen, 60″ × 40″, 1990.

Page 11: *The First Artists*, ink on paper, 8½″ × 8½″, 1998.

Page 12: *Egyptian Goddess Tawaret*, ink on paper, 8″ × 11″, 1997.

Page 13: *Klytios*, Greek statue, third century BC, ink on paper, 8″ × 11″, 1996.

Page 22: *Jewel Net of Indra*, by Allyson Grey. Oil on wood panel, 40″ × 40″, 1988.

Page 23: *Universal Mind Lattice* (Sacred Mirrors series), acrylic on canvas, 48″ × 84″, 1981.

Page 32: *To See or Not to See*, charcoal, ink & gouache on paper, 8″ × 12″, 1996.

Page 37: *The Thinker*, ink on paper, 8″ × 11″, 1997.

Page 38: *Headache*, ink on paper, 8″ × 10″, 1995.

Page 39: *Insomnia*, ink on paper, 8″ × 10″, 1995.

Page 58: *Staring down the Chain of Being*, ink on paper, 11′ × 14″, 1981.

Page 62: *Ken Wilber*, ink & charcoal, 10¼″ × 15″, 1998.

Page 68: *Holding the Brush*, charcoal, ink & gouache on paper, 8″ × 12″, 1997.

Page 70: *Deeply Seeing*, charcoal, ink & gouache on paper, 8″ × 12″, 1996.

Page 77: *Transfiguration*, oil on linen, 60″ × 90″, 1993.

Page 81: *The Imp of Inspiration*, ink on paper, 9″ × 12″, 1996.

Page 84: *Pietà, Michelangelo*, ink on paper, 9″ × 12″, 1994.

Page 86: *van Gogh*, ink on paper, 6½″ × 9″, 1996.

Page 87: *Rembrandt*, ink on paper, 9″ × 12″, 1995.

Page 93: *Psychic Energy System* (Sacred Mirrors series), acrylic on linen, 48″ × 84″, 1980.

Page 96: *Artist at Work I*, charcoal, ink & gouache on paper, 8″ × 12″, 1997.

Page 108: *Mystic Eye*, charcoal, ink, & gouache on paper, 8″ × 12″, 1997.

Page 110: *Self-Portrait with Brain*, photograph, 1974.

Page 112: *Polar Unity Spiral*, photograph of painting, with author, 1975.

Page 113: *Study for Kissing Sculpture*, ink on paper, 16″ × 22″, 1985.

Page 118: *DMT*, ink on paper, 8½″ × 11″, 1997.

Page 123: *Body, Mind, Spirit*, oil on linen, three panels 12″ × 12″, 1985.

Page 127: *Eye of the Heart*, charcoal, ink & gouache on paper, 1985.

Page 136: *Vision Practice*, charcoal, ink & gouache on paper, 8″ × 12″, 1996.

Page 138: *The Seer*, charcoal, ink & gouache on paper, 8″ × 12″, 1997.

Page 140: *Conversing with the Light*, ink on paper, 9″ × 12″, 1997.

Page 144: *Clear Light*, ink on paper, 8½″ × 11″, 1986.

Page 159: *Vajra Brush*, charcoal, ink & gouache on paper, 8″ × 12″, 1997.

Page 171: *Schopenhauer*, ink & gouache on paper, 8″ × 10″, 1996.

Page 172: *Ecstasy*, lithograph, 14″ × 23″, 1995.

Page 174: *Theologue: The Union of Human and Divine Consciousness Weaving the Fabric of Space and Time in Which the Self and Its Surroundings are Embedded* (detail), acrylic on linen, 60″ × 180″, 1986.

Page 176: *Music of Liberation*, ink & gouache on paper, 8″ × 12″, 1997.

Page 181: *The Gift*, charcoal, ink & gouache on paper, 8″ × 12″, 1996.

Page 189: *Healing*, oil on linen, 38″ × 48″, 1985

Page 197: *Schweitzer Playing Bach*, ink on paper, 8″ × 12″, 1998

Page 201: *Journey of the Wounded Healer* (panel three), oil on linen, 60″ × 90″, 1985.

Page 204: *Vision Taking Form*, charcoal, ink & gouache on paper, 8″ × 12″, 1997.

Page 209: *Kongo Power Figure*, ink on paper, 8″ × 11″, 1996.

Page 211: *Torah Scribe*, ink on paper, 9″ × 9″, 1998.

Page 213: *Nature Study*, ink on rice paper, 8″ × 12″, 1997.

Page 216: *Artist at Work II*, charcoal, ink & gouache on paper, 8″ × 12″, 1997.

Page 220: *Michelangelo's Captive*, ink on paper, 11″ × 14″, 1997.

Page 222: *Daibutsu*, ink on paper, 10½″ × 7½″, 1996.

Page 231: *Holy Fire* (panel three), oil on linen, 60″ × 90″, 1987.

Pages 235–41: *How to Be a Great Artist*, by Zena Grey.

Chapter 1

Vision and Mission

It is the first vision that counts. Artists have only to remain true to their dream and it will possess their work in such a manner that it will resemble the work of no other artist— for no two visions are alike, and those who reach the heights have all toiled up the steep mountains by a different route. To each has been revealed a different panorama.

—ALBERT PINKHAM RYDER

MY EARLIEST CHILDHOOD MEMORIES OF ART are of watching my father draw. His large hand would hold a pencil and its tip would skate across the surface of a perfect white sheet of paper. That pencil was like a magic wand to me, because from its tip were conjured creatures and objects that had not existed just moments before. My excitement made my hair stand on end and I would delightedly dance in place as I watched new worlds emerge from his pencil.

My first drawing attempts were not more than scribbles with legs, from around age three. But under the spell of my father and enraptured by my own embryonic ability to draw, I felt I was an artist. Almost every child must.

I was fortunate that my kind mother saved some of my childhood drawings and presented them to me a few years ago. Sorting through the box, I came across several drawings of skeletons and references to death done within my first five years, which seemed oddly predictive of my life's work. Much of my later work has revolved around the subject of mortality. I even worked in a morgue for five years. My paintings include detailed images of the human anatomy, and skeletons continue to be the foundation of my art.

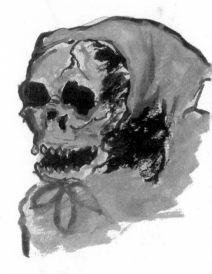

GRIM REAPER

SKELETON

One of my best works from around age five was a somewhat detailed skeleton watercolor. The proportions of the skeleton are appropriate to a child of five, with its big head in relation to the rest of the body. There is also a bird like a magic power animal, attached to the arm of the skeleton, a coffin shape, and a happy gravestone. From age six to twelve I became obsessed with drawing monsters and cartoons, typical mythic imagery for a child of that age. Among the monsters I drew at around age ten was a death's head with the cowl and grin of the Grim Reaper.

By the age of seventeen I was enrolled in art school, and one of our assignments was to study the anatomy. This was my favorite subject, and I spent a lot of time observing the refer-

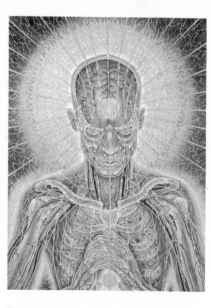

PRAYING

ANATOMY STUDY

ence material and carefully rendering and labeling the bones. I was in greater command of my drawing skills by then and could rationally dissect the subject. In 1984 I drew and painted an X-ray type of praying figure, with bones surrounded by flesh and vital energies. *Praying* expresses a more spiritually oriented worldview than the earlier works by alluding to the higher dimensions of subtle inner light and sacred language. By 1990 I was still using the skeleton as the foundation of my figurative work, and again focused on death, but this time from the vantage point of the dying subject, as the ectoplasmic wisp of a soul leaves the top of the head and ascends through a tunnel of infinite awareness toward a clear white light.

One can see definite stages of consciousness development in the trajectory of these artworks, which span thirty years of my life. An artist progresses from the primitive scrawls of childhood to magic-mythic imagery onto disciplined reasoned skill and clever ideas then potentially onto works of creative and spiritual depth. As a child's brain and mind grows, and it gains social experience, its self-image and vision of the world changes. The first artistic marks a child makes are little more than scratches and jots, with an occasional handprint. For the young child, the world can be a magical place, where Santa Claus seems plausible and invisible playmates abound. Likewise, the child's drawings may mirror a crudely defined magical world. The older child tends to see life dominated by mythic power figures—mommy, daddy, teacher, and so on—as the child struggles for both approval and independence. Many children from age six to twelve become interested in cartoons, monsters, superheroes, and supervillains. Drawing these fantastic characters allows children to draw power from them, to assimilate them in some way and assemble a cast of mythic personae in their unconscious psyche.

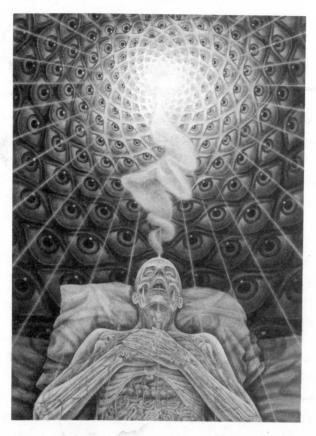

Dying

The adolescent's developed mental and physical capacity drives him or her toward independent expression, desire for recognition, and sexual gratification. The adolescent artist's improved eye-hand coordination results in more skillfully done works and original ideas. The graffiti artist is usually young, and tagging an alias is both a gesture of social defiance ("defacing" or "beautifying" property without permission) and an inventive bonding ritual within a gang or graffiti crew.

For most adults, reason dictates a level of behavioral con-
formity within a social group and adoption of common beliefs.
For most artists, this means using the conventional approaches
of the art world of their culture. Certain individuals evolve
beyond the group mind; they excel and develop their own spe-
cial vision of life. Development of the individual artist can both
recapitulate and foretell the evolution of art. An original artis-
tic vision is both acquired from the surrounding culture and
attained through a depth of personal experience and introspec-
tion. When artists give form to revelation, their art can ad-
vance, deepen, and potentially transform the consciousness of
their community.

Art and the Evolution of Consciousness

Art spans human history, from prelinguistic cavedweller to
postmodern city dweller, and stands as witness to an ongoing
creative process, an evolution of worldviews, a historic unfold-
ing vision of nature, humanity, cosmos, and consciousness it-
self. Every work of art embodies the vision of its creator and
reveals a facet of the collective mind. Artists offer the world
the pain and beauty of their soul as a gift to open the eyes of
and heal the collective. In order to produce their finest works,
artists lose themselves in the energetic flow of creation, be-
come possessed by an art spirit. Art history shows each succes-
sive wave of vision flowing through the world's artists. Like
the seers and oracles of old, Art sings and shouts from the axis
of truth to wake us up to who we are and where we are going.

The genesis of art is a mystery buried deep in the psyches
of our prehistoric ancestors. At least forty thousand years ago
people started to draw, paint, and sculpt, and probably to make
music. What is this deep need that drives humans to symbolize

their feelings and ideas? Art can transfix and exert a strange influence over us; we freely and curiously give it our attention. Art seems to be a spark of the eternal coalesced with a distinct historic moment, driving artists to do something that witnesses their depth, that expresses their most personal and universal insights. Artists compose music, perform theater, paint pictures, sing songs, write poems and books, make cartoons, videos, websites. They somehow make their mark, and their art asks us to open our senses and take in the world anew, to experience and appreciate the full range of life in all its terror and glory, its strangeness and beauty. Art helps us maintain our creative excitement about life, and at its best, art can inspire and transform us. The mission of art advances as individual artists express their culture's view of the world, in a personally hewn collective vision.

I painted the *Vision Crystal*, (reproduced on the back cover) after seeing it during a meditation. It appeared as a multidimensional living crystal, glowing and growing, continuing to sprout facets with eyes seeing in all directions. Each eye in each facet of the Vision Crystal seemed to symbolize a worldview represented by an artist's work. The vast history of art opens us to multiple views of self and world, and this transcendental object pointed to art's continuing capacity to expand our minds and hearts. In the center of the Vision Crystal is the fulminating, energizing sun of universal creativity, the source of all visions manifested as the eye of God. Each artist is a facet of God's unfolding infinite vision, refracting the light of awareness in his or her own particular way. The shallows and shadows and terrors of life are just as much a part of the Vision Crystal as views of abstract beauty, spiritual heavens, and our precious endangered planet are.

The history of art is a vast record of tens of thousands of

artists and their acts of disciplined passion bringing vision to form. Such a program of passionately committed actions could be called a mission. Yet the mission of art cannot be limited or strictly defined with words. It is much as Lao-tzu said of the Tao, "the way" of enlightened wisdom: The Tao that can be put into words is not the real Tao, not the ultimate eternal Tao. The artist's mission may not ever be reduced to words or rationally understood, but its invisible magnetizing presence will infuse an artist's work completely. The goals and visions of artists will vary greatly, depending on their temperament, their nationality, and the epoch in which they live and work. For each culture, artworks come to embody and communicate insights that help to interpret life and take action in the world.

We all organize and interpret life according to a unique psychological filter or lens, our worldview. This psychological context, the way we hold the realities of life, including who we think we are, mostly goes unnoticed. Our mind and body use it somewhat automatically. In order to notice our own worldview, we have to think about the way we think; we have to rise above our habitual thought patterns and notice that they are habits. We have to question who we think we are. This happens only when our worldview is sufficiently challenged, when new visions collide with and unsettle our existing vision of life. If the challenge is great enough, our worldview and sense of self will dissolve and either regress, break down, or transform to a higher and deeper vision. Art history is a record of such breakdowns and breakthroughs.

How has the mind-set or vision of humanity, as shown in its art, been seen to transform over the course of millennia? Anthropologists, psychologists, and philosophers[1] have mapped out the evolution of human consciousness and noted

the following progression: (1) primitive prelinguistic mind, embedded in nature, absorbed with foraging for physical survival, (2) magical mind with early stages of language, focused on worship of animal and nature powers, (3) mythic mind absorbed in the appeasement and avoidance of the taboos of goddesses and gods, (4) self-conscious reasoning mind and empirical inquiry into nature. Broadly, we may say humanity has progressed from a mostly prerational magic-mythic worldview to a more rational worldview.

The earliest human records show rudimentary tools and basic survival skills within harsh surroundings. The use of fire to cook food and create warmth suggests how making marks and drawing with charcoal could easily come about. Some of the earliest "artistic" evidence from Australia, up to forty thousand years old, shows scratches, organized jots, and hand-

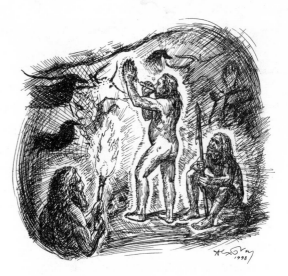

THE FIRST ARTISTS

prints on cave walls. Later paleolithic artists, from 30,000 BC to 10,000 BC, painted bison, horses, shamans, and sculpted fat goddesses in the bowels of remote and nearly inaccessible caves. The many faceless figurines of goddesses likely functioned as a way of honoring and aligning with the "Great Mother" and the magical forces of human fertility and nature's fecundity. The masterful cave paintings of animals were likely to have played a part in some ritual hunting magic. The scratches and handprints on some animal images could have been the result of an initiation of new hunters or the bonding rituals of a clan. Cro-Magnon animal paintings, which are found in caves throughout Europe, most certainly honored the

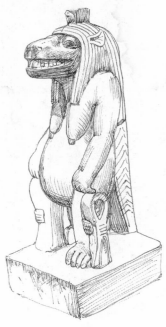

EGYPTIAN GODDESS
TAWARET

human-animal bond and provided a magical participation with the subject. A unity with and even a mastery over the subject is still a fundamental motive for making art.

The next great phase of artistic development after the Paleolithic was the portrayal of mythic power beings. Agriculture began to supplement nomadic foraging and hunting for food, which brought people together in larger groups, enabling them to build houses and temples. People interpreted their lives and fears of the unknown as subject to the control and intercession of external Goddesses

and Gods. From Mesopotamia to Egypt to the Aztec culture, the proper worship and supplication of these tribal animal-human hybrid deities demanded offerings and sometimes bloody human sacrifices to maintain the harvest and social order. Paintings and statuary of idols became the focal points of worship, a means to make communal contact with these animal-human power fusions. As the artistic representations increased in size, so their power assumed greater proportion in the minds of the people. Think of the Egyptian Sphinx. The artists and craftsmen engaged to build the various mythic monuments throughout the world were anonymous and sometimes cruelly exploited laborers.

The new vision of Greco-Roman art began to shift away from the fusion of human-animal deities and focus more on ideal and naturalistic human forms. Naturalism corresponded more with the ascending worldview of rational investigation and description of nature (including human anatomy), which was the beginning of organized scientific and medical inquiry. Realistic art tended to focus artists on the human dimension and on themselves as potential subjects of their art. The sculptors of Greece were no longer anonymous craftsmen; we remember the names Praxiteles

KLYTIOS, GREEK STATUE, THIRD CENTURY BC

and Phidias. The increase in self-portraiture from the Renaissance onward reflected the tendency in human consciousness toward increasing self-awareness. The invention of a singular style or approach, to demonstrate an individual artist's originality, became a premier value in Western art.

As the nineteenth- and twentieth-century human psyche matured into the analytical rationalism of objective science, the moderns turned their attention to analyzing the formal characteristics of painting and sculpture itself, reducing the natural world to essential and nonrepresentational shapes. The search for unique and personal approaches led artists to increasingly clever explorations of abstract, surreal, and nonobjective painting and sculpture. Each "ism" signified original insights and inventions of the artists: impressionism, fauvism, expressionism, cubism, futurism, dadaism, constructivism, surrealism, abstract expressionism, pop, minimalism, conceptualism. Thanks to Pablo Picasso, Henri Matisse, Marcel Duchamp, Frida Kahlo, Jackson Pollock, Judy Chicago, Josef Beuys, and Louise Bourgeois, among many others, there is no need for the contemporary artist to acknowledge idol or regime, as artists were forced to do hundreds of years ago. The artists of ancient and even Renaissance culture had no choice but to conform to preestablished myths and traditions. The freedom to invent whatever kind of art one could imagine was modernism's hard-won freedom, yet it came at a bitter price, the alienation of the artist from society and the general "meaninglessness" of modern art for the public. So here we stand today: the magic-mythic "superstitions" of most cultures have been displaced by the modern worldview of rational objectivism, which is the current measure of truth for most of Western

and Eastern intelligentsia, and artists are free to do as they please.

Today's culture of high rationality has been dubbed postmodern, because we have deconstructed reason and language itself, finding that there are always multiple points of view on any subject. Any attempt to comprehend a "whole" or "higher" truth must take the cacophony of individuals, each with his or her own opinion, his or her own "truth," into account. This fragmented, multiperspectival climate has lead some thinkers to the conclusion that there can be no linguistic basis for truth at all. Postmodern doubt has replaced the confident trajectory of invention and progress which characterized modernism. European and American (mostly male) artists dominated modern art, favoring and reinforcing a belief in their self-importance. An overemphasis on ego-driven artworks has lead to a culture of narcissistic spectacle and nihilist fragmentation. Yet because postmodern pluralism embraces so many maverick points of view it can help generate tolerance toward cultural difference. This is an important step toward a more global understanding and renewal of art.

The current cultural situation is calling for individuals to transcend the fractured vision of postmodernism and awaken to some transpersonal and collective spiritual basis for truth and conscience. At this transitional time it is inevitable that artists will reflect regressions into romantic mythic fantasies and nihilist nightmares. Yet can we use the wisdom gained from each stage of consciousness and artistic epoch and transfigure our minds and our art into a new integral vision, honoring the truths of both objective and subjective worlds, and save the planet while we're at it?

The Mystic View

The next great phase in the development of human worldviews began more than two thousand years ago, with the appearance of certain avatars, or enlightened teachers, who claimed *not* that God was an outside force demanding obedience but that the "kingdom of heaven is within you." Their message was that Buddha-nature or Christ-consciousness, the perfection of wisdom and compassion, is our inherent potential and can be experienced and realized. This radical message is still being implemented only slightly, even though great religious institutions and beautiful religious art have been created over the past two thousand years. The great sages' vision was so beyond normal comprehension that the sages themselves were considered the new mythic "gods" and worshiped in the usual way with supplicative prayer and appeals for worldly assistance. The sages' transformative spiritual exercises were used by only a few dedicated practitioners, the yogis or spiritual geniuses who penetrated to the heart of the avatars' message, the mystics.

In the mystics, from Plotinus to Padmasambhava, from Madjig Labdron to Saint Teresa, we see states of consciousness that point beyond the separate self to transpersonal states, transcending yet integrated with the physical, emotional, rational, and subtle psychic worlds. The mystics encountered multiple dimensions of reality, making visionary contact with infinite levels of meaning and being. Their teachings report a boundless ground of absolute reality, our true identity, which is beyond yet nondualistically at one with the objective world. Described variously as ultimate reality, God, infinite love, primordial awareness, our true nature, the Tao, it is from this

view that the meaning of life is realized. The mystics did not regress to previous childish mythic tribalism but ascended beyond their personal reasoning intelligence, uniting with transcendental truth. Some artists have engaged in spiritual practice, gaining glimpses of these higher states, and reflect this transpersonal awareness in their artworks.

I feel that the example of art history shows that human consciousness has been evolving through different worldviews in a direction toward the transpersonal. This is mirrored in the microcosm of the stages of development and understanding that many artists undergo. A progressive revelation is unfolding. The art of every people has responded to its unique historic call. And now we are called toward a new spiritual vision and conscience.

How can one claim that human consciousness is evolving and going in a transpersonal direction when the twentieth century has witnessed such distressing carnage? Let us also remember that the twentieth century has been the time of great liberation movements, recognition of racial and sexual discrimination, and awakening ecological awareness. Although human greed, hatred, and ignorance have led us to the current crisis of our overpopulated and polluted world, the question is, Can enough individuals personally awaken to a reverence for life, as Schweitzer called it, and then, through their creative actions and interventions, redirect the tendency of society away from self-destruction? When people stare death in the face, they begin to question the direction and motivation of their lives, their worldview, and their priorities. There is greater potential now for people to realize our fragile global interdependence and access transpersonal truth. In the twentieth century we see the common features of the world's great

wisdom traditions pointing toward ethically responsible action. The availablity of these teachings lends support to the activation of human spiritual potential. The exoteric dogmas that separate world religions are not the shared esoteric truths at the core of these traditions. At the core is a concern for the common good and loving-kindness based in the unshakable knowledge of our deep unity with each other and the cosmos.

Art and the Soul

The artist's mission begins with full-bodied enthusiasm. The passion and delight of making art seduces a young artist into unknowing alliance with primal forces of creativity. The collective consciousness of a spiritually malnourished humanity seeds the artist's soul with countless images. The artist's soul is a psychic antenna tuned to the needs of the world soul. Mostly, artists remain unconscious of the nature of the creative forces operating through them, except to feel the tormenting drive and joyful satisfaction of their work. Creation is the Mystery itself. Wise artists respond to the call of creation by peering into their own hearts.

In the heart of the artist is a studio. The soul works constantly there, shuttling between heaven and hell, spirit and matter. Each moment, every sound, vision, taste, smell, and feeling, is a brilliant creation, dynamically colored with emotion and meaning. In reverie, the artist enters the studio of the heart and is awed by the soul's work. The artist then labors to bring these revelations into tangible form. Angels and demons compete to lift the artist's hand. Each artwork is possessed by the unseen forces that motivate its creation. The artist be-

comes a prophetic witness of the truth of the time and a messenger of the timeless. By touching our deepest center, great art transmits the condition of the soul and awakens the healing power of spirit.

Art is communion of one soul to another, offered through the symbolic language of form and content. An artist creates a sensible *form*, through harmonious use of the medium (paint, clay, music, and so on), which expresses *content*, by subject and feeling. We absorb metaphysical sustenance from the balance of formal means and expressive ends. Art expands the appreciator's consciousness by providing a glimpse into the hearts and minds of strange beautiful humanity. Art is nutrition for the soul. The soul cannot thrive on junk food.

Many artists develop technical skills—they can draw, paint, or play an instrument—but seem to have little that is fresh, original, or worthwhile to say. Other artists really have something important to express but lack the skills or courage to express it. Rare is the artist with skill who offers a significant statement.

The only way to formal inventiveness and technical ability is to work and work, studying and perfecting the craft. Artists discover unique features of their medium that contribute to actualizing their personal vision. A well-crafted work of art requires discipline. Devotional labor lavished on a work of art radiates love and care to the viewer.

On the other hand, a work that only affirms inherited or preexisting forms and techniques lacks an essential ingredient of the highest art. Technique is just the way to arrive at a statement. Great art is a concentration of transformative insight into skillful and original forms.

Art and Time

Of course, it is not the quantity of time spent on a work that
determines its greatness but the quality or intensity of the time
spent. A Japanese Zen monk named Jakuchū contemplated a
bamboo tree, became one with the bamboo tree, and in twenty
minutes with ink, brush, and paper completed a "timeless"
evocation of the essence of the tree. Van Gogh went out paint-
ing and completed a canvas in one long day of furious concen-
tration. The rhythms of the cosmos are perceptible in van
Gogh's undulating landscapes and portraits. Ivan Albright
worked for eleven years on a portrait painting of a friend, an
old man. The sitter died and was buried during that eleven-
year period, yet Albright continued to work on the painting.
Called *The Vermonter*, the painting has a subtitle that hints at
its power: *If Life were Life there would be no Death*. The subject
appears to dissolve into the cosmos. One gets an uncanny sense
that Albright was really able to immortalize his friend, to al-
chemically find a way of cheating death by transmuting life
into art. Art can have the magical power to arrest time. When
we gaze into great works, mundane thoughts dissolve for a
moment and we stare into Spirit's timeless presence.

There is something of the quest for immortality, or at least
"life extension," that fuels art. A well-made work of art will
usually outlast its maker. Artists are in a race with time to try
to extract from their depths a significant body of work before
they die. The fear and anger at the injustice of death cannot
be underestimated as a catalyst for creation. A close encounter
with illness and death, the death of a loved one, or the viewing
of an accident or disaster puts one face to face with mortality.
Frequently the quest for spirituality or serious pursuit of art

begins in earnest only after facing death. The Buddha states in the *Dhammapada* that the greatest meditation is on impermanence and death. When we realize our limits, we take our commitments to life more seriously, using and appreciating whatever time we have left.

How does an artist maintain the intensity of his commitment to a subject for as long as eleven years or put enough intensity into making an important and moving work of art after working for only twenty minutes? In order to create anything of importance, artists must be expressing their vision, their authentic outlook on life, the creative source or wellspring, the issues, the ideas, the matrix of meaning that keeps their mind and work alive and flowing. The nagging questions that act like a piece of sand or grit in the oyster shell of the mind can be the source of the vision pearl. The worldview of artists may be indicated by their strong or indescribable inclination toward a subject, a color, a sound, or a texture, or possibly their distinctive way of making marks. For some people, their understanding of self and life is drastically altered by a full-blown mystical experience accompanied by searing mental imagery.

A Vision

In 1976 my wife, Allyson, and I had an experience that changed our lives and our art. We sacramentally ingested a large dose of LSD and lay down. Eventually a heightened state of consciousness emerged in which I was no longer aware of physical reality or my body in any conventional sense. I felt and saw my interconnectedness with all beings and things in a vast and brilliant Universal Mind Lattice. Every being and

thing in the universe was a toroidal fountain and drain of self-illuminating love energy, a cellular node or jewel in a network that linked omnidirectionally without end. All duality of self and other was overcome in this infinite dimension of spiritual light. I felt I had been there before, or perhaps in some way was always there. This was the state beyond birth and death, beyond time, our true nature, which seemed more real than any physical surrounding and more real even than my physical body. The clear light matrix arose out of a field of pure empti-ness. As utterly convincing as it was, when the light receded, I opened my eyes to behold Allyson and our bedroom once again. I was somewhat shocked to learn that she had experi-enced the exact same transpersonal dimension at the same time, which we determined by our descriptive drawings and

JEWEL NET OF INDRA, *by Allyson Grey*

UNIVERSAL MIND LATTICE

discussion of the awesome beauty of the state. This experience of the infinite net of spirit transformed our lives and gave us a subject that became the focus of our art and our mission.

We both became obsessed with the implications of the vision of boundless love and light we had experienced. I searched many references and found near-death research and mystical literature that related powerfully to the revelation that we had received. The Hwa-yen Buddhist description of the Jewel Net

of Indra was one such reference: In the abode of Indra, Lord of Space, there is a net that stretches infinitely in all directions. At every intersection, each "eye," of the net there is a jewel so highly polished and perfect that it reflects every other jewel in the net.[2]

Allyson started painting sacred geometric gridlike yantras using the title *Jewel Net of Indra.* I started a series of paintings called the *Sacred Mirrors,* which featured a view of the Universal Mind Lattice. Whatever work either of us does refers to the insights from that state and related spiritual experiences.

Artists are driven to create by a balance of known and unknown forces, and though they may glimpse themselves or their culture through their works, much of why they do what they do remains shrouded in mystery. God has ordained that imagination be stronger than reason in the soul of the artist, which makes the artist build bridges between the possible and the seemingly impossible. How do artists gain insight into their own character and realize their own unique vision? By entering the studio in their heart, all artists have access to a personal yet universal vision that can guide and inspire them and, perhaps, all of us.

The Mission

A mission is the setting of intentions to perform specific actions in the world. A mission is essential to accomplishing great things. Without President John Kennedy's visionary inspiration of the Apollo lunar mission as a goal to be attained by the end of the 1960s, it might never have been achieved. *Mission,* in the context of this book, refers to the inner calling to creatively serve our physically and spiritually depleted

world. The artist can be a spiritual emissary working in any medium in any part of culture. *Mission* connotes personal, passionate commitment to something. Mission is applied vision.

As previously mentioned, an artist's mission is determined by his or her view of life. The transpersonal worldview is based on personal experience of the divine to the greatest depth possible. The artist attempts to make those inner truths visible or audible, sensible in some way, via an external material-world manifestation (such as a painting or a song). After the artwork is produced, it needs to interconnect with the socio-cultural context within which it arises by being exhibited or performed for an audience. This level brings the artist out of the studio and begins a communal and political life for the artwork. The artwork is sent into the world to fulfill its function, to bring pleasure and invite reflection, to become an object of influence and commerce. Then an artwork needs to be interpreted, or subjectively internalized by the culture (experienced, critically reviewed, spoken of). The level of cultural integration is where art influences, uplifts, or erodes the spirit of the people.

Any obstacle in the complete round of the cycle of art can weaken, disrupt, or cripple the art matrix. Artists may have difficulty accessing their deepest levels of insight. Maybe they have visions they are unable to realize because of the level of their technical ability. Once artists successfully realize their vision, the next level of difficulty comes when they attempt to share their works. Artists have no chance of entering the culture unless conditions are favorable. This may mean making the "right connections" or sharing their work with the right person at the right time. There is a bit of luck and some strategy involved in this. Linda Burnham, the original publisher of *High Performance* magazine, once told me, "If you want to put

yourself on the map, publish the map." The creative cycle de-mands an audience, yet there are many cultural obstacles and negative reactions with which the artist must cope. Many art-ists seek the perpetual shelter of the studio, yet feel the internal ache of incompletion of their creative cycle and yearn to have their voice join the cultural choir. The difficulties encountered with galleries, museums, and collectors leave some artists feel-ing bitter and rejected.

Art provides a mirror for its culture. What becomes popular art and what lurks in the shadows of a culture reveal much about the collective psyche of its people. Any work of art or body of work that successfully runs the art cycle gauntlet has the potential to influence the worldview of many individuals, thereby subtly transforming the entire culture. So take care, artist, you shoulder responsibility for affecting the collective mind. Even a tiny drop of a powerful tincture can change the color of an entire glass of water.

Art and Creative Freedom

Totalitarian regimes fear freedom of expression in works of art and attempt to control and censor them because the visions embedded in art have the capacity to transform culture. Hitler denigrated and banished artists and artworks that he felt were antithetical to Nazism. Nazi "degenerate art" exhibitions were held to ridicule modern art, which did not use realism or por-tray the allegiance to nationalist self-absorption that Hitler de-manded. John Heartfield, one of the greatest political satirists and collage artists of twentieth-century Germany, risked much by publishing explicit and disturbing works directly criticizing Nazi terrorism. Heartfield was nearly executed for his art, nar-

rowly escaping the jackboots. His art is a testament to the highest standards of truth and moral authority.

In a society that tries to standardize thinking, individuality is not highly prized. Yet it is typical of artists to creatively individuate and stand out. Artists need an audacity, an almost arrogant self-confidence that what they are doing could be worthwhile, because they often sustain many critical insults if they are developing an original approach. True creativity depends on fostering independent thought, and the ability to peek beyond the current cultural horizons. To see beauty demands that we see freshly, that our perceptual sensitivity be attuned to discovery. After a life of accumulating theories and techniques, the artist has to toss it all and return to ground zero—an empty mind and a blank canvas. For the Zen practitioner, this state is called beginner's mind, a surrender to not knowing what comes next, and an attunement to the flow of the creative core. In the Hindu sacred arts, surprise is one of the essential elements of beauty. In the Taoist and Zen arts, spontaneity is especially revered. Artists are self-reflective creators reliant on intuition for guidance. By questioning what has gone before and inwardly seeking the new, artists bring the vital force of creative transformation into our lives. The personal yet universal artwork both catalyzes the artist's inner spiritual progress and serves the community. The creative arts are redemptive when they deepen us, reminding us of our unity with spirit and the sublime beauty of nature and the cosmos.

I'm going to go out on a limb and say that there is a lot of good for anybody in making almost any kind of art. Just as each of us benefits from physical exercise and meditation, even though we may not become professional athletes or enlight-

ened yogis, making art is intensely cathartic and healing, and should be enjoyed by everyone, even those who don't think they will become the next T. S. Eliot or Picasso. The act of drawing or painting, writing poetry, dancing, or making music brings us into personal contact with the creative spirit, and that has inestimable value for enjoyment and self-discovery. The health of the soul depends on whether we can express our creative energy freely or feel we must keep it hidden and suppressed.

Who is to draw lines of distinction between the so-called professional artist and the amateur? William Carlos Williams was a country doctor but later received the Pulitzer prize for his outstanding poetry. James Hampton, of Washington, D.C., went about his janitorial work from day to day, but at night he had visions of God, Moses, Mary, and other spiritual beings. They instructed him to build the *Throne of the Third Heaven of the Nation's Millennium General Assembly*, an elaborate environment made of gold and silver tinfoil over wood and glass. When Hampton died, his sister discovered the magnificent work in a rented garage. After the news media were made aware of the piece, it was acquired by the National Gallery of Art in Washington, D.C., and has continually drawn a crowd of admirers.

What Art Can Do

Though each artist has his or her own personal limitations, the potential of art is unlimited. Art can be anything we want it to be. Contemporary artists can create their own formal and nonrepresentational worlds exploring the properties of materials, visual effects, and design concepts. An artist can hold a

mirror up to the personal or the sociopolitical world, unmasking pleasures and tragedies. The artist can also serve to remind us of the sacredness of life and create a picture of our transformative and spiritual potential.

Art reveals the truth about human character, from the unflinching self-portraits of Rembrandt to Goya's portraits of the grandiloquently superficial royal family. Art shows the entire spectrum of character, from shallow and pathological ugliness to radiant and mystical beauty. A walk through an art museum that has objects from various world cultures can foster appreciation of the diversity of humanity and the creative imagination. Art can amplify compassion and sensitivity by sharing deep feelings. Listening to music such as Beethoven's Ninth Symphony can cause people to enter ecstatic states. Art can point to the many levels of reality—the physical body, the emotions, the intellect, intuition, and spirit. Art can make visible the subtle-energy bodies, as in the paintings of saints with halos and auras, and provide a home for fantastic demonic and luminous angelic beings. Art can show the importance of respect and collaboration among people, as in the AIDS-quilt project. Any orchestra or dance company requires this kind of creative collaboration as well. Art can demonstrate the intricate interconnectedness of the web of life, as in magnificent landscapes or the cosmological mandalas from Native Americans, Australian Aborigines, and Tibetan Buddhists. Art can portray human struggle and suffering but can also uplift and heal the soul. Art can point to the transcendental source of wisdom. By doing all these things and more, art can encourage and nurture what is best in us and give people joy and hope. If we cannot envision a better world, we cannot create one.

If an artist has not experienced mystic truth, if the spiritual

has not become known to the artist, then it would be a lie to represent it. But for the sake of ourselves and our world, we must aim high with our artistic vision and motivation. Salvador Dalí may have seemed arrogant when he said that he regarded himself as the savior of modern art, but regardless of whether one appreciates Dalí's work, the man had a mission. He was taking responsibility for the mission of art. With every painting he felt he was saving art.

The Tibetan Buddhists use the word *bodhichitta* to describe the awakening mind of enlightenment. They say that without the correct intention there is no advancement toward enlightenment, the spiritual practices just don't function. The proper motivation is to seek your own liberation for the benefit of all beings. The idea is to develop a kind and empathic heart, dedicated to acting on behalf of the common good. Never have the effects of ignorance, greed, and hatred been more capable of destroying the fabric of nature and the foundations of life than today. The need for healing actions that foster collective awakening and demonstrate personal responsibility for global conditions has never been greater.

The correct motivation is also critical for the artist. The type of energy artists put into their work has an effect on the artist, the viewers, and the collective psyche. Artists need to consider what type of energy they want to put into the world. There is an ethical dimension to works of art. Artists are poised between society and the responsibility to be completely truthful to themselves. The question of the artist's mission is only answerable within the crucible of their own soul.

To See or Not to See

Chapter 2

To See or Not to See

===

Just as we cannot talk of visual beauty if we are blind, so we cannot discuss inner spiritual beauty if we have never received it.

—Plotinus

I HAD A STRANGE DREAM SEVERAL YEARS AGO IN which I visited a school of clairvoyant art historians. Their habit was to gather and divine the character of artistic epochs. I asked how our age appeared to them. They replied that art used to be like a game with one ball and discernable artistic goals. Various artists from various teams or schools of art would score points—make "masterpieces" that could be judged according to critical rules. Now there is a playing field with no discernable goals. The "players" each have their own ball and are running wildly in every direction. It seemed like an

apt description of postmodern nonhierarchical relativity, the breeding ground of today's art.

For most of recorded history, art has reflected the mythic and religious life of humanity. Each community of artists would depict the deities, demons, and teachings of their tribe. But starting with the Renaissance, and increasingly since the dawn of the industrial era, artists have left religious iconic traditions in search of complete freedom and self-expression. Humanity's entry into rational modernity was a part of our maturing worldview, a growing into independent adulthood from the childlike myths of local tribalism. As is typical in the adolescent and young adult, there is the potential to get stuck in feeling righteous, or to rebel or be angst-ridden and nihilistic, and we shall examine these modernist tendencies. However, without the self-centered expressions of modernism, art would have remained a tool of religion, science, politics, and commerce and not become an unfailing instrument of personal truth and creative liberation, deserving of respect and reverence. Modernism is the song of the energetic and independent ego. Artists have taken personal responsibility for their form and content, their vision and mission, thus taking an essential step toward the transpersonal.

Considering the evolution of art and intellectual history "beyond" the myths and religious beliefs of our ancestry leads one to the worldview of objective science. Darwin's theory of evolution declared that humanity evolved from apes and that coincidence, mutation, and natural selection, not divine causation, accounted for life on earth. Freud believed that religion was inherently a regressive and sometimes pathological need of neurotic humanity searching for the security of a perfect parent (God) to assuage the wounds of childhood. Marx de-

clared religion to be the opiate of the masses, which kept people deluded into a concern for a nonexistent afterlife while not dealing with their oppression and exploitation in the present world. The ascension of scientific accomplishment and the decline of theology as a basis of truth corresponded with an increasing confidence in materialism as the true basis of reality. Serious questions were raised regarding the tactics and influence of religious authority toward the end of the ninteenth century. The philosophical genius Friedrich Nietzsche declared, with poetic succinctness, "God is dead." I feel that Nietzsche's dead God represented the exoteric patriarchal religious authority of the church. The authority of theological dogma had been replaced by the authority of reason.

Scientific reasoning and the subduing of nature have occupied the Western mind for the past few centuries to the point of our current amazing technological conveniences and alarming ecodevastation. Modern materialism has been a destructive ideological force hidden in the Trojan horse of orthodox science. Scientific orthodoxy and the materialist worldview propose that the entire universe and the miraculous biodiversity of our natural world are the result of a series of accidents. The materialist view would state, further, that consciousness is a by-product of the brain, and that when a person dies there is no soul, spirit, or afterlife. In short, the subjective inner experience of meaning is devalued or eliminated. Altered states of consciousness are considered pathological, and primary focus is placed on manipulations of the phenomenal world. An attitude of materialism shuts off a person's intuition, by which the spiritual world is apprehended, because spirituality is labeled as a delusional belief or dangerous hallucination.

The history of Western art reflects the breakdown of reli-

gious authority. Increasingly after the Renaissance, artists focused less on religious storytelling and more on the representation of single individuals (portraits) and secular history or bourgeois lifestyles. This certainly had to do with who was buying paintings. A rich upper and middle class came to replace the church as primary employer of artists. Occasionally, as in the art of Rembrandt and Vermeer, the everyday took on a mystic grandeur. Some artists began to take the insights of science as a point of departure for their vision. Perceptual tricks such as anamorphism, the distortion of images in reflected surfaces, occupied some artists, and the camera obscura developed skill in the knowledge and use of perspective. By the nineteenth century, European academies were filled with competent representational art. A stiff kind of neoclassical realism abounded, which occasionally had its peaks in Jacques-Louis David and Ingres, but which for the most part consisted of tiresome portraits, landscapes, or still lifes, and scenes from mythology or history.

It is no wonder that by the late nineteenth century artists began backing away from realism, because mechanical means of representation in the form of photography began to accomplish the same feat. One no longer needed to sit for hours for a formal portrait. Cézanne took the same subjects painted by the realists—still lifes, portraits, and landscapes—and focused less on trying to convince the viewer of the "realness" of the scene and more on the painted surface, flattening the shapes into balanced patterns of modulated color. Cézanne put more emphasis on the abstract form of his subjects. His later portraits were not concerned with the psychological depth of the sitter but with the beauty of the visual pattern that represented them. He suppressed symbolic meaning in favor of inventive

approaches to flattened, abstracted space and formal balance. The pointillist painter Seurat wanted to make pictures based on an understanding of optics and rational application of color. The impressionists were interested in quickly recorded perceptions or impressions focusing more on light effects and color patterns than on realism. With few exceptions, by the late nineteenth century there was little focus on art related to religious or spiritual life, and there was an obvious steering away from traditional sacred symbols.

At the opening of the twentieth century, one boldly inventive and sacred-iconic sculpture was Rodin's unfinished masterwork *Gates of Hell*, exhibited at the Paris Exposition of 1900. The prophetic nature of Rodin's *Gates*, with the piles of suffering and tangled bodies as the anxious "thinker" contemplates the scene, is remarkable, for it eerily anticipates the Holocaust and other horrors of the twentieth century. Rodin's composition for the doors was in many ways similar to Michelangelo's swirls of bodies in the Vatican fresco of the *Last Judgment*, or Rubens's baroque nightmare *Fall of the Damned*. But a crucial difference in Rodin's composition is the elimination of a sacred figure of redemption. The Christ figure has been replaced

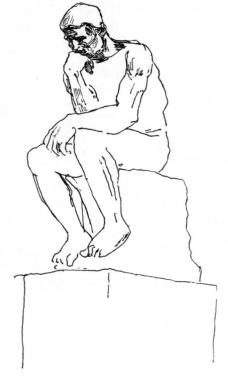

THE THINKER

by the "Thinker," who was originally called "The Poet." The poet or artist is the closest the *Gates* comes to having a spiritual messenger, yet the poet/thinker seems to offer no transcendent potential and no hope. The poet's downward gaze is witness to a humanist nihilist chaos. Rodin's genius divined the position of twentieth-century existentialist artists.

Perhaps the whole of modernism and postmodernism could be read as a psychopathological descent into dissociation and madness. Take the archetypal artist of the twentieth century, Picasso, for example. In Picasso's departure from the simple humanity of the blue and rose periods, he went in the direction of

HEADACHE

Insomnia

Cézanne, toward concern for flattening forms and focusing on composition. Schizophrenics sometimes speak of their world as composed of flattened cardboard shapes without meaning. Cubism became a head game, the fractured planes in some ways inspired by the "primitive" simplicity of African masks and ritual objects. When an art historian of Congo culture, Robert Farris Thompson, showed Congo artists some of Picasso's cubist works inspired by African art, they looked and shook their heads, calling it "broken-shadow art," and did not feel the kinship.

Picasso's *Les Demoiselles d'Avignon* is the crown jewel of the collection of the Museum of Modern Art and a breakthrough work in its forceful combination of representation and emerging cubist abstraction. The women in the painting, who are supposed to be prostitutes, become flattened and fearsome objects. One of the unusual references that Picasso drew upon in his preparation for this masterpiece was photographs of syphilitic patients. The hideous loss of features, such as a nose or lips or an eye, distorted people's faces most grotesquely. There were good reasons to fear these women, Picasso seems to say. In the light of his notorious sexual power and succession of broken relationships, the painting reveals a troubled sexual atmosphere as well as a new style of painting. In his "way with women," Picasso seemed the typical, if exaggerated, twentieth-century male persona, both dominator and philanderer, unable to find an enduring and equitable partnership of love and respect. Picasso's true love was his spellbindingly voluminous and inventive work. He is the archetype of artist as creative fountainhead, a true genius skillfully spewing forth new visions.

Picasso changed art forever; he opened the way for more radical artistic investigations and infused art with a tireless experimentalism. Yet Picasso's continuously surprising inventions occur mostly on a mental level, rarely seeming to emanate from heart and soul. He seemed capable of inflicting and understanding pain in others, but strangely lacking in his work is the dimension of personal suffering, of human vulnerability and spiritual torment that artists like Michelangelo, Rembrandt, van Gogh, Kahlo, and Pollock touch us with. Picasso's production is awe inspiring, and we must be forever grateful to him for our artistic freedom, but his worldview lacked the transcendental.

The Spiritual in Abstract Art

During the early twentieth century the modernists Malevich, Kandinsky, and Mondrian professed a transcendental intention to their works. Kandinsky and Mondrian studied the occult works of Theosophy written by H. P. Blavatsky, Annie Besant, and C. W. Leadbeater. There are surprising visual correlations between the occult art produced for theosophical texts, such as *Thought Forms*, by Besant and Leadbeater, and the later works of Kandinsky. These early pioneers of abstraction demonstrated tremendous courage to seek the spiritual in original forms without resorting to the use of traditional sacred imagery or references to the physical world. Kandinsky's book *Concerning the Spiritual in Art* remains one of the twentieth century's essential artistic statements of intent.

Abstract shapes and patterns have long been part of the world's sacred art traditions. In fact, the art of both Judaism and Islam maintain that there must be no attempt to represent God iconically. This edict has brought the artists and craftsmen of these traditions to the development of dense and metaphysical patterning adorning many temples and mosques and has led these traditions to pour great invention and beauty into their calligraphy. Tantric and alchemical art have long used abstract and symbolic forms to point to the spiritual ground of being, yet just as often they portray the interrelatedness between the transcendent spiritual world and the immanent or manifest material world.

But in the artistic quest for spiritual abstraction in the twentieth century, a rift between the spiritual and the phenomenal world was espoused by some of the modernists. The idea that the universal is only abstract and not to be represented

through references to the phenomenal world became a man-
date for many artists claiming spiritual content in their work.
In the words of Mondrian, "More and more, not only the use-
lessness of figuration, but also the obstacle which it creates,
will become obvious. In the search for clarity, non-figurative
art develops. . . . It must be obvious that if one evokes in the
spectator the sensation of, say the sunlight or moonlight, of
joy or sadness, or any other determinate sensation, one has not
succeeded in establishing universal beauty, one is not purely
abstract."[1] Though seeking a direct way to make visible the
transcendental domain, the early modernists could be said to
have "camouflaged" the spiritual in abstract forms. The works
were not exhibited in churches or temples but in galleries and
museums alongside paintings whose creators held no spiritual
intentions. As a consequence, the uninitiated did not readily
perceive the meaning or hidden subject of the paintings. Many
critics and art historians have discounted the spiritual claims
of these pioneer modernists and focused on their revolutionary
formal inventiveness. In the catalogue for Mondrian's recent
retrospective at the Museum of Modern Art, scant mention
was made of his involvement with Theosophy, let alone its
influence on his approach.

The question arises as to what effect an artwork may have
on a cross section of average people. If artists consider their
work spiritual, does it necessarily convey that sense to the
viewer? Because recognizable spiritual symbolism is not obvi-
ous in their works, nor are the works exhibited in a "sacred"
context, claims of spiritual content are subject to interpretation
and, with rare exceptions,[2] have been largely ignored by the
mainstream art world and public.

Mark Rothko, an abstract painter who was embraced by
New York's modern art world, early in his career acknowl-

edged his art as related to the search for the transcendental, and then later in life he felt that it had become difficult to speak openly of it.[3] Fortunately, his huge paintings of holy darkness in the Rothko Chapel in Houston, Texas, and many of his paintings in museums remain as statements of his exploration of spiritual mystery through broad and muted empty fields of color.

During the 1950s and 1960s, the devaluation of spiritual meaning and content in art led to a predominance of formal concerns—pictorial structure and the surface qualities of different materials—for abstract painters. The critic Clement Greenberg, who had befriended some of the abstract expressionists and claimed to speak for them, further emphasized surface and formal concerns while deemphasizing content. In his book *Art and Culture*, Greenberg states, " 'Art for art's sake' and 'pure poetry' appeared, and subject matter or content became something to be avoided like the plague." His formalist interpretations reduced the intention of some of the metaphysically oriented abstract expressionists.

Art and Materialism

The rise of reductionist materialism and the acceptance of the paramount importance of formal qualities was voiced by one of America's leading abstract painters, Frank Stella: "I always get into arguments with people who want to retain the 'old values' in painting—the 'humanistic' values that they always find on the canvas. If you pin them down, they always end up asserting that there is something there besides the paint on the canvas. My painting is based on the fact that only what can be seen there is there. . . . What you see is what you see."[4]

Stella appeared to regard art objects as separable from the context in which they arise. Certainly a painting can be reductionistically described by its physical properties only: its shape, the paint, the design, and so forth. But every artwork that exists is both an individual thing, a whole unto itself, and simultaneously a part of the matrix of forces that brought it into being. A painting is a discrete object, yet it can be interpreted in many ways. A work of art refers to its maker, the artist, and the artist's emotions or states of consciousness embedded in the work. The object has a place in art history. How is the artwork valued by the individual viewers, their society, and the marketplace? The work of art can be interpreted technically, psychologically, politically, economically, socially, philosophically, or spiritually. A complete discussion of a work of art would address all these interpretations. Yet what often happens is that a favoring of one point of view (to the exclusion of other views) sweeps the art world, catapulting some artists into the spotlight if their works happen to coincide with the critical fashion.

For the pop artists of the 1960s, content was based on the merchandise of a media-saturated and product-oriented materialistic culture. Warhol's iconic and ironic soup cans are a prime example. The media stereotype of artist as rich and successful "pop" star secured art's entrenchment in materialism and spiritual blindness. The art historian Rosalind Krauss has commented: "Now we find it indescribably embarrassing to mention 'art' and 'spirit' in the same sentence."[5]

The Current Condition

Both complete freedom and chaos define the art world today. Formal novelty and egoic struggles for marketplace recogni-

tion have increasingly concerned the contemporary artist. The art market has become a vast commercial enterprise, from small galleries to huge auction houses. The art object is regarded by some collectors as a commodity for speculative investment, focusing on fast returns or "short-term gains" if an artist's career skyrockets. The fluctuations in market value of contemporary artworks is truly astonishing and has left many an investor burned. The favoring of market-based evaluations for works of art has sometimes blinded both artists and the public to the spiritual function of art.

At what point does the monetary evaluation of an object eclipse the form and content of the art itself? When do we begin to see only dollar signs and miss the beauty of an object? It is amazing to find that a piece of cloth with a few dollars' worth of paint on it could be sold for fifty to eighty million dollars, as is the case with a painting by van Gogh. There is a perverse irony in the ever increasing prices for works by an artist who couldn't sell a picture to save his life. Yet there is also some important message in the fact that art objects are the things that human beings economically value most. Van Gogh's life and death have a mythic quality and pop-culture status that are auratically transferred to each of his works, feeding into the complex desires to own rare status symbols. Yet it is the purity of feeling, the richly created beauty and spiritual authenticity in a work by van Gogh, that makes it truly priceless and deserving of mythic stature. The tragedy that van Gogh died before he was recognized and appreciated points to the gulf between the artist and the public, which has only grown greater throughout the twentieth century.

To peer back over this tumultuous century is to see one approach or "ism" replacing another at a dizzying pace. If one view of this century's art is to see a descent into madness, one

could alternatively view the procession of different art modalities as a celebration of boundless and unprecedented artistic freedom. The individual sensibilities of artists have replaced the mythic and religious subjects of previous centuries. Who would rather live in an earlier time when the artistic choices were so limited and constrained by tribe or religion? Yet unlimited freedom makes no demands of personal and social responsibility to honor or portray the interdependence of the individual within the larger context of community and planet. Only rarely do artists demand such responsibility of themselves.

Many artists believe they have no moral obligation to their parent culture. The following statement by contemporary German painter Georg Baselitz is an extreme indication of how today's artists are alienated from their public and any sense of contributing to the common good:

> The artist is not responsible to anyone. His social role is asocial; his only responsibility consists in an attitude to the work he does. There is no communication with any public whatsoever. The artist can ask no question, and he makes no statement; he offers no information, and his work cannot be used.[6]

If Baselitz were an isolated crank with a bad attitude, unnoticed by the rest of the art world, his statements would not indict our culture. However, Baselitz is fully canonized by the art world and is regarded as one of the best that contemporary art has to offer. Therefore his statement provides insight into both the individual and cultural pathology of alienation. In a sense Baselitz is simply the latest incarnation of the same alienated modernist attitude expressed by Oscar Wilde nearly a

century ago when he said, "A true artist takes no notice whatever of the public. The public is to him non-existent."[7]

Baselitz and Wilde express a partial truth. We need to understand their attitude of alienation as part of the necessary process of individuation that allows an artist to create original works. Art is the expression of strong individuals; it emerges from their passionate personal vision. Art must first please the artist. Works created to please the public, to imitate an established style, or to attract commercial interest are a trade or craft, not worthy of the weighty respect we reserve for true art. Emerson understood the artist's need to withdraw from the public in order to gather creative steam: "Happy are the artists who look only into their work to know if it will succeed, never into the times or the public opinion; and who create from the love of imparting certain thoughts and not the necessity of sale—who create always for the unknown friend."[8]

While respectful of the need of artists to distance themselves from society's stifling influence, Emerson saw beyond the artist's narcissistic self-absorption and generalized contempt for people and saw the artist as providing a gift for humanity.

Art and Alienation

During the 1980s and 1990s the alienation of artists and "the public" reached a breaking point, when many artists began to run afoul of cultural watchdogs and moral censors. The most dramatic case was the condemnation of author Salman Rushdie by the Ayatollah Khomeini of Iran. For his "offenses against the prophet Muhammad" in his book *The Satanic Verses*, Rushdie was put on a death hit list and had to go into hiding.

In America, artists like Andres Serrano and Robert Mapplethorpe were condemned in Congress for creating religiously offensive art while being publicly funded by the National Endowment for the Arts. Serrano's *Piss Christ*, a photograph of a plastic crucifix submerged in urine, enraged many. Serrano also received death threats. The censorship furor over controversial artists helped fuel the dramatic downsizing and near elimination of the NEA, an important fund for creative artists.

Rushdie gave a lecture shortly after his condemnation in which he spoke of two absolutes, the religious absolute and the artistic absolute. Religious absolutism vehemently and sometimes violently condemns the profaning of sacred religious values or icons. Since Muslim followers of the Ayatollah believed that Rushdie blasphemed the Prophet, there was no room for compromise. He must be killed. But Rushdie claimed allegiance to another absolute, the absolute of complete artistic freedom. Rushdie felt that the necessary freedom to create places artists beyond ethical concerns for the effect of their works on the human community, beyond aesthetic concerns about good and evil. Both of these views seem inflexibly strident and lacking in compassion.

Art *is* a territory of complete freedom for the artist, but as Rushdie discovered, there may be strange consequences when the art enters society. The twentieth-century artist has frequently played the role of amoral child-god creating without consideration of the common good. A 1996 essay in the *New York Times Magazine* entitled "Designer Nihilism" details popular cultures arena of perversion and degradation. The article cites popular "transgressive fiction" and movies that feature tales of pedophilia, sadomasochism, dismemberments, and

necrophilia, and notes the current celebrity of artists that embrace all that is ugly and vile.

"Obviously some work that is disturbing and repellent is also great art. But unlike Dostoyevsky or Baudelaire, contemporary artists are just interested in sensationalism for sensation's sake. Their peek into the abyss isn't philosophically interesting; it's just an excuse for a self-congratulatory smirk. The so-called artists are obsessed with money and self-promotion.[9]

The ultimate alienation of artist and audience, or eruption of hatred and sickness in art, occurs with the phenomenon of the artist as murderer, or with art that inspires or glorifies murder. Some infamous rap singers and white racist rock groups boast of members who have murdered people. "Gangsta rap" artists who were extremely talented have been killed by rival gangs for the spiteful messages in their songs. An auction was held recently for the clown paintings of serial killer John Wayne Gacy. These paintings would probably be worth very little if not for the infamous and sinister aura the murderer brings to the works.

Oliver Stone, an Academy-award winning director and Vietnam veteran turned Buddhist made a film entitled *Natural Born Killers* based on a script by Quentin Tarrantino. An artfully outrageous and intelligent film, it also celebrated graphic and extreme violence, showing two remorseless and twisted lovers enjoying the negative power of murder. The film was watched repeatedly by two young, emotionally unstable persons, and one day after having ingested LSD and watched the film again, they went out on a copycat killing spree. When they were later arrested they referred to the film as their inspiration.

Has art morally bottomed out? Is popular art's embrace of violence and evil a worthy subject, and do these artworks serve their community in any positive way? I admit that as a young artist these questions never even occurred to me. The possibility of my works' having an effect outside the studio was not my concern. In many ways my own art was morally bankrupt and spiritually blind. If I did think about it, I justified my art as a reflection of a diseased society.

My Shadow

My own works that I consider most disturbing and morally questionable center around the use, or misuse, of bodies at a medical school morgue where I worked more than twenty years ago. I did a variety of "performances" using cadavers. At the time I felt I was courageously exploring the realm of the ultimate polarity, that of life and death, but it seems that I was also uncovering my own lack of values and understanding of good and evil. In one piece, *Inner Ear*, I cut the head off a dead woman, then poured hot lead into her ear as a way to make a model of the delicate spiral labyrinth. It was a violent way to make contact with her spirit, so she would speak to my inner ear. I experienced psychic repercussions later when her spirit angrily confronted me in a dream. In another piece, entitled *Life, Death and God*, I tied a rope around my ankle, then tied the other end of the rope around a cadaver, and we both hung suspended on a wall, strung on either side of a drawing of a crucifix. Around the same time, I made a painting of myself lying on top of a dead woman, entitled *Necrophilia*.

For my photo essay *Monsters*, I found a number of malformed babies preserved and tucked away in corners of locked

rooms at the medical school. Each specimen was strangely beautiful and seemed to express unique insights about human nature. There was a brainless wise one, a double-headed messiah, a wrinkled siren, a cyclops, and on and on. I took photographs of thirty of them. A few weeks after completing the photographs, I was awakened in the middle of the night, drenched in anxious sweat. A translucent hallucination of a malformed fetus hovered in front of me. Demonic voices spoke from it saying that it was time for me to come with them. A presence of absolute evil seemed to be focused in that ghostly monster. I trembled in fear, seeing myself on the edge of an abyss, which appeared to fall endlessly into darkness and insanity. From my depths, my voice repeated, "I know that divine love is the strongest power." A blue light dispelled the apparition of the monster, and the voice of an angel told me that his name was Mr. Lewis and that he would watch over me for a while. With his reassuring protection, I went back to sleep.

Around this time, in 1976, while sitting in my studio one night, a vision of an ominously menacing courtroom appeared. Before a judge I could not see and an angry jury, I faced a woman who accused me of trespassing her body in my morgue work. I tried to explain that I was making art, but there was absolutely no forgiveness. The judge told me that from now on I must do more positive work, putting me on lifetime probation. These visions were a turning point for me that helped me realize that I could spend a lifetime in negativity and darkness or begin to uplift my focus. I came to see those performances as a misuse of innocent people. Even if they were dead, they did not agree to such actions. My actions had serious consequences, scaring off a number of people who might other-

wise have been interested in my work, and cursing my work to somehow being precariously near or over "the edge."

Fortunately, I was in a relationship with Allyson, and she provided the uplifting daily experience of love and acceptance that I needed to heal and reorient my distressed soul. Some friends heard of my work in the morgue and introduced me to Buddhism through a book by the fourth-century Indian scholar Buddhaghosha called *Path of Purification*. The book recommends dead bodies as meditation objects. My orientation toward the bodies began to change. A respect for the sanctity of the body and a sensitivity to the mystery of life and its impermanence began to take hold. To learn more about Buddhism, I read the *Tibetan Book of the Dead*. That changed my relationship with the bodies as well. When accepting bodies that funeral homes brought in, if no one else was around, I would do a simplified *bardo* ritual, calling the dead person's name and encouraging him or her to go toward the light. Psychedelics also led to breakthrough spiritual experiences that transformed the focus of my art.

My attitude regarding this early "shadow" work is ambivalent, if I had not performed those dark works, I would not have been inwardly pushed toward a more numinous light. Following the promptings of my artistic unconscious led me to the brink. Those disturbing visions were a form of grace, forcing a turning about in my soul. The experience has given me great respect for the mystery of the creative process. We do not know where we are being led; though we might pass through miserable swamps, our creativity can become a redemptive path.

Some popular art reflects the spiritually blind zeitgeist of alienated egoism, souless materialism, moral degradation, vio-

lence, and the extremes of artistic absolutism. But I have come to accept even "negative" art as a "positive" gesture because it harnesses the creative fire and describes an aspect, even if an ignorant or vile one, of human character. Some art that appears sick may be a diagnostic tool for social ills. If we have learned nothing else from the history of modern art, it is that artists who are driven, internally compelled to create, are expressing their truth and fulfilling the mission of art, even if they disturb, disgust, or engender fear or anger in their audience. An alchemical process is at work here, bigger than any of us knows, integrating the shadow into the human psyche. In art's mission to reveal the complete range of human character, part of its function is to examine taboos and map the extremes of human consciousness. When art abandoned the moral compass inherent in sacred subject matter, it was free to examine any subject, but at the risk of losing the depth, heart, and sense of idealism that a spiritual context can give to it.

Art and Nihilism

Good leads people toward living spirit and compassionate action. Evil leads people away from life, away from spirit, away from kind and wise action, toward fear, confusion, and emotional and physical violence. A strange form of evil has infected the soul of humanity in the twentieth century, and it bears the name nihilism. Nihilism is the belief that all existence is meaningless and there is no possibility of truth. Nihilism is the hopeless darkness of the spiritually blind. Nihilism blinds us to the interdependence of all beings and concern for their common good. Nihilism leads to greed and sexual predation, and in corporate boardrooms can lead to rape of the environ-

ment. Nihilism leads to transgressive and criminal behavior, cynically disregarding the possibility of loving-kindness and heroic action. Nihilism is the attitude of egoic paranoia and amorality that makes murder justifiable. And nihilism has become one of the premier attitudes displayed in popular culture.

Why has nihilism become a dominant cultural sensibility in the twentieth century? Look at the heaps of millions of innocent victims of the Holocaust of World War II or the killing fields of Pol Pot's Khmer Rouge if you want the beginning of an answer. The lower mythic tribal mind has gotten hold of weapons born of higher rationality. Both morally and financially, the paranoid arms race bankrupted the superpowers and coined terms such as *overkill* and *acceptable losses*. The total killing power of the world's stockpile of nuclear weapons amounts to every person on earth receiving a nuclear blast equivalent to the force of four tons of TNT. Or we could look at the careless, callous disregard for health and the environment that individuals and corporations all over the world have gotten away with, laughing all the way to the bank. Species are disappearing at a frightening pace. The air, water, and soil are poisoned by the chemical and agricultural industries. Is it any surprise that a century filled with such devastation, degradation, and inhumanity should reap a culture of hopeless spectacle? The artist Joe Coleman has suggested that mass murderers, whom he celebrates in his amazing nightmarish paintings, are nature's attempt to "thin the herd" and rid the world of the cancerous disease of humanity before it kills its host planet.[10] Part of the artist's job is to tell the truth, to describe the world we live in, to reveal the condition of the human soul. No art, no matter how foul, will ever adequately

express the obscenity, stench, and stupidity of Auschwitz or the pernicious disaster of pollution. If our art projects a poisoned, perverse, and sick mentality, it is an accurate portrayal of humanity's dark side.

However, artists need to consider the hidden power in their projections. Mind-body medical research has demonstrated the importance of intention and imagery in healing. In study after study positive prayer has been shown to speed recovery in groups of patients. These are patients who did not even know they were being prayed for! Thoughts are things of power. Every thought is a prayer! Even bacteria growing in a laboratory petri dish have been shown to be affected by prayer and imagery. With strongly negative imagery and intentions toward the bacteria, they can be killed. Likewise, when the bacteria are prayed over with loving intentions and protective imagery, they can even resist antibiotics. Experiments to study the mind's influence on living systems from a distance have been performed with of all types of life-forms: yeast colonies, fungus, algae, plants, ants, mice, cats, dogs, and humans. It takes strong intention to bring imagery to form as an artist does, and these intentions and images can catalyze pathology or empower the healing response within both the artist and society. This leads the introspective artist to a moral dilemma: how to deal responsibly with negative subjects. The artist's works are expressions of the cultural body, yet they also feed back into and affect the culture in obvious and subtle ways.

The arts are therapeutic and emotionally cathartic for most of us. Art has a healing function, and if we didn't have our uncensored and free creative outlet or enjoy other people's music, dance, theater, sculpture, painting, and cinema, there would be a lot more sick and hateful people in the world. A

world without art would leave us bereft of a language of beauty; we would lose access to one of the primary ways that spirit reaches people. Fortunately, as long as humans exist, a world without art cannot occur, because where there are people, there is art.

The quest of contemporary artists for individuation and originality leads them to an internal universe, beyond the external authority of family and society, where they must find their own creative principle and internal authority. Can artists navigate inward beyond slickness, cleverness, and nihilism, beyond desires for fame or money, and give consideration to the type of ethical and spiritual energy woven into their art objects? The anarchic chaos of postmodernism has given artists the freedom to "carry their own ball" and be artistically responsible to themselves, but isn't it time to consider the effect of art on one's own health and the web of human relations? This does not mean lying to ourselves, or going backward, or repudiating the breakthroughs of modernism and postmodernism. Let intuitive artists incline themselves toward spiritual maturity. Let us offer our art not only as pus, poison, and self-indulgence, but also as medicine to heal the alienation and sickness of the human soul.

Artists individuate in order to attain an original statement. Yet to be fully ourselves—to realize our deepest nature—is to transcend alienation, transcend our constricted ego, and unite with the world. Our mission is realized in relationship, in participation with life. The will to create and the will to love become one.

Is it possible to have a positive spiritual outlook and avoid the dangers of deluded religious zeal? The ferocity of life wounds our idealism, tempers it, matures it, and perhaps even

extinguishes it momentarily. But the whole point of spirituality is to enable us to retain contact with our own capacity for loving-kindness, wisdom, honesty, generosity, self-sacrifice, and inspired creativity. We reject nihilism when we assume the divine. Tomorrow's art is the mystery of the Creator. Some artists will express visions of planetary healing and a universal sacred art. Transpersonal psychology has uncovered the perennial vision of this universal spirituality.

The Perennial Vision

The miraculous complexity of human consciousness is the result of billions of years of cosmic and biological evolution. To observe nature in any detail is to be spellbound by the infinite creativity and divine intelligence inherent in the cosmos. If the sun were a slightly different size, or if the earth had deviated a few degrees from its present orbit, life on earth in its astonishing variety might not have occurred. There was nothing accidental in the creation of the universe. Only a perfectly balanced tension of opposites could lead to the creation of galaxies, planets, and life-forms. Artists unknowingly or knowingly align themselves with the force of universal creativity.

Scientific reason has overthrown centuries of mythic-magic superstition. We don't burn witches for failed crops any longer. One reasoned proof has built on the next, constructing a refined scientific worldview. One of the major breakthroughs of science has been the theory of evolution. Since the time four billion years ago when blue-green algae were the only life-forms, planet Earth has developed magnificent plants and creatures. Animal morphology and behavior have adapted and refined according to environmental cues.

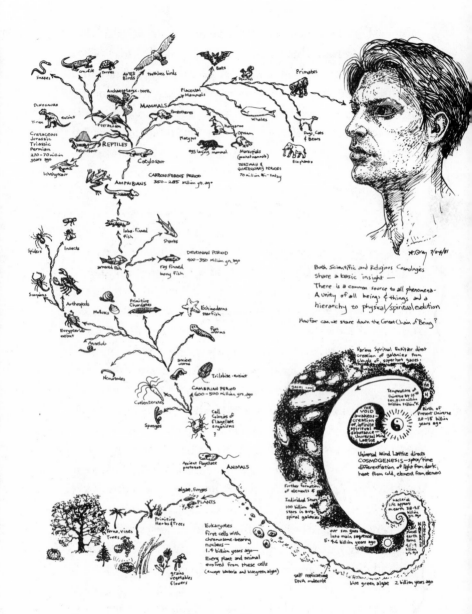

Both Scientific and Religious Cosmologies share a basic insight —
There is a common source to all phenomena— A Unity of all being; & things and a hierarchy to physical/spiritual evolution

How far can we stare down the Great Chain of Being?

STARING DOWN THE CHAIN OF BEING

Consciousness is an aspect of all life-forms and has obviously evolved and diversified along with the physical forms of all living things. Observing human development in the light of evolution theory, we may surmise that human consciousness in its very early stages was without language and probably without the capacity for rational and conceptual thought. Humanity has developed to its current state of complex rationality because of the refinement of language. Considering consciousness as an evolutionary force may imply that there are higher states of consciousness beyond reason, transrational states. Some psychologists have been fascinated with altered and mystical states of consciousness, interpreting them as either pathological or holding promise for expanding perception. The Nobel Prize–winning scientist Francis Crick has recently stated that the derangement of mystical experience might be explained by a "theotoxin" (God-poison) in the brain. Freud hoped that his psychoanalytic clients would reach a state of well-adjusted functional neurosis. Is this the best we can hope for? What are the higher capacities of human awareness? The field of transpersonal psychology has been mapping these possibilities for several decades now.

By confining itself only to what can be measured with instruments, the materialist point of view becomes a metaphysical flatland allowing no subjective insight into why we are here. Scientists and artists need not limit themselves to such a view. No less a scientific genius than Albert Einstein professed a profound respect for mysticism and the importance of the imagination:

> The most beautiful and most profound emotion that we can experience is the sensation of the mystical. It is the

source of all true science. He to whom this emotion is a stranger, who can no longer wonder and stand rapt in awe is as good as dead. To know that what is impenetrable to us really exists, manifesting itself as the highest wisdom and the most radiant beauty which our dull faculties can comprehend only in their most primitive forms—this knowledge, this feeling, is at the center of true religiousness. My religion consists of a humble admiration of the illuminable superior who reveals himself in the slightest details we are able to perceive with our frail and feeble minds. That deeply emotional conviction for the presence of a superior reasoning power, which is revealed in the incomprehensible universe, forms my idea of God.[11]

The transpersonal model of consciousness is based on dimensions of the human mind that transcend reason. *Transpersonal* means beyond the personal, toward a universally spiritual consciousness. The influx to the West of Eastern wisdom texts, meditational disciplines, and psychedelic explorations during the latter half of the twentieth century led a few courageous scientists, psychiatrists, and philosophers to revise the materialist-impiricist paradigm. Instead of following Freud's focus on mapping the mind by examining the neurotic and psychotic, the psychiatrist Abraham Maslow based his research on psychologically healthy and creative individuals and their higher states of awareness, or "peak" experiences.

According to the transpersonal vision, consciousness is central to understanding the nature of reality, and not merely a "byproduct of brain activity." There are many states of awareness, from dreaming to wakened rationality to psychic clairvoyance and states of mystic union. Each state reveals its own

characteristic reality, its own worldview. The laws of the dreamworld are not the same laws that govern the physical world.

The way one views reality is dependent on specific states of mind. To see the world anew you have to enter into a new state of consciousness. A child of five cannot understand complex mathematic functions until higher reasoning abilities are acquired. All philosophies or points of view are "state specific." If language was the necessary mind tool needed to develop reasoning intelligence, what mind tool is needed to develop beyond reason? Spiritual practice is the tool that gives access to the transpersonal-transrational state. Every culture has spiritual practices, and the mystics of those traditions have left records of their insights.

In his book *The Perennial Philosophy*, Aldous Huxley compares quotes from the world's spiritual teachings. For example, he shows how Hindu, Taoist, Buddhist, Islamic, and Christian mystics all describe the human spiritual essence as united with the divine ground. The nature of the spiritual ground is then examined through the same comparative approach, as well as the subjects of divine incarnation, the morality of good and evil, and methods of spiritual practice. Huxley shows an uncanny unanimity among mystical insights at the core of the world's great religions.

In his numerous books on the transpersonal perspective, Ken Wilber details a spectrum of consciousness evolving from the least conscious through dozens of hierarchical levels to the most superconscious.[12] He refers to the span of progressive levels of awareness as the Great Chain of Being. This hierarchy of consciousness is broadly divided into the dimensions of matter, body, mind, soul, and spirit. Wilber makes the case

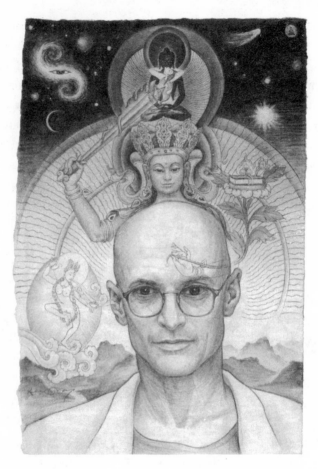

KEN WILBER

that individuals go through a microcosm of human evolution, developing through the sequence of prerational to rational and, potentially, transrational states, each level superseding and incorporating, "transcending and including," the former levels.

Wilber is fond of quoting Saint Bonaventure, a fourteenth-century Franciscan mystic who taught that humanity has three

modes of knowing or "three eyes." First is the eye of flesh, by which we perceive the "outer" material realm of objects within the framework of space and time. Second is the eye of reason, which discloses a knowledge of symbolic language, philosophy, mathematics—the conceptual realm. Third is the mystic eye of contemplation, which reveals the luminous transcendental realms. The artist must be adept at opening each of these eyes.

For a mystically inclined artist of the twenty-first century, the transpersonal vision offers a unique and essentialized spiritual synthesis. Transpersonal psychology and the perennial philosophy have shown that within the sacred teachings of world religions are universal spiritual truths. To paraphrase Huxley:[13]

1. All that exists is dependent upon the divine ground.
2. Human beings can realize the existence of the divine ground by transrationally uniting with it.
3. Humanity possesses a double nature, both an egoic contracted self and a timeless spirit.
4. The purpose of life on earth is to identify with one's spiritual nature and achieve liberative unity with the divine ground.

And I would add:

5. Once liberative unity has been experienced, it is the responsibility of individuals to share their insights and act in accordance with their new vision.

Religion and Spirituality

Transpersonal psychology examines the mind from the perspective of every wisdom tradition and also includes many

other fields of consciousness research, such as psychedelics or near-death experiences, which may or may not have spiritual or religious components. Let us distinguish the meanings of the words *religious* and *spiritual*. Both words point to what humanity considers sacred. Yet there is a difference between the exoteric dogmas of a religion ("You are inherently sinful and will go to hell. Take Jesus as your saviour and you will go to heaven when you die") and the esoteric revelations of spiritual practice ("The kingdom of heaven is within me now, as infinite clarity, awareness, and bliss. Christ-consciousness, Buddha-nature, the Atman in the Brahman, all are different names for my innermost spiritual nature, which is beyond the reach of words"). Religion is based on faith in a traditional dogma, whereas spirituality is based on transpersonal experience. Religion offers the external authority and security of a belief system, the guidance of a code of moral conduct, and a community of like-minded believers. Spirituality is a subjective, internal experience of the sacred, an opening to ultimate reality that positively affects the heart and mind of an individual. The spiritual does not depend on any specific religious setting, yet it obviously may be found in individuals within every religion.

The fact that a person holds religious beliefs is no guarantee that he or she has had a mystical experience that has grounded him or her in transpersonal spiritual knowledge. Sensing an internal spiritual emptiness, many people join religions or cults looking for the security of an idealized family or community and a belief system that dogmatically proclaims them to be "right." Others are called to religion by a conversion experience in which a specific religious archetype reaches out to them. Unfortunately, the most self-righteously religious per-

sons appear to be the most intolerant, uncompassionate, and spiritually blind. The religious zealots who kill in the name of their religion are inflicting emotionally based tribal hatreds perversely masquerading as religious dedication. True religion and spirituality begin at the heart level. As Albert Schweitzer once said, "Dogma divides, spirit unites."

Obviously, the wisdom inherent in the living religious traditions and the power of a master teacher's transmission within a spiritual lineage goes far to assist aspirants in their journey. The encouraging context and group soul of a religious community can sometimes make a profound and beneficial difference in furthering one's spiritual progress.

The Potential of Sacred Art

It is important for artists and creative people to gather together and support and encourage each other. In Buddhism, the spiritual community is known as the sangha, which is one of the Three Pillars of the Path. A gathering of the art community mutually honoring and empowering each other is art sangha. Can we transform the art world, or our attitude toward the art world, to the degree that we can regard it as a spiritual community? The other two pillars of the path are the teacher (Buddha) and the teaching (called the dharma.) As artists, if we wanted to continue the correlation with the three pillars, perhaps we could think of the teacher as a lineage of master artists who transmit spirit, and our art dharma is the art itself and all the teachings about or approaches to creating spiritual art. The spiritual aspirant needs direct personal contact with a teacher who embodies the teaching. This face-to-face meeting allows for a subtle transmission to occur. Contact with a great

teacher catalyzes and encourages the spiritual process. Our teachers can be living or dead; as long as their legacy and their realization live in their works, we can learn from them. Art dharma is the art, the craft, and the truth conveyed by the art. A work of sacred art is a carrier, a messenger of wisdom. The art object or event is one of the primary distinctions between art and other spiritual paths. Through their craft, artists leave tangible traces of the states of being they have entered.

Religion and art that emphasize ecstasy and mystical experience will always fulfill profound human needs, bringing people back to the source of infinite love and ultimate reality. A reverence for life is one of the hallmarks of true spirituality. Our violence as a species and our destructive assaults on the web of life make obvious humanity's spiritual blindness and the critical need for spiritual awakening. Art can serve that awakening.

When an artist's work is a sacred mission, it gives meaning to his or her life; it is a satisfying and mighty motivational force. Artists become sensitive to spiritual inspiration, to overarching psychic forces, and allow themselves to be guided by these intuitions. Artists of today may not find spiritual inspiration by reading popular critics' or curators' assessments of contemporary art. The transpersonal vision has not become a common context for assessing art. That is not to say that art catalogs, magazines, and books ought not to be read or that one should deliberately ignore current fashions in the contemporary art world. But the artistic refinement of one's own "soul's gold" and the spiritually transformative potential of art are usually not the motivation for most critics' theories and concepts.[14] The art-historical or postmodern imperatives that are discussed in much art criticism ignore the consciousness-evolutionary imperative driving the quest for planetary ecolog-

ical awareness and spiritual renewal. The artists of the twenty-first century will have to look deeply into themselves and ask hard questions about the mission of art. Is art merely the fashionable expression of artists' egos and a reflection of the world they live in, or can art become a healing path that reveals the beauty and holiness of our selves and our world, projecting an ideal of what we and our wounded world may become? This is not a dogma for new art, merely a call for art to manifest its power to uplift, inspire, and become a flame of spiritual vision.

Though we may try to write about it, the transcendental is beyond all concepts or theories. The best that theory and critique can do is point us toward the creative source. Artists rely on themselves, peering into their own souls for inspiration and guidance, but the friends and mentors of artists and a spiritual practice may all be able to assist the birth of spirit in their art.

An art object of sacred beauty can bring joy and profound insight to a viewer. Art objects may also catalyze consciousness transformation and even stimulate healing responses in sensitive persons. There are statues of Madonnas and church icons that weep healing oils. The ex-votos found in Spanish and Mexican churches are testimonials to the healing power of some art. The ex-voto is a small painting offered to a statue or other work of art, and hung in close proximity to it, that shows how the art acted as a transmitter of healing power. A common ex-voto may show a person sick or on a deathbed and an image of the honored statue or painting of Mary or Jesus appearing in a vision and offering healing grace. The inspiring art in the church thus becomes surrounded by artistic testimonials supporting its power and enlarging its aura of effectiveness as mediator of holy spirit.

Certain statues in Tibet are regarded as being capable of

HOLDING THE BRUSH

accelerating the process of enlightenment. Pilgrimages are made to the statues, which are believed to bless the viewer's mindstream. The blessing leads a person to a more fortunate rebirth or removes obstructions to spiritual progress. What higher goal for artists' intentions than that their art may bring healing and blessings to viewers and catalyze their own and the viewer's spiritual evolution?

Let artists honor the values that make life worth living, that they might plant seeds of transformative power in the field of art. The mind of the artist should always be a stronghold of free will. May the mind of the artist find a home in the divine will.

DEEPLY SEEING

Chapter 3

Deeply Seeing

Things are because we see them, and what we see, and how we see it, depends on the Arts that have influenced us. To look at a thing is very different from seeing a thing. One does not see anything until one sees its beauty. Then, and then only, does it come into existence.

—OSCAR WILDE

MOST OF OUR DAYS ARE SPENT PASSING BY things that we glance over but may barely be able to recall. This kind of looking is necessary for survival— "look both ways before you cross the street"—but it's totally superficial. As we glance at life, we are often wrapped in a tangle of our own thoughts and judgments. This is the normal self-contained state of ego. But what is the difference between merely looking at a thing and actually seeing it? Seeing occurs

when our attention is arrested by a person, object, or scene. Our mind stops chattering and pays attention. We see both the shape of the thing and its meaning to us. We are drawn out of our isolated, self-absorbed state. I will never forget the night an emergency call brought me to the scene of an accident, where I saw our car smashed against a tree, totaled. I felt shocked at the fresh oddness of the scene and then a rush of terror prior to discovering that my wife and daughter escaped without serious injuries. Such an encounter with the gripping potential of death and loss of loved ones cuts through many layers of egoic chatter all at once, and appreciation of life and its sweet preciousness overwhelms you. If you love someone, all your eyes open on him or her. Fascination with the beauty of the beloved can quickly deepen to profound levels. When deeply seeing, the object of our contemplation enters our heart and mind directly. In the act of deeply seeing, we transcend the egoic boundaries between the self and the otherness of the world, momentarily merging with the thing seen.

> There is a vast difference between looking and seeing—a difference which is fundamental to the artist's experience.
>
> —ERNEST W. WATSON

Seeing determines every aesthetic decision. First, artists see their subject, which inspires them to create. Then there are the technical aspects of seeing, such as an accurate analysis of the formal relationships that the artist wishes to express. Next comes a critical translation phase, where the art-making hand dialogues with the seeing mind. This dialogue can be a halting argument filled with traps and pitfalls or a harmonious song

that flows from the soul of the artist. Frequently it is both. Seeing is also the recognition of meaning.

> No wonder that once the art of seeing is lost, Meaning is lost, and all life seems ever more meaningless: "They know not what they do, for they do not see what they look at."
>
> —FREDERICK FRANCK

Let us recall Saint Bonaventure's three eyes of knowing: the eye of flesh sees the "outer" realm of material objects; the eye of reason sees symbolically, drawing distinctions and making conceptual relationships; and the mystic eye of contemplation sees the luminous transcendental realms. Artists need to be able to see on each level in order to bring technical beauty, archetypal beauty, and spiritual beauty to their work.

Saint Thomas Aquinas, an Italian philosopher of the thirteenth century, declared that three things are needed for beauty: *integritas* (wholeness), *consonantia* (harmony), and *claritas* (radiance). We will examine these qualities of beauty by considering how artists discover their subject.

When an artist encounters an artistic subject, love opens all his or her eyes. There is a rush of aesthetic pleasure, and something clicks simultaneously on every level. The artist's spiritual eye recognizes the subject as a special aspect of the absolute. The holy presence of the subject's unique beauty is its *claritas*, or radiance.

Second, the artist scans the subject, seeing now more with the eye of reason, dissecting the relationships of part to part balanced within the forms, appreciating the rhythm of its structure. The eye of reason also begins to see symbolic corre-

spondences between the form and its meaning. This apprehension of formal pattern and content is *consonantia*, harmony.

Then the eye of flesh distinguishes, draws a boundary line around the form of the subject, separating it from the boundless backdrop of space and time. The subject is recognized as a discreet whole and is brought into a material form. This is *integritas*, wholeness.

The artist's three eyes of knowing are inspired by the radiant spiritual beauty of the subject, fascinated by the subject's harmonic structure, and motivated to express the unique wholeness of the subject by drawing a bounding line around it. The levels of seeing that inspire an artist to create are retraced during a viewer's response to an art object. In order to see the object deeply, the viewer must first distinguish it from the field of many material objects, then, fixing the attention on that one thing, the viewer senses its rhythms and harmonies both formally and conceptually, leading to complex and subtle sensations of pleasure mixed with awe as the unique spiritual radiance of the art and its subject are appreciated.

To see deeply and to understand are different from mere looking or observation. In order to experience art fully viewers must go through a mini ego death by placing themselves in the inspired mind of the artists, who themselves are out of their minds and only acting as channels of creative spirit. Viewers thereby recognize the perfection of the form generated, and by that sympathetic communion, an understanding and a change of mind and heart take place. To understand is to see through the rough image made by the artist's hand and recognize the transcendental archetype that is the empowering source behind the image.

"Depth perception" is the ability of the mind to understand

visual space by recognizing certain cues. Overlapping, size differences, degree of focus, and perspective are all ways that the mind perceives depth and space. The soul has its own sense of depth perception. Each blade of grass can be a mirror of the absolute when seen with the eye of contemplation.

> To see a World in a grain of sand,
> And a Heaven in a Wild Flower,
> Hold Infinity in the palm of your hand
> And eternity in an hour.
> —WILLIAM BLAKE

An artist's finest works can symbolically unveil depth upon depth of meaning, like mirrors reflecting each other, deepening endlessly. In order to bring forth their most profound work, artists need to be sensitive to and courageous about their own creative process.

There are many stages in the creative process. Several scientists have attempted to outline the mysterious phases of creativity.[1] Below is my adaptation of their findings.

The Creative Process

1. *Formulation*: discovery of the artist's subject or problem.
2. *Saturation*: a period of intense research on the subject or problem.
3. *Incubation*: letting the unconscious sift the information and develop a response.
4. *Inspiration*: a flash of one's own unique solution to the problem.
5. *Translation*: bringing the internal solution to outer form.
6. *Integration*: sharing the creative answer with the world and getting feedback.

Not all artists will recognize each phase in their work, and each phase takes its own time, widely varying from work to work. The first stage is the discovery of a problem. This is the most important question for an artist, "What is my subject?" The formulation of the problem arises from the artist's world-view and may set the stage for an entire life's work, if the problem is sufficiently broad. The problem is the "well" dug to reveal the source, the vision, the creative matrix of questions and obsessions that drive the artist. Solving the aesthetic problem becomes the artist's mission.

In an effort to illuminate the many stages of the creative process, I would like to share a bit of the story behind my painting *Transfiguration*. I have always been mystified by the body-mind-spirit relationship and the difficulty of making these multiple dimensions of reality visible in a work of art. It took me about ten years of making art and obsessing over this subject to reach the *formulation* that this was one of my primary artistic problems, an important part of my "vision."

During the next stage of *saturation*, I looked over everything I could find about the subject. It was a period of research that led me through the art of diverse cultures. I prepared a slide show and lectured on the subject of transfiguration, showing artistic representations of transcendental light or energy in relation to the body. At that point I didn't know I would be doing a painting by that name.

The *incubation* stage is where the vast womb of the unconscious takes over, gestating the problem. The embryonic artwork grows effortlessly at its own pace. For the *Transfiguration* painting, this phase lasted about half a year.

Then early one morning I woke from a dream. In the dream I had been painting a piece called *Transfiguration*. The painting

TRANSFIGURATION

had a simple composition: two opposing spherical curves connected by a figure. Floating above the earth sphere, a human who was fleshly at the feet became gradually more translucent. At about groin level the figure "popped" into a bright hallucinogenic crystal sphere. The dream revealed a unique solution to my simmering aesthetic problem. This illumination or *inspiration* phase, my *"Aha!"* moment, provided by the dream, was extended or underscored later that week when I smoked DMT—dimethyltryptamine—for the first time. As I inhaled the immediately active and extremely potent psychedelic, I experienced the transfigured subject of my painting firsthand. In my vision, my feet were the foundation of the material world. As I inhaled, the material density of my body seemed to dissolve and I "popped" into the bright world of living geometry and infinite spirit. I noticed strange jewel-like chakra centers within my glowing, wire-frame spirit body, and spectral colors that were absent from my dream painting. I was *in* my future painting and was being given an experience of the state in order to better create it.

After receiving these two visionary encounters of the same painting, I began to draw in my sketchbook what I had seen. This started the *translation* phase, bringing the inner solution of my artistic problem to an outward form. I drew the body and worked on the computer to help me plot an accurate texture map of the electric grid around the hypermindsphere. I then assembled the various elements and stretched a fairly large canvas, because I wanted the viewer to identify with a "life-sized" figure. Finally, I started painting. After many months of work, my wife, Allyson, continued to ask me about an unconsidered area of the painting. This was the space beneath the hypermindsphere. I hadn't noticed the space in my

visions except that it was dark. This was a puzzling dilemma, which lasted for a week or two, because "empty" looked wrong or unconsidered, yet what belonged there? Stars, obviously, but this was not just outer space, this was inner space, the place of numinous angels or demons, the oddly glowing mind-spheres anticipating the transformative megasphere above. This seemed like the appropriate answer among the many that occurred to me. Work on the piece lasted almost a year.

Once the transfiguration painting was complete, I had to decide how to share the work with the world. Where would I exhibit it? Would I sell it or make a poster of it? *Transfiguration* was exhibited in numerous places throughout the country, and I did eventually sell it to a private collector. After a couple of years, though, I bought back the piece, feeling that it was important enough to be part of a chapel that would make my works available to the public. Part of the function of the vision and the creative process is the *integration* of the inspired moment, via the art object or event, into the world beyond the studio, a process that continues as I share this story.

Art is the transmission of states of being. Viewers appreciate art because they resonate with those states of being. No matter what state of being is expressed in a work of art, universal creative spirit is the prime mover behind all art media. The transparency of a work of art to its spiritual source makes visible the depth of an artist's penetration into the divine mystery of creation. Most works of art produced during the twentieth century do not deliberately invoke or evoke God and therefore remain opaque or obscure to their true source. If metaphysical truth is a virtue of great art, then the artist's creative receptivity or spiritual attunement to inspiration must be developed as conscientiously as any skill with clay, pen, or brush. For artists,

the goal is to reach a state of mind where art flows irresistably through them. Finding that energetic and idiosyncratic fountain of creation, an art spirit, is the artist's task. Artists must remain open to the tumultuous ocean of potential inspiration, the entire spectrum of consciousness, and yet reduce or essentialize that infinite ocean to a few flowing strokes from their own fountain, providing tangible evidence of inner discovery to the outer world.

Inspiration

Every artist has his or her own unique process of inspiration. My wife and I have noticed in our workshops on visionary art that some people receive full-blown, detailed images in a flash during the guided visualizations or shamanic drumming. Others may receive only the briefest glimmer or feeling and it is not until their pencil touches the paper that the imagery comes flooding through. For me, glimpses or "snippets" of a grander idea may take years to finally gel into a completed form. These I carefully note in my journal-sketchbook, which is always by my side. Documenting even minor visions or ideas is a way of honoring the muse and shows good faith that you can be counted on to develop new work. It shows appreciation for the creative process and keeps the funnel of inspiration well greased. For me, pressure is a great catalyst. Important ideas can come at the last minute under a deadline. Often as a painting is coming to completion, I will have to change an entire section because an essential insight suddenly arises.

Allyson's artwork is very labor-intensive, each work deriving its inspiration from the one before it. She claims that new ideas are like a flowing river. She has to stay away from "the river"

while working on a piece so that she will not be distracted and
driven crazy by too many possibilities. Then, as a work is com-
ing to completion, she "goes to the river." Ideas for her next
work are invariably "going by" and she selects one.

> The poet is a light and winged and holy thing and there
> is no invention in him until he's been inspired and is out
> of his senses, and the mind is no longer in him.
>
> —SOCRATES

Inspiration is the most mysterious step in the creative pro-
cess. The artist is possessed by a creative force, overtaken by a

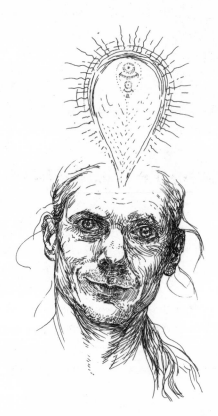

THE IMP OF
INSPIRATION

vision and driven to create. Inspiration is beyond reason. Inspiration is like an unseen lover, a muse, an angel or demon, or perhaps an entire committee of discarnate entities, who creep up to your imagination and give it the most sumptuous gifts. The word *inspire* refers to the breath, which has always been associated with life and spirit. To breathe means that our bodies are alive. To in-spire is to be in-spirit. *Inspiration* means access to spirit. Spirit brings vision to the artist via the imagination, the multidimensional media center of our minds. Art is a matter of training in a skill, such as painting, and contemplative attunement to creative inspiration. The masterful artist transcends the limited sense of self and becomes an active channel of universal creative spirit.

Seeing Art

As I have mentioned, the viewer first encounters a work of art as a physical object seen by the eye of flesh. Second, the eye of reason sees a harmony of sensations that stir the emotions, and a conceptual understanding of the art arises. Third, and only in the deepest art, a condition of the soul is revealed, one's heart is opened, and spiritual insight is transmitted to the eye of contemplation. The sensitive viewer contacts the many dimensions that the artist brings into the work.

In James Joyce's *Portrait of the Artist as a Young Man*, the main character, Stephen Dedalus, makes an effort to distinguish what are the proper and improper functions of art. It was his opinion that improper or lower works of art inspire movement in the viewer and that the higher or proper works of art inspire static contemplation. Lower art forms such as food advertising and pornography engender in us desires to

consume or to fantasize interaction with the subjects portrayed; they promote instinctual attachments.

At the moment of aesthetic perception, if one is viewing a great work of art, one's rational faculties are transcended and the ego seems to dissolve into an awe-filled timeless presence. The viewer is temporarily "artfully intoxicated" and in a state of aesthetic arrest or ecstasy. At that moment we wish or desire nothing, only to remain in the state of aesthetic fusion or contemplation. *Samvega* is a Buddhist term for the aesthetic shock that overcomes the serious viewer of art. It is a feeling of fear, awe, and delight. Like the Zen master's stick whacking us to attention, it is the force inherent in an artwork that wakens us. Extreme aesthetic shock has even been classified as a medical condition called the Stendhal syndrome. The syndrome was named after the nineteenth-century French novelist Marie-Henri Stendhal. When he visted Florence in 1817 and viewed artworks by Giotto and Michelangelo, he became so completely overwhelmed by their beauty and meaning that the rush of intense emotions caused him to collapse. He was so sensitive to the power of great works of art that he fainted.

> If you can see, you have nothing else to do, because in that seeing there is all discipline, all virtue, which is attention. . . . Then where you are, you have heaven: then all seeking comes to an end. . . . Real seeing brings with it this extraordinary elimination of time and space.
>
> —KRISHNAMURTI

Many of us can recall profoundly moving experiences of art. In 1994, during my family's pilgrimage throughout Italy to view Michelangelo's work, I made drawings of his sculptures

and paintings as an offering of respect and a way to carefully observe and absorb the energy from them. It was never disappointing. All of his works bristle with the same devotional power. Michelangelo's insistence on the body as a window to the soul has helped me clarify my own primary subject matter, visualizing the interface of body and spirit. I was amazed that after two hours of staring at *The Last Judgment*, it was as if virtually no time had passed at all. A friend of mine calls this quality of timelessness *chronocide*, the ability of art to extinguish

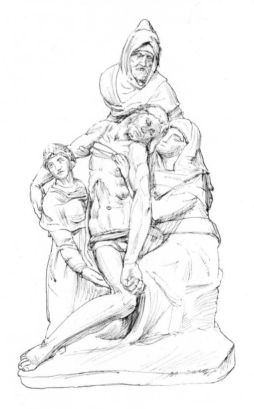

PIETÀ, MICHELANGELO

one's sense of time. *The Last Judgment* was transmitting a continuous stream of metaphysical revelation. Days after viewing this work I was still under its spell and woke before dawn to write pages in my journal about its meaning. I remain convinced that this is the greatest painting in the world.

George Washington Carver, the great inventor, said, "If you love anything enough, it will speak to you." At the Museo Dell'opera del Duomo, I was drawing the Pietà that Michelangelo carved while in his seventies, which includes his self-portrait as a hooded Nicodemus. I began to hear in my mind what I sensed was Michelangelo's voice: "This stone that you see is like the flesh body; respect it but never worship it. Reserve your devotion for the living Christ, the light of God within and unseen. All flesh is dead as this stone. The spirit animates it. Love that." I felt as if the divine Michelangelo were trying to keep me focused on the true source of beauty and telling me not to get so overwhelmed by the material object.

At the Metropolitan Museum in New York, after prolonged observation of van Gogh's painting *The Reaper*, I began to hear a deep, slow, oscillating tone, a strange sine wave sound that reminded me of the resonant pulse of Tibetan chanting. Sometimes to hear a painting you merely need to relax into the image and ask a question. I have experienced this in front of images of the Buddha and Jesus and once with a self-portrait of van Gogh. As I stood in the museum drawing his self-portrait, I heard van Gogh speak, so kind and gentle, firm and clear. "Draw every day," he said. "Put your heart into every work of art you do. I am there to help, to assist. Call upon me. Feel the rhythms of nature. Look for them in the country or the city." Our spiritual teachers are not limited by the constraints of the material world; they reach out to us as we reach out to them.

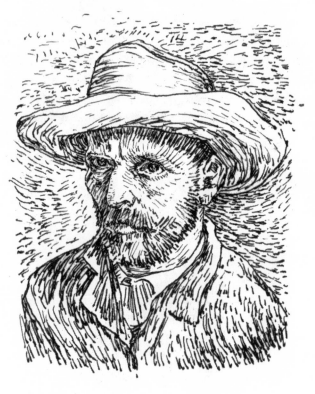

van Gogh

Artists must be able to absorb the depths of meaning contained within a work of art. Artists develop advanced seeing because their life's work depends on it. Some master artists—Michelangelo, Rembrandt, van Gogh, Kollwitz, Kahlo—created self-portraits whose eyes are holes drilled through the material body and opening into the boundless mystery of soul. Drawing is a way of entering into the spiritual practice of art and seeing. At times I have tried to enter into the hearts of the great masters by drawing from their self-portraits and relaxing

into the space, the presence behind their works. I sometimes feel that I haven't completely "seen" a work of art until I've drawn it. By drawing from the original artwork, you notice the harmony of the parts to the whole, every nuance and curve, the quality of every form. A meditative concentration is needed to enter into a subject that you are drawing. Attention needs to be focused and directed, yet flexible. The hand must be disciplined to respond to the eyes of the head and the heart, and open to spontaneous possession by positive influences, to strokes of genius.

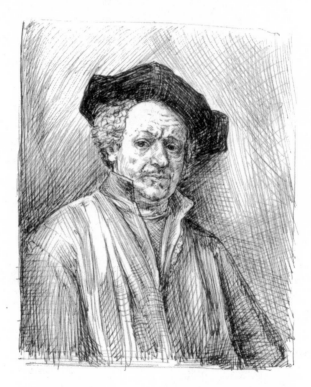

REMBRANDT

Legitimacy

After perceptually encountering a work of art, while in the aesthetic afterglow, the mind begins the complex and many-layered task of interpretation. Regarding the work from the "eye of flesh" would relate to an understanding of the physical properties of the work, its medium, its location, and its acceptability and legitimacy within the cultural context. We assess the artwork's economic value and ask, "How does the work fit into or deviate from the artistic mainstream?"

The scale of legitimacy is the way that society interprets or confers success upon the work of art. The art object is related to or classified according to preexisting definitions. For example, bronze figure sculpture is a traditionally accepted form of artistic expression, whereas Marcel Duchamp's exhibition of a urinal in an art gallery tested the boundaries of legitimacy. Much dada-inspired art of the twentieth century has challenged the legitimacy of certain acts or objects as art, such as Carolee Schneemann's naked "Meat Joy" performances, Rauschenberg's erased de Kooning drawing, Warhol's soup cans, Chris Burden's gunshot in the arm, Jenny Holzer's signage systems, Jeff Koons's kitsch and pornography, Damien Hirst's sliced pigs.

The works of dadaists and performance gestures force the art world to broaden the context of what art can be. This does not automatically confer greater depth or meaning to a work. An early earthwork, Robert Smithson's dumping of a truckload of asphalt down a hill, established a new possibility of considering sculptural operations in nature. It was a somewhat aggressive and expressionist gesture, with vague political overtones of a wasteful polluting culture, but it also simply ex-

pressed the anarchic joy of watching a truckload of something get dumped and seeing what chaotic patterns it might assume. Several years later the artist Joseph Beuys performed an earthwork that consisted of planting seven thousand oaks across Germany. This piece was a more mature and heartful act of partnership with the earth. The state of complete artistic freedom was acknowledged in the 1960s when Donald Judd, minimalist sculptor and critic, declared that if an artist claims something to be art, then it is art. The state of freedom to recontextualize new and shocking objects or acts as art continues, and the drive for aesthetic novelty is a strong creative force. Artists will continue to challenge the legitimacy of established modes and find ongoing and ever broadening ways of "legitimizing the illegitimate" as art.

Success

It's sad to say, but most art-school graduates will give up creating art within five to ten years because of the difficulty in gaining legitimate support for their art, either financially or psychologically. Support for one's art in some form or another could be called success.

Of course the difficulty in attaining success is not the only reason artists abandon their art. If artists have explored themselves deeply they will have encountered a complex of fears that come from the shadowlands of their psyche. The power of the shadow and its intricate alliance with creative energies may frighten artists into distracting activities or responsibilities that safely remove them from the creative encounter. Even serious and dedicated artists have periods of avoidance or ambivalent resistance like this.

There are many kinds of success. The first and obviously most important kind is when your art fulfills your inspiration. The primary responsibility of artists is to transmit their state of being to the work of art. Sometimes you look at a thing you've made and you get a trembling thrill when you realize that the thing is doing what you wanted it to do. There is unsurpassable joy in that. There are artists like van Gogh and Adolph Wölfli, and numerous other "outsider" artists who have labored all their lives in complete obscurity with only this kind of success.

The second kind of success is when you have friends who appreciate your works and give you good feedback. This can be fairly important to maintaining a healthy ego. We all need to feel that we have value and that someone understands or appreciates us and what we do. You don't need friends who drag down your work. On the other hand, a true friend who is an honest critic and understands your motives and capabilities is an invaluable aid and may encourage you to continue and deepen your creative path. Allyson Grey, my wife, is a great artist and I completely respect her opinion about my work. It isn't always easy to satisfy her discerning eye. Our combined aesthetic perception of an artistic problem creates a third mind greater than either of ours alone.

There are many other levels of success. Money and fame come to mind. If you are a serious artist and you are aware of the art marketplace and the art game as defined in art magazines, you can respond to contemporary art history and make objects that grow out of the art-historical imperative. You associate with people who know what is hip. You tinker with your art objects until you get a positive response from a gallery owner. Sometimes these efforts at salable commodities work

for a while, but if you are only taking your cues from the art marketplace and magazines, newer fashions will soon replace your once-fashionable objects. Many people spend a lot of time trying to maintain hipness and art-critical relevancy. This game can produce much hollow art.

Yet no art is without influences. Artists who examine the art world and the work of their contemporaries open themselves to potentially refreshing influences that may bring their personal vision to full fruition. Such was van Gogh's contact with the impressionists of his day. Without their influence on his color sense and subject matter, he might have produced nothing but dreary peasant scenes. Jackson Pollock was a traditionally trained realist, but was called to break through pictorial invention by his study of the modernist currents of his day and his Jungian art therapeutic process.

Artists cannot evolve in total isolation from other art, yet the art-historical imperative for making art, an art for art's sake, or a concern for only the formal characteristics of art, is not a sufficiently deep motivation to sustain art as a living cultural force. Artists breathe in and are inspired by the condition of their world. Today artists need to consider the consciousness-evolutionary imperative.

Being aware of the crisis that humanity and the world are facing, the artist makes artwork directed at the development of personal and collective higher consciousness and healing. A merging of contemporary art sophistication and spiritual consciousness is rare but certainly possible. Once in a while someone comes along who can do it all. These artists balance inner authenticity with art-historical hipness and position themselves in the right place at the right time. Ana Mendieta, Joseph Beuys, and Anselm Kiefer, among others, seem to have

balanced both a spiritual vision and art-historical relevancy. It is a great challenge to retain a personal vision, an authentic foundation of creativity, while utilizing the potential of new art approaches.

Authenticity—Art and Levels of Consciousness

Art can be interpreted from the standpoint of its cultural legitimacy or success, but another way of evaluating art relates to the authentic meaning, the height or depth of being and awareness that the artist is accessing and transmitting. How does the artwork move us? Are we shocked or delighted into awakening? Is the artist primarily focusing on materials, emotional expression, rational realism, concepts and ideas, devotion or compassion, subtle visionary perceptions, or high states of mystic union?

To examine how art manifests from various states of mind, let us look at a map of human consciousness keyed to the body. The physical body is composed of various complex interlocking systems: the nervous, skeletal, cardiovascular, and lymphatic systems, and the skin, which maintains the visible mundane body. The bioluminescent imaginal body is a series of complex bioelectromagnetic and conscious subtle "life energy" sheaths overlapping and interpenetrating the physical body. These subtle bioplasmic fields form the human aura, which has been seen by clairvoyants throughout human history and documented cross-culturally in sacred art as halos or radiances emanating from holy people. The imaginal bioplasmic body includes many layers, appearing somewhat like the various layers of clouds, atmosphere, and geomagnetic fields surrounding the earth. The layers of the subtle body are graded

from the gross etheric level nearest the physical body, which keeps the cells in proper biomagnetic alignment, to the increasingly more subtle emotional, mental, and astral layers, and finally the most subtle ideal spiritual layers. Each layer of the subtle body is interacting with all the others as well as sending information to and receiving information from the

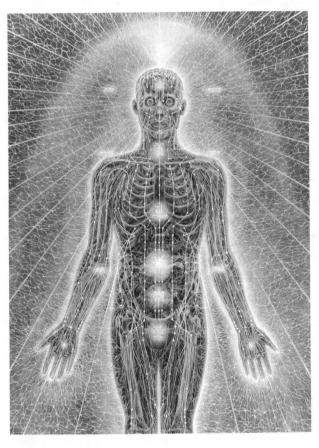

PSYCHIC ENERGY SYSTEM

physical body. The radiant imaginal bioplasmic body integrates our spiritual and psychological attributes with our material body.

As portrayed in my painting *Psychic Energy System*, there are seven levels of consciousness corresponding to seven chakras aligned along the spine, familiar to anyone who has studied tantric, yogic, or theosophical art. It is a matter of my personal preference to use this chart with seven levels. There are many models of human consciousness,[2] from the ten *sefirot* of the esoteric Jewish Kabbalah to the Buddhist *skandhas*, and Vedantic *koshas*. What is consistent to each of these models is a hierarchical progression of increasing consciousness from matter to body to mind to soul to spirit. As a model of the Great Chain of Being, the chakra system is simple and has the virtue of visually tying spirit and mind to body. After describing the general nature of each chakra, we will attempt to key works of art or artistic intentions to each level of this map.

CHAKRAS

According to the kundalini yogic tradition, there are seven primary chakras or wheels of subtle energy located along the central axis of the body. The chakras mediate the energies of the auric bodies that surround and interpenetrate the physical body. More to the point here, the chakras each describe psychological worldviews that hierarchically ascend from the material to the spiritual levels.

The lowest chakra, situated in the genital region, is the source of the primal hungers and survival drives. This chakra forms our basic attachments to the material world. The second chakra corresponds to the emotional "gut reactions" and sexual drives. Here is the primary connection point between the

emotional and the physical body, hence a primary locus of pleasure and anxiety. The third chakra corresponds to reason and intellect and connects the physical to the structuring, logical mental body. By the time we are young adults, these three chakras are open and functional, channeling essential bioenergy to the material, physiological, emotional, and mental aspects of our being. It seems they are God-given properties of normal human development.

The development of the next four chakras depends on awakening an awareness of the higher self, beyond the ego, toward higher self-knowledge and self-realization. The heart chakra is the center of love and caring, which takes an individual beyond personal feelings motivated by desire or anger to a higher altruistic sense of compassion for others. Positive development of the throat chakra channels divine will and higher authority and represents the capacity to lead, to find your voice and speak the truth. The next chakra, the third eye, opens to creative spiritual vision; it is also the tunnel to the highest chakra. The opening of the crown chakra is the goal of yoga, union with God.

An artist's inspiration depends on the functionality and receptivity of his or her chakras. As was indicated in chapter 1, artists progress through different visions of life and self as they grow from childhood to adulthood—the chakras open somewhat progressively. Accessing all levels of creative inspiration can be accelerated by sensitizing oneself to the dimensions of the chakras.

The apparently solid phenomenal world is really a world of subtle energetic vibration. Each material object has its own vibrational frequency. In physics this corresponds to the electron shells of the atom, the atomic vibration. Likewise there is

a pranic or subtle conscious force linked with all objects. If all objects are truly vibratory force fields, then attuning to the vibrational frequency of a work of art does not seem so odd. The viewer becomes a psychometrist, a psychic who "reads" objects, getting a "vibe" from the work of art.

The relation of particular styles and motives of art to the hierarchy of the chakras is an imprecise but not totally arbi-

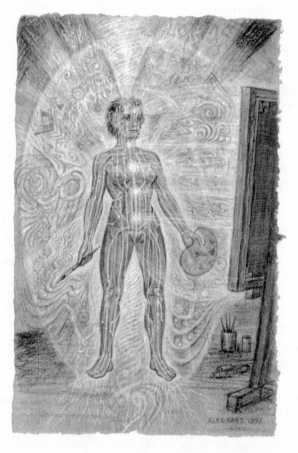

ARTIST AT WORK I

trary system of classification. I have simply noted the nature of the chakras and now will attempt to match them with types of art. Consider your own work and other people's works. What chakra characteristics, motivations, and subject matter dominate in the work? Of course, this consideration overgeneralizes the true complexity of art objects, but it highlights an appreciation of the levels of consciousness involved in making art.

An art object must be "grounded" in some material form. The lowest "root" chakra corresponds to one's attachment in the material world. The artist's skill in handling the chosen media may be influenced by higher chakra centers, but basic material appearance and technical know-how come from the disciplined exercise of this foundational center.

The lowest chakra also represents the level of material attachments and survival drives, putting the motivation of art done only for material gain and survival needs on the lowest level. Most commercial and advertising art would fall into this category. Kitsch, which Webster defines as art "of tawdry design, appearance, or content created to appeal to popular or undiscriminating taste," also falls into this category. Similarly, art that is primarily focused on developing technical skills (practice art) with paint, clay, or other materials, or on the imitation of styles or subject matter, is on a low level of value relative to the greatest works in the history of art.

Each work of art from a higher chakra will include but transcend elements from the lower chakras. For example, all successful art objects depend on skillfully handled materials or media (first chakra) in order to become art objects. Art that is motivated by higher chakras may still become an object of commerce, even though this is not the primary motivation of the artist.

The second chakra, the emotional and sexual focal point, corresponds to the pleasures and passions of raw expressionism and fauvism. Dionysian energy, pornography, melodrama, themes of entrapment, violence, and the feeling of being out of control all originate at the second chakra. The six basic emotions—anger, sadness, surprise, disgust, happiness, and fear—are second-chakra manifestations. Many of Edvard Munch's early paintings and de Kooning's paintings of women fit into this category.

The third chakra relates to reason and intellect. Logic and strategy appear dominantly in this art. We recognize here the formally inventive works of Mondrian and Stella, the wry wit of Duchamp, the cool and clever works of pop and op art, and the arid simplicity of much minimalist and conceptual art. An Apollonian balance or control permeates work from the third chakra.

The fourth chakra relates to works that focus on love and compassion as their primary subject matter or motivation. The art of Mary Cassatt shows the everyday love between a mother and child. Käthe Kollwitz's drawings and prints reveal her love and compassion for the suffering of common people, as do Goya's sociopolitical paintings. Sue Coe's deeply felt paintings and drawings examine injustice and suffering in the contemporary world, including what happens in the meat industry and human cruelty to animals. Sculpture, installation, and performance works that are devotionally ecological or community enhancing include Mel Chin's *Revival Field*, an installation/ earthwork that used cutting-edge bioremediation techniques to clean up a toxic waste site; Dominique Mazeaud's *Cleansing the Rio Grande*, in which she spent years removing trash and debris from along a riverbed; Helen and Newton Harrison's

elaborate sculptural ecological projects; and Rachel Rosen-thal's many passionately spiritual/ecological performances, such as *Gaia Mon Amour*. Each of these artists seems motivated from the heart chakra.

The fifth chakra gives voice to divine inspiration and a sense of sacred mission, inspiring works of soulful leadership. Mi-chelangelo captures the sense of divine mission in the *David*'s expression of fearless determination. Grünewald's resurrected Christ from the Isenheim altarpiece, and Asian bodhisattva sculptures or paintings, are also good examples of spiritual au-thority.

The sixth chakra is the third eye and pertains to high vision-ary and luminous archetypal deity forms. Hildegarde of Bingen, twelfth-century abbess, had prophetic and cosmologi-cally dense visions, which were then illuminated by an icon maker. Her art provides some of the best examples of early spiritual visionary art. Michelangelo's and Blake's *Last Judg-ment* both include visions of hell and heaven, the material and spiritual worlds. Bosch's *Garden of Earthly Delights* represents his unique view spanning heaven and hell. The greatest in-sights of the imagination result from use of the third eye. The surrealist works of Dalí and Magritte juxtapose dreamlike imaginal elements glimpsed from the third-eye level, with fan-tasies focused on the lower sexual and mental chakras. William Blake immersed himself in a world of vision, but he was a dedi-cated mystic who elevated his fantastic imagination to subjects of the highest spiritual truth.

The seventh, "crown," chakra represents the goal of yoga, union with the highest spiritual source. An opened crown cha-kra means that our entire being is integrated, physically, emo-tionally, mentally, and spiritually, bringing profound meaning

and purpose into our lives. Individual will is aligned with divine will, attaining a spiritual overview and unity with the cosmos. Artworks that radiate this state of divine union reveal a pattern of universal connectivity or point to the boundless "clear light of the void." The mandala, or wheel form, is a perfect compositional device for representing the higher levels of unitive consciousness. Mandalas appear cross-culturally, from the Native American medicine wheel to the complex Jain cosmological diagrams, the Tibetan Buddhist Kalachakra mandala, the alchemical cosmological mandalas of Robert Fludd, and the gigantic stained glass windows of Chartres cathedral. One of the most ambitious sculptural mandalas ever created is the Roden Crater project by James Turrell. Turrell has excavated the rim of an existing crater in Arizona and made a more perfect bowl interior for the crater so that when one stands in the middle of the crater, the vast sky is framed by the huge circular perimeter of the earth. There are many references throughout tantric Buddhist scriptures to the empty, skylike nature of mind. The naked primordial Adi-Buddha, Samantabhadra in union with Samantabhadri, is a symbol of the state of ultimate realization found in Tibetan *thangka* paintings. The deep blue space of the male figure is united with the white energy of female creation, ecstatically conjoining the dimensions of samsara (form) and nirvana (emptiness). One of the most essentialized graphic depictions of the enlightened state is the Zen brush stroke of the perfect circle.

Taoist and Zen Buddhist paintings demonstrate a methodical approach to integrating seventh-chakra energy within artworks. The goal of these artists was to achieve meditative integration, a profound nondual state of unity with their subject. In order to paint a mountain, one must become the

mountain. As Chang Yen-yuan wrote in 845 AD, "Painting . . . penetrates completely all the aspects of the universal spirit."[3] Zen painters are disciplined meditators who have stabilized their concentrative awareness and can tune in to the emptiness inherent in all forms. Likewise they have mastered their craft so that no technical problems impede the process of painting. The act of painting becomes a state of "flow" with the true nature of mind. Wu Chen (1280–1354), a Yuan-dynasty master painter, said, "When I am painting I am in a state of unconsciousness; I suddenly forget that I am holding a brush in my hand."[4] By linking with universal mind the painter "disappears," allowing the natural rhythms of divine creativity to channel through the hand. Especially prized were the unexpected qualities of natural spontaneity and a steadfast, unhesitating demeanor. Zen painters do not present complex cosmological mandalas, but by their absorption into the primordial nature of reality, their work directly expresses or issues from the highest levels of consciousness.

In the West, the paintings of van Gogh show a similar trancelike level of engagement with the natural world and the flow of the cosmos. Compare his words with the Chinese painter's mentioned above. In van Gogh's own words, "It's emotion, the sincerity of feeling for nature, that guides the hand . . . such feelings are sometimes so strong that the work goes on unconsciously."[5] It was also van Gogh's goal to reveal the sacred nature of his subject, as is clear in the following: "I want to paint men and women with that something of the eternal that the halo used to symbolize, and which we seek to give by the actual radiance and vibration of our colorings. . . . Ah! portraiture, portraiture with the thought, the soul of the model in it, that is what I think must come."[6] The universal attraction

to the art of van Gogh rests not only with the emotional inten-
sity (chakra two) of his works, but also with the state of devo-
tional absorption and spiritual presence (chakras four and
seven) that his works convey.

Art—Context and Meaning

Viewers interpret a work of art through the filter of their
worldview, the knowledge and experience conditioning their
mind. When we look at a painting, for example, we may know
nothing of its history or background and only appreciate its
patterns and colors. When we learn the title, it may lend fur-
ther meaning, and if we are familiar with the painter's other
works, our insights may increase. Knowing the sociopolitical
and art-historical context in which the work was created will
lend deeper meaning. There may be symbolism or narrative
content in the painting that will allow the viewer to have even
greater understanding. Artworks can be examined from a
merely technical, or from an economic, historical, or psycho-
analytic viewpoint. The viewers' life experiences will "load
their eyes" and color their interpretation of the painting. Ken
Wilber has adapted Arthur Koestler's term *holon* to consider
the way artworks are interpreted. *Holon* is used to mean that
which is both a whole and a part, an infinitely reducible or
expandable context and constant property of reality. For exam-
ple, a whole atom is a part of a whole molecule that is part of
a whole cell that is part of a whole organism that is part of a
whole species, and so on. The world is an ongoing series of
nested whole-parts. Neither wholes nor parts exist indepen-
dently of each other; there are only whole-parts: holons. Wil-
ber states:

Any specific artwork is a holon, which means that it is a whole that is simultaneously a part of numerous other wholes. The artwork exists in contexts within contexts within contexts, endlessly.

Further—and this is the crucial point—each context will confer a different meaning on the artwork, precisely because . . . all meaning is context-bound: change the context, you elicit a different meaning.[7]

A painter paints a painting: each stroke is a part of the whole painting, each painting is a part of the artist's body of work, which is part of an expression of the time, which is part of the history of art, and so on. The meaning of that painting will depend on who is looking at it. One can only guess at what private meaning the Mona Lisa held for its maker, Leonardo da Vinci. He carried it with him from country to country throughout his many sojourns. Many people have wondered at its meaning and why Leonardo was so attached to the work. Some theorize that the painting represents an unrequited love affair. Others contend it's a self-portrait of Leonardo in drag. Most people who have ventured to the Louvre in Paris and spent any time in front of this most famous of all works of art cannot deny its weird arresting beauty. Consider the various contexts in which the Mona Lisa may be viewed. An insurance assessor may look at it and see millions of dollars. A conservator may see millions of tiny cracks. A tourist may see "something famous" and want to have a snapshot made while standing next to it. A security specialist will admire the protective encasement. An art historian may see a High Renaissance portrait that exhibits Leonardo's sfumato technique and his access to nobility. The museum director may see a "crowd

pleaser." A sensitive art appreciator may see that Leonardo has expressed a transcendent timeless beauty in Mona Lisa's painted presence that is both palpable and inexplicable. Each one of these views is true within its context. The Mona Lisa's knowing smile has come to symbolize the power of art to embody genius and mystery.

The meaning of an artwork varies depending on who is considering it and how they are considering it. To the artist, the work may be a trace of any of many levels of the artist's own awareness. Once an artwork is created, it exists within the confines of particular material-world spatiotemporal and sociopolitical contexts. To its viewers, the artwork fulfills a variety of private and collective meanings. A comprehensive view of art will consider the multiple truths that an art object comprises, the "art holon." Accepting the range and multiplicity of contexts in which art may be interpreted opens any work to consideration of its spiritual and transformative component.

Meaning in art is the transmission and reception of symbolic density. Meaning is only possible when a relationship is drawn between two separate subjects. An object or subject that is only self-referential cannot have a meaning. If the word *painting* referred only to the sound of the word *painting*, it would contain no meaning, no referent outside itself. But we understand the symbolic meaning of the word *painting*, and therefore myriad samples pop into our mind. In order for language to function as a meaningful symbol system, it must refer to things and events in the world, not to mouth noises. We realize this when we observe two people speaking a foreign language; their mouth noises have no meaning to us because we do not use the same coded conceptual language.

The function of the conceptual mind is to isolate and distin-

guish one thing from another: "This wine has a woody, fruity bouquet." The discerning aspect of our mind recognizes gross and subtle distinctions and gives them names. "Don't go down that street. That is a bad street." The conceptual mind constructs a coded world of meaning by assigning names to things and then comparing them. The everyday functioning of civilizations is completely dependent on the powers of the conceptual mind and its coded world. The downside is that by creating a world of isolated distinct objects, the conceptual mind creates a mental trap of limits and opposites, distinguishing our isolated self from everything else. The ego is the construction of this intellectual self-distinction. The conceptual mind creates a seductively logical prison of words that only spiritual insight can cure by transcending.

Let us turn to the metaphor of Plato's cave. The shadows cast on the wall of the cave were taken as the only reality by the inhabitants of the cave. A brave seeker turns about and sees the source of light; he steps outside the cave and is practically blinded by the brilliance of the sun. From his new perspective the shadowy cave suddenly makes sense; his understanding thus deepened, he returns to his fellow cave dwellers and attempts to convince them to turn around and know the true source and cause of their shadow world. As the world treats most mystics, he is scoffed at. Plato's cave metaphorically refers to our material phenomenal world; the seeker is the mystic who unites with the absolute, attaining gnosis of the divine light that shines unseen through our mundane shadow world.

God is the transcendental context outside of history that gives meaning to art history. Art attains its ultimate meaning when it points to God, the transcendental context beyond yet interlacing all realities. By bringing transcendental reality into

the phenomenal realm, sacred art becomes a scintilla of numinosity, a portal back to the source of meaning and truth.

Timeless spirit is the ultimate context or reference point that the flesh- and-bone human refers to for meaning. Contact with the spiritual ground provides the true basis for meaning in our lives. We experience an altered, or in this case "altared," state of consciousness, a contact with infinite love, infinite bliss, and infinite awareness. The meaning of the physical world is realized to be a beautiful dream symbol requiring our lucid participation, a shadow play cast by the transcendental sun.

The mystical perspective reveals that we and the world are so profoundly integrated that neither we nor any other thing is truly isolatable. No thing arises independently of the entire web of creation. The mystic eye opens to the view of nonduality, a groundedness in the simultaneous arising of all beings and things (God's immanence) and the boundless state of emptiness, clarity, and presence, the infinitude of compassion and wisdom that all beings share as their common core of spirituality (God's transcendence). Deeply seeing the meaning of our art and our lives requires that we open the mystic eye.

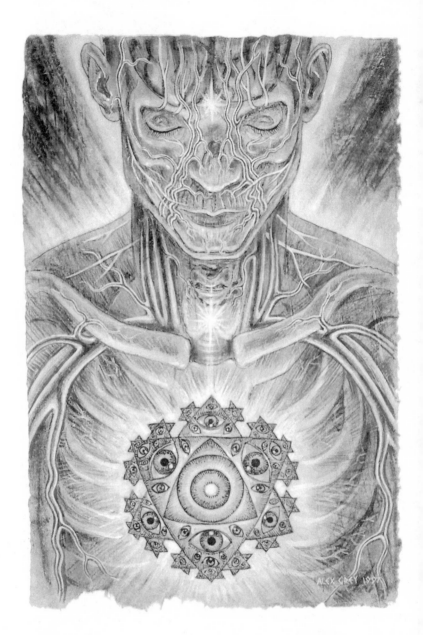

Mystic Eye

Chapter 4

The Mystic Eye

Our whole business in this life is to restore to health the eye of the heart whereby God may be seen.

—SAINT AUGUSTINE

WHEN I WAS NINETEEN YEARS OLD I HAD A dream in which I opened the lid of a trash can and saw myself with one side of my head shaved bald. The other side had long hair. This strange vision haunted me. Looking in the mirror I would imagine half of my hair missing. I did not understand this dream, but felt that it was important. At first I thought that I could paint the image to exorcise it. Employed as a billboard artist at the time, I was able to paint a large self-portrait and find a "dead board" on which to mount the image. The obsession was still not subdued, so I shaved my hair the way it had appeared in my dream. Even then the experience was not complete for me. I did a series of

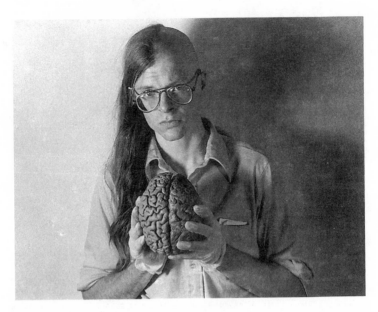

SELF-PORTRAIT WITH BRAIN

public performances displaying my split persona. I maintained this haircut for half a year, during which time I wrote and gave a great deal of thought to what the image and my actions might mean.

I came across Robert Ornstein's research into the hemispheres of the brain in which he distinguishes between the largely rational functions of the left hemisphere and the intuitive functions of the right. I was allowing for the unrestricted growth of the intuitive (the hairy side) and eliminating or reducing the "tentacles of reason" from the rational (the daily shaved side). I decided that my new self-image was an exploration of the polarities of life.

Our mind uses words to polarize, differentiate, and categorize. We separate the world into polarities: poor and wealthy,

dark and light, female and male, self and other, matter and spirit. Our words describe a dualistic world, defining and limiting our concepts of self. I am a certain race and nationality. I am a certain age and earn a certain amount of money. I wear my hair a certain way and wear certain clothes. These defining characteristics are only a partial aspect of who we are, a fraction of our true identity. I was disrupting my normal appearance and behavior to examine these mentally imposed polarities.

It became apparent that I was killing or discarding (the dream trash can) one identity, and initiating myself into a new yet-to-be discovered intuitive self. I continued to do strange performances, including works where I vomited on a human brain (Brain Sack), lay in urine and excrement for hours (Idiot's Room), and spent all my money to go to the north magnetic pole (Polar Wandering). After returning from the north magnetic pole, broke but elated, I reflected, "I must be looking for something. I must be looking for God, whatever that is." It seemed like a challenge or a prayer. Within twenty-four hours the following two life-changing events occured.

At a party I took LSD for the first time. Sitting with my physical eyes closed, my inner eye moved through a beautiful spiralic tunnel. The walls of the tunnel seemed like living mother-of-pearl, and it felt like a spiritual rebirth canal. I was in the darkness, spiraling toward the light. The curling space going from black to grey to white suggested to me the resolution of all polarities as the opposites found a way of becoming each other. My artistic rendering of this event was titled the Polar Unity Spiral. Soon after this I changed my name to Grey as a way of bringing the opposites together.

The same evening I met Allyson. She was the only other

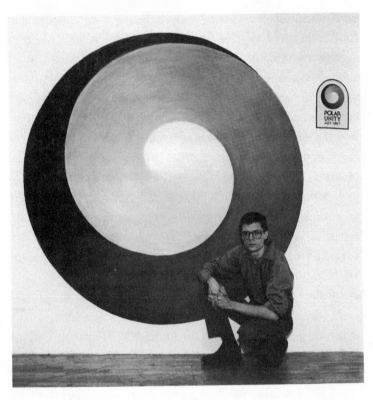

POLAR UNITY SPIRAL, PHOTOGRAPH OF PAINTING

person who had taken LSD at that party. We have been together ever since that time in 1975. Our love has been the greatest teacher in my life. For me she is the flesh and blood incarnation of God's infinite love. So my challenge to God, my prayer, had been answered.

The heart is the altar of the body. The heart is consecrated by its association with love and the living light of the soul. The eyes are receivers and transmitters of this divine light. We know another's soul by watching his or her eyes. Seeing with the eye of the heart, the mystic eye, is seeing with the soul.

Artists build a bridge to the soul by doing their art. Building that connection can take an artist through unknown and treacherous regions of the psyche. Sometimes our inner drive toward authentic creation can resemble a regression into the fractured world of madness. To pass beyond the worldview of reason cannot be done through logic and discursive rational thought. The artist leaps into the unknown until love ignites the mystic eye.

The Calling of Art

Artists are called to fulfill their creative potential. They elect this path for themselves or feel fated to it. In mystical literature there are references to shamans and mystics being "chosen." Sometimes it is unclear whether an invisible spiritual world is choosing a candidate or whether the innermost nature of the aspirant is the cause. Both factors—an "external" calling and an "internal" calling—coalesce and direct the will. The artist comes into synchronistic partnership with a force that broadens and deepens his or her life's work.

The mission of both mystics and artists is frequently revealed

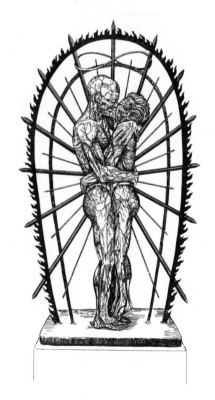

STUDY FOR KISSING
SCULPTURE

through inner voices and visions. Transcendental reality completely envelops and convinces the experiencer. Some psychopathologists might misname this as a hallucination or evidence of psychosis, but the mystical experience is of primarily positive affect. Those who heed the call, though their lives or egos come undone in some ways, will be in contact with the most powerful of all forces in the universe, divine creativity and love.

The mystical experience is not some dreamy fantasy, as anybody who has been there can agree. In his book *The Idea of the Holy*, Rudolf Otto writes of the "mysterium tremendum," the experience of losing control and of awe, dread, and terror when confronting the transcendental. This is something that a lot of New Age artists and musicians forget about. As Rabbi Hillel said, God is not just flowers and bird songs, God is an earthquake. One is shaken to the core and the "little self" dies (rarely permanently). When you are experiencing universal mind, your identity is not restricted to a little meat-bag body. The constricted ego is gone, and your awareness is infinitely coextensive with the All.

William James and Walter Stace put together a categorization of some of the most important common denominators of the mystical experience. James writes:

> Mystical states in general assert a pretty distinct theoretical drift. . . . One of these directions is optimism, and the other is monism. We pass into mystical states from out of ordinary consciousness as from a less into a more, as from a smallness into a vastness, and at the same time as from an unrest to a rest. We feel them as reconciling, unifying states.[1]

The mystical experience imparts a sense of unity within one-self and potentially with the whole of existence. With unity comes a sense that ordinary time and space have been tran-scended, replaced by a feeling of infinity and eternity. The experience is ineffable, beyond concepts, beyond words. The mental chatterbox shuts up and allows the ultimate and true nature of reality to be revealed, which seems more real than the phenomenal world experienced in ordinary states of con-sciousness. When we waken from a dream, we enter the "real-ness" of our waking state and notice the unreal nature of the dream. In the mystical state we awaken to a higher reality and notice the dreamlike or superficial character of our normal waking state. When mystics describe the experience, reducing it to words, their statements seem inherently paradoxical, such as "Form is emptiness, and emptiness form" or "Thou art that." These are true statements coming from the perspective of integration with the All, the view of mystic nonduality. Conventional, rational discourse, however, is dualistic.

Perhaps that is why art can more strongly convey the nature of the mystical state. Art is not limited by reason. A picture may be worth a thousand words, but a sacred picture is beyond words. The worshiper uses art to see through the rough image made by hand to the transcendental subject that is the arche-typal source of the image. The art historian Roger Lipsey re-counts an experience of viewing Russia's most holy icon, *Our Lady of Vladimir*, in Moscow's Tretyakov Gallery. A shabbily dressed older man was reciting aloud from his tattered prayer book, while "planted a few feet from the exhibition case." The man was undisturbed by passing schoolchildren and continued his prayers as other viewers came and went. Lipsey noticed his own irritation at having this man pray openly in a secular mu-

seum setting, and the praying affected his impression of the icon, pointing out how spiritual art is a function of its use. The man was using the work of art as a focal point for spiritual communion, and Lipsey was forced to reflect on his own relationship to the object:

> How differently we have had to proceed than the Russian worshiper whose use of the icon of *Our Lady* is predetermined by tradition. . . . The image of *Our Lady of Vladimir* points far beyond itself. Its traditional mission is fulfilled when the worshiper remembers deeply—remembers and reexperiences the values, sacred narratives, teachings and characteristic emotions of the Christian cosmos. The work of art preserves and restores a worldview; not merely an intellectual worldview, but the feelings that at best animate and authenticate that worldview.[2]

The attraction of divine beauty and sublime depth shines through and draws us toward transcendental art as the man praying in the presence of the icon was drawn to the roots of his faith. When our dualistic rational mind is temporarily suspended and we fuse with the mystic state symbolically transmitted through the art, the spiritual art has succeeded. The mystical experience provides transformative contact with the ground of being, filling both artist and viewer with an expanded appreciation of life and meaning beyond words.

In contrast to the religious artist who repeats a previously established and prescribed iconic tradition, the contemporary artist must find a way to plunge into the transpersonal state in order to experience and then convincingly convey transcendental reality. The revelations of mystical experience consti-

tute the initiation of the spiritually inclined artist. An initiate is one who is introduced to new knowledge, admitted into seership, sometimes with secret rites. There are many ways by which the aspirant may access the mystical dimension: meditation, prayer, yoga, breathwork, tantric practice, dream, vision quest, working with a qualified spiritual master, visualization, fasting, sleep deprivation, sensory isolation, shamanic drumming, chanting, near-death experiences, and psychedelic or entheogenic drugs. These or other related methods may trigger experiences that take the aspirant from a mundane perception of reality, wherein objects seem separate and composed of only material properties, to a view of divine unity with boundless depth of dimension and meaning.

Once the artist has had a mystical experience, the task is to integrate the visions and energy of this state into the physical act of making art. The artist brings the infinite into finite form, compressing absolute reality into the relative phenomenal field of appearances. The deeper the individual artists penetrate into their own infinitude, the more able they are to transmit that state. The artist relies on visionary revelations that point to the spiritual ideal beyond mundane perception. By externalizing these revealed symbols in art objects, the artist provides a crystallized passage back to the mystic visionary state.

Spiritual imagery can have several effects on the viewer. An experience of transpersonal vision can seem like an encounter with an awesome "other" and yet be intensely personal, introducing one to the vast creative force of the universe and yet being as intimate as the blood in one's own veins. Spiritual imagery performs an act of psychic integration and healing by uniting opposites. Most religious symbolism brings together dualities that the intellect has taken pains to separate, such as

spirit and matter, heaven and hell, female and male, yin and yang, life and death. Also, spiritual imagery can give us a new worldview, a new way to interpret reality. Since the transcendent force is embedded in sacred art, it can empower us to transform the ways we think, feel, and act by awakening our own creative spirit. The mystic artist offers gifts of sensuous beauty through art, while also offering a deeper gift, a contribution to spiritual growth.

I have effectively used visualizations, meditation, and shamanic drumming to access powerful vision states. But having mentioned drugs several times in this book, I want to discuss my feelings about artists and the use of visionary drugs, a process that could be termed experimental mysticism. The visionary substances include such drugs as marijuana, hashish, DMT, LSD, mescaline, psilocybin, MDMA (Ecstasy), 2CB,

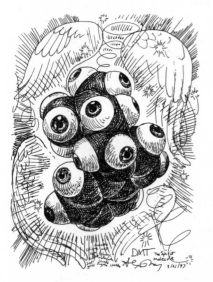

DMT

ketamine, ayahuasca, Salvia Divinorum, and many other natural and synthesized compounds. Each kind of sacrament has its own individual properties, such as duration and quality of mental influence. Substances like LSD tend to catalyze the visionary state but can allow access to hellish dimensions as well as heaven worlds. MDMA has been called a heart-opening "empathogen," bringing a sense of fearless appreciation of existence, without the overwhelming visionary plenitude of LSD. This class of

drugs has been called Phantastika, psychomimetics, hallucinogens, psychedelics, and, most recently, entheogens, because of their ability to provide the user with a glimpse of the divine within. Psychically unstable artists with "borderline personalities" should avoid the drugs because further destabilization of the chemistry of their brains can lead to a psychotic break. This happened to a friend of mine, who had to be hospitalized a few weeks after taking LSD. The drug seemed to catalyze his latent manic-depressive disorder.

However, many artists have derived tremendous visionary and spiritual insights from these sacraments. In the recently published journals of Keith Haring, one of America's finest artists of the 1980s, there is a letter written to LSD guru Timothy Leary. In the letter Haring states:

> There is too much to explain to put into writing: my first LSD experience at 15 and consequent trips in the fields surrounding the small town where I grew up in Pennsylvania. The drawing I did during the first trip became the seed for all of the work that followed and that now has developed into an entire "aesthetic" view of the world (and system of working).
>
> The effect that the reprogramming had on my life at 16-17-18, made me find new friends, leave Kutztown, see "God" and find myself (with complete confidence) inside myself and believe in this idea of "chance," change and destiny.[3]

Visionary drugs have provided crucial insights to artists, as is obvious by Haring's testimony and many other artists'. A study of LSD and creativity was performed by Oscar Janiger,

M.D., and many painters during the 1960s before LSD was made illegal. By their own assessments the art produced by the artists while under the influence was more creative. In my own experience, LSD has provided access to very high spiritual realms, but the artwork that I produce during that time is not very accomplished. Later, when my hands are steadier, I recall the peak visions and sometimes base my work on them.

Unfortunately, in America at this time, the entheogens remain illegal substances, with stiff penalties for use, unless one is a Native American pursuing the religious freedom to take peyote. This is a grossly unfair restriction of religious rights for nonnative peoples, which I hope will be rectified in the twenty-first century. One of the main problems is finding proper sacramental support structures and environments for the elixirs' responsible use. Various ayahuasca churches are now cropping up where small groups of people can journey in a supportive group setting. Rave events, where participants take psychedelics with large numbers of others while listening to trance-dance technomusic, have also provided a means of experiencing group soul. But because of religious persecution of "illegal users," there remain great dangers in this pathway.

The first hurdle that an entheogenic visionary encounters is ensuring the purity and effectiveness of the sacrament. That is, given the illicit status of the drugs, can you find pure enough and heavy enough dosages to catapult you into the oversoul? Concerns about purity have steered many toward natural or plant-based compounds. Given that one can find such a source, there are two other main factors that determine the degree to which an entheogenic session will be successful, and these have been described as "set" and "setting."

"Set" means the psychonaut's predetermined attitude, that

is, his or her preparation and willingness to experience directly the infinite spirit within. There are cases of completely jaded cynics having mystical breakthroughs, but mystical experience favors the spiritually inclined mind. Pray for a positive, transcendental experience. Be clear and state your intentions to use your insights for the benefit of all beings. Perhaps you may find a ritual way to rid yourself of considerations and obstructions to accessing ultimate reality. One way is the Native American ritual of taking a section of string and tying a knot for every emotional or intellectual obstruction that you can name. After a period of meditative knot tying, you take the substance and then burn the string. Other people go through a period of fasting and meditative orientation prior to ingestion.

"Setting" refers to the physical and psychological environment one chooses to surround oneself with during the period of the session. A meditative environment where one feels secure and supported by the beauty of nature, art, and loved ones is an ideal setting for eliciting mystical visionary states. Adequate time alotted to the journey is essential, in order to minimize causes for anxiety. A spiritual setting can be greatly enhanced, even defined, by the proper use of sacred sound. The mind is incredibly suggestible and sensitive in the entheogenic state, and choosing the most uplifting mantras, music, or sounds of nature optimizes the experience.

Whatever vehicle your journey takes, be it meditation, prayer, yoga, breathwork, shamanic drumming, or vision drugs, may it take you to the highest heavens where you come face to face with your spiritual source, and may the insights gleaned from such a journey be brought directly into your sacred art.

Mystic Maps

Cross-culturally, the maps of consciousness are surprisingly consistent. Most spiritual traditions present a hierarchical arrangement of three broad domains, the physical, mental, and causal, also called body, mind, and spirit. There can be many levels "in between." The physical/body level may break down into considerations of material, physiological, sensorimotor, and emotional systems. The mental levels include aspects of will, verbal capacity, conceptual reasoning, ego development, social conformity and individuation, and transition into higher mental functions such as psychic intuitive understanding of complex systems and a facility to synthesize disparate fields of inquiry into a more unified vision. The spiritual/causal levels can include visionary revelatory perceptions of subtle light and angelic or deity forms, the Platonic "ideas," cosmic unity, universal mind, formless clear light/void, and the ultimate spiritual awakening of continuous nondual integration with all levels of existence.

In Tibetan Buddhism the three main dimensions are known as the *trikaya*, referring to the three bodies, or three worlds, in which a Buddha manifests. These three worlds are the phenomenal realm of material objects *(nirmanakaya)*, the full richness of the luminous imaginal realm *(sambhogakaya)*, and the unmanifest clarity, emptiness, and boundless awareness of the primordial realm *(dharmakaya)*. The sambhogakaya is where the higher mental realms transition into subtle spiritual perception. Tantric meditation practice encourages the internal imaginal visualization of guru and deity forms, with complex interactions and exchanges of energy with these figures. As a practitioner you are asked to imagine the figures glowing and

BODY, MIND, SPIRIT

translucent, spreading infinite rays of light from their form to you, and to merge your consciousness with these spiritual archetypes. These practices are based on spiritual experiences of enlightened yogis that have then been transcribed into meditative practices.

The highest dimension of spirit is the dharmakaya, the primordial state of voidness and infinite awareness. Direct insight

into this realm of clear boundless emptiness is called *shunyata*. *The Tibetan Book of the Dead* describes the clear light of the void: "All things are like the cloudless sky, and the naked, immaculate Intellect is like unto a translucent void without circumference or centre."[4]

This dimension is the true Buddha essence, which manifests in the lower realms as both luminous vision and physical bodies. The dharmakaya is the unmanifest ground of all manifest form. Dharmakaya means "truth body," thus the formless abode of clarity and emptiness is the true source and essential nature of forms.

Although the trikaya terminology is specifically Buddhist, the three-tiered hierarchical map of mystical dimensions, including the material realm, the luminous archetypal realm, and the formless void, has been described by mystics of all spiritual paths. The Sufi name for the luminous visionary imaginal world is *alam mithali*, or *Malakut*—the world of the soul. The Sufi philosopher al-Ghazālī describes the mystical transport:

> From the beginning, revelations take place in so flagrant a shape that the Sufis see before them, whilst wide awake, the angels and the souls of the prophets. They hear their voices and obtain their favors. Then the transport rises from the perception of forms and figures to a degree which escapes all expression, and which no man may seek to give an account of."[5]

The Christian mystical perspective outlines similarly the transition from subtle spiritual perception of saints and angels to a formless and indescribable state of union with God. Here William James discusses orison, the spiritual exercises of Saint Ignatius:

The acme of this kind of discipline would be a semi-hallu-cinatory mono-ideism—an imaginary figure of Christ, for example, coming fully to occupy the mind. Sensorial images of this sort, whether literal or symbolic, play an enormous part in mysticism. But in certain cases imagery may fall away entirely, and in the very highest raptures it tends to do so. The state of consciousness becomes then insusceptible of any verbal description. Mystical teachers are unanimous as to this.[6]

The highest states of mystic union pass beyond rational description and form of any kind. The Catholic mystic Meister Eckhart advises, "Thou must love God as not-God, not-Spirit, not-person, not-image, but as He is, a sheer, pure absolute One, sundered from all duality, and in whom we must eternally sink from nothingness to nothingness."[7]

Out of transcendental no-thingness comes every thing. This is the action of universal creativity. Having sketched the three basic dimensions of consciousness, we can observe how universal creativity operates through the artist: from the primordial ground of the highest spiritual realms beyond form, essential archetypal forms emerge as self-luminous symbols, detectable by the sensitive visionary artist, inspiring the artist to create the physical object of art in the phenomenal realm. This is the process whereby the most holy visions enter mystical art.

Categories of Sacred Art

Now that we have briefly mapped the domain of mystical reality by examining chakras in the previous chapter and broad categories of mystical experience in this chapter, I would like

to define seven types of art that relate to the spirit. The Buddhist scholar and teacher Sangharakshita distinguished four types of art,[8] which I have expanded and rephrased in order to refine our understanding of art related to religious and spiritual content:

1. Art that uses no overt sacred symbols and transmits little or no spiritual presence: Examples of this type of art could be found throughout commercial advertising and among much of the art of this century, whether abstract or representational.

2. Art that uses religious imagery to transmit an ambiguous or antireligious and sometimes antispiritual presence: Art of this type can be intentionally blasphemous, and uses the power of religious archetypes to profane the sacred or press a personal rephrasing of the archetype. Examples can be found in Félicien Rops's pornographic crucifixion works (blasphemous) and Warhol's commercialized generic *Last Supper* (ambiguous), among many others.

3. Art that does use traditional religious symbols, but transmits a flat spiritual presence: Examples of this could be some popular reproductions of saints and religious subjects to be found in many churches and homes of believers. These works serve as a positive reminder of religious beliefs, but they are not powerfully transformative as works of art and do not speak of the internal spiritual authority or mystical experience of the artist.

4. Art that uses traditional devotional sacred symbols and transmits a spiritual presence: The majority of great works of traditional sacred art from every culture would qualify, such as exceptional Hindu cave sculptures, Ti-

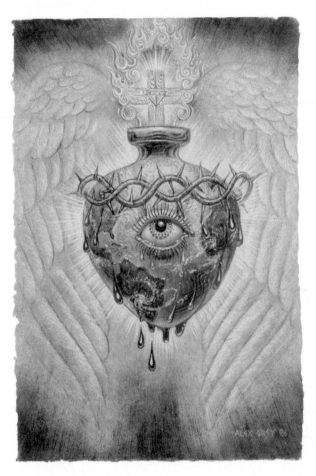

EYE OF THE HEART

betan *thangkas*, Buddha sculptures, Byzantine icon paint-
ing, Hebrew and Islamic calligraphy and mosaic work.
Each tradition has its canons of proportion and technical
requirements of objects in order to qualify them as legiti-
mate works of traditional sacred art. These and the fol-

lowing types of work contain the power to shock the viewer into some revelatory spiritual understanding.

5. Art that uses no obvious sacred symbols but transmits a personally realized spiritual presence: Examples of this type would be Zen landscapes and the paintings of van Gogh, Ivan Albright, and Pavel Tchelitchew. Tantric art displays a symbolic abstraction of the spiritual realm. Nonrepresentational painters in this category would include Mark Rothko, Jackson Pollock, Richard Pousette-Dart, Alfred Jensen, and Agnes Martin.

6. Art that uses visionary and sacred symbols in nontraditional or unconventional ways to transmit spiritual presence: Various inspired individuals, such as Hildegard of Bingen, Hieronymus Bosch, Michelangelo, and William Blake provide examples of this type of art. The art of these individuals shows a high development of spiritual knowledge based on their own divinely inspired dreams and visions, as well as an idiosyncratic but positive orientation toward religious symbols.

7. Art that brings together sacred archetypes of various religions, based on personal experience and expression of nondenominational interfaith relatedness and multicultural awareness: I believe that this type and the previous two types will lead to a new spiritual art that celebrates the unity and synthesizes the diversity of world culture and spirit. This art will be the handmaiden of a future universal spirituality.

There are many types of art that may qualify as spiritual, only some of which use traditional sacred symbols. The power of spirit in the artist determines the power of spirit in the work

of art, not just the subject matter portrayed in the work. A cypress tree painted by van Gogh or a flat field of maroon color painted by Rothko can have more spiritual presence than an emotionally flat crucifixion scene painted by an uninspired artist.

However, subject matter can help artists symbolize a power greater than themselves. We would never dream of the Dalai Lama prostrating before a Warhol or de Kooning painting, but if an artist makes a statue or painting of the Buddha and places it on an altar, Tibetan Buddhists show their respect by prostrating before the image, and even the Dalai Lama will do it. Is the Dalai Lama responding to the art? Yes, but only because of the sacred message it conveys. He is offering respect to the Buddha, not to some cloth and paint.

We may find our path as artists by falling in love with a formal or traditional school of sacred art. Each religion has its sacred art, from calligraphy to icon making, tantric art, and so on. Religions flower with creative expressions of great power. The discipline and commitment necessary to learn successfully the craft of a sacred art is tied to one's deepening understanding of the faith. Today artists drawn to the sacred have the opportunity to view several religions and, if called, to enter into a tradition.

The artist's spiritual path is as unique and individual as his or her own work. An artist may study the teachings of a particular tradition and choose to make art that falls outside that tradition. Or the spiritual practice of an artist may show up only indirectly in the work. Although I am mostly a student and practitioner of Tibetan Buddhism, my own artistic orientation is toward the examples set by the Christians Michelangelo, Bosch, and Blake, relying on my own visionary revelation

and making artwork from those visions. This could be called the visionary tradition.

The visionary is at the origin of every sacred tradition of art. The religious art tradition's initial revelation of "divine canons of proportion" or mystic syllables and sacred writing was through visionary contact with the divine ground, by which the early wisdom masters and artists of those sacred traditions received the original archetypes. After a sacred archetype has been expressed into material existence, given form as a work of art, it can act as a focal point of devotional energy. The artwork becomes a way for viewers to access or worship the transcendental domain represented by the archetype or sacred word. In sacred art, from calligraphy to icons, the work itself is a medium, a point of contact between spiritual and material realms. Traditional religious art has attracted the attention of masses of adherents over hundreds, sometimes thousands, of years, building up a powerful devotional field of energy around these traditional archetypes. The accumulation of devotional intensity around a work of art forms a field of morphic resonance that affects future viewers.

Morphic resonance is a theory developed by Rupert Sheldrake that states that each member of a species draws on the collective memory of the species, tunes in to past members of the species, and may in turn contribute to the further development of the species. Sheldrake cites the inexplicable simultaneous development of habits in geographically separate species, and even points to the fact that after a particular kind of crystal is grown in one laboratory, it becomes easier to grow throughout the world. Each thing has a morphic field, an organizing, form-shaping field that brings its singular field into "resonance" with the habits of the collective field. The more often

an action is repeated, the more powerful and influential, and the easier to access, is its morphic resonance. The morphic field of the individual has the potential to influence the collective through creative acts.

The difference between lunacy and time-honored religious rituals is a thick layer of morphic resonance built up over many generations of devotional repetition. Many of the most sacred rituals would appear to be the behavior of psychotics were it not for their acceptance as demonstrations of faith. Prostrations, the use of phylacteries, genuflection, and numerous self-mortifications—all are strange to the uninitiated. When ritual becomes habitual and widespread, a tradition is born. The power of morphic resonance promotes the unquestioned or unconscious acceptance of traditional behavior.

The creative spirit is in turbulent resonance with the collective morphic field. Part of the job of creative persons is to challenge traditional habits of thought and behavior and develop new expressions to surprise and reinvigorate the collective mind-set.

Profane and Sacred

Art is a mirror shining into the complicated recesses of the human psyche. Increasingly in this century we have art that uses traditional religious imagery yet seeks to profane or desecrate that imagery, such as Manuel Ocampo's grotesque parodies of the Stations of the Cross. Personal expressions of icon desecration through artwork may be the monsters born from abuses of power that traditional religions have wrought on their followers. As well as expressing a cynicism and resentment toward unfulfilled promises of religion and spirituality,

artists may simply oppose the hegemony that individual religions have claimed over the soul. Sometimes the accumulated morphic resonance or field of meaning around a sacred archetype has become oppressive and meaningless to an individual. Outbursts of blasphemy proclaim the decline of religious authority. This is not to endorse desecration of religious property, sacred grounds, or holy objects belonging to others. There is a difference between buying a crucifix and photographing it in a vat of urine, as Andres Serrano did in his controversial *Piss Christ* image, and going into a local church and peeing on the altar crucifix. Both are symbolic acts, but one is a personal artistic expression and the other is a stupid act of criminal mischief. This is a difficult issue with boundaries that artists will continue to press.

On the other hand, the dawn of the twenty-first century is unique in that the great religions and indigenous peoples of the world have grown beyond their former cultural isolation, and many great spiritual teachers have traveled throughout the world fostering a sense of interfaith fellowship. The Dalai Lama of Tibet is an exemplar of this tendency and has stated, "Now it is crucial to accept that different religions exist, and in order to develop genuine mutual respect among them, close contact among the various religions is essential." He has also said, "I believe deeply that we must find, all of us together, a new spirituality. This new concept ought to be elaborated along side the religions in such a way that all people of good will could adhere to it."[9] Worldwide exposure to many sacred art traditions gives, for the first time ever, a true sense of the diversity and inventiveness of world culture, inspiring curious artists to look beyond the confines of their own culture.

The mystic artist guides us to an oasis of spiritual truth and

clarity within the postmodern desert of false and shrill media information saturating our consciousness. By contemplating a beautiful work of sacred art, one may momentarily remember the silent center of mystery that is our very soul.

The Mystic Life

The spiritual path can seem paradoxical. When we seek or strive to find spirit outwardly, it remains illusive. Merely sitting in church or reading a holy book or meeting a holy person is no guarantee of spiritual awakening. A guru, a spiritual teacher, is an outward symbol of one's own highest nature. In a cult situation, people project their own spiritual authority onto their "infallible" guru and then become morally blind by justifying the guru's outrageous behavior, or they become disillusioned if the guru doesn't live up to their projections.

True spirit manifests as we realize it has never been absent from us, that it is always already present as the infinite potential in our own hearts. The paradox is that without a strong yearning or intention to wake up to this true nature, it is unlikely that it will ever manifest. Ideally, this yearning to awaken leads to encounters with spiritual authorities whose transmissions encourage (and don't damage) our own spiritual growth.

Spirit manifests uniquely through every shade and nuance of individuals. As mentioned, there are many inner paths to access spirit: from prayer and meditation assocated with any of the great spiritual traditions to various yogas, shamanic drumming, holotropic breathwork, and entheogenic drugs. Mystical visions and experiences force us to question our assumptions about life and the world, challenging us to live more spiritual

lives. Making art can be a way of integrating our visions into daily life.

But just because an artist has a mystical experience is no guarantee that he or she will lead a more spiritual life. The mystical experience is just a glimpse, just the beginning, showing the potential for transformation. In her major book *Mysticism*, Evelyn Underhill defines five phases of the mystical life, paraphrased below:[10]

1. *Awakening*: the ecstatic encounter of the self with divine reality.

2. *Purgation*: after experiencing the infinite, the self realizes its imperfections and finitude. There is a painful recognition of the immense gulf between the delusions of everyday life and dwelling in true spirit. Therefore, disciplined efforts are made to purify the soul of its falsehoods. These practices might include prayer and meditation.

3. *Illumination*: through the diligence of spiritual practice, a state of visionary contemplation with glimpses of the absolute is reached. Many mystics never go beyond this stage. The mystic has a sense of divine presence and happiness, but not a complete union.

4. *Dark night of the soul*: now the consciousness suffers a sense of divine absence; there is a higher purgation of craving for the personal satisfaction of mystic vision. The self surrenders the need for personal gratification and becomes totally passive to the divine will.

5. *Union*: this goal of the mystic quest places the consciousness, not at observation or with glimpses of the absolute, but at one with it. Complete absorption into divine presence brings a peaceful joy and clarity, a certitude and nat-

ural moral authority. Because mystics have become one with the transcendent, their wise and compassionate actions are for the benefit of all people; they teach and serve the world in the best ways they can.

Can the practice of art foster a mystic life and bring the artist to the summit of union with the divine? Much may depend on the grace of God, or the transmission of a qualified spiritual master. A crucial ingredient to making any practice function is wholehearted intention. A prayer said by rote without inner understanding contains no blessing. A painting made without full engagement of the artist's spirit is an empty shell. What changes need artists make in their consciousness and lifestyle so that their art may better reflect and transmit the mystic state? And further, how can art itself become a spiritual practice? These are questions to hold in our hearts and answer with our deeds.

Incompleteness

Because this chapter is filled with definitions of the undefinable, it seems appropriate to close with nonclosure. I used to search for a complete theory of reality, an all-encompassing metaphysics that could guide me and my art. Then I came across Gödel's mathematical incompleteness theorem, which basically states that all closed systems are incomplete. Reality is not a system. Systems are conceptual flowers that philosophers grow in the gardens of their heads in order to grasp and communicate an ultimately indescribable and unknowable mystery. As knowledgeable as any conceptual system seems, that knowledge is always only a portion of the truth. Because the

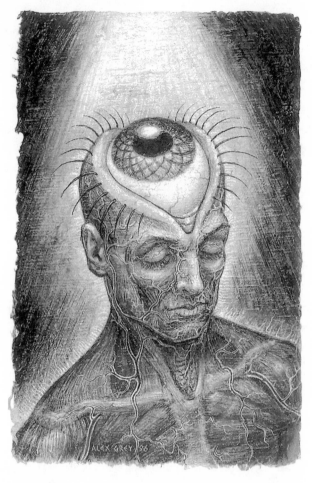

VISION PRACTICE

nature of knowledge is evolutionary and must be updated and retooled, all theories of reality are partial and incomplete. This does not negate the value of theoretical inquiry for charting a personal mission of art. It simply means that one proceeds with a sense of nonclosure and realization of the limits of any map

of mysticism. No conceptual system will ever adequately explain or predict the ineffable nature of spirit, or the creation of artists. Artists tolerate a lot of ambiguity in order to be open to the creative spirit. Creative ambiguity means proceeding with a sense of "not knowing" and is akin to the "beginner's mind" of Zen. We approach our work freshly with the intention to strike to the core of truth. The only state of completeness arrives when you open the mystic eye and know your own spiritual core, beyond all limitations. Seeing with the mystic eye reveals visions of illumination.

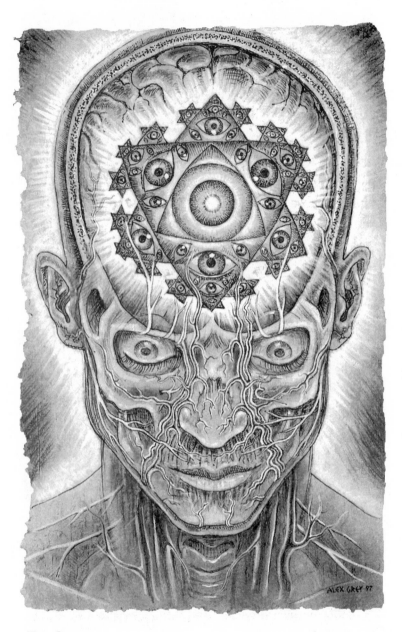

The Seer

Chapter 5

Illuminating Visions

All opaque things are transparent and the light of heaven struggles through.

—Ralph Waldo Emerson

In a dream, two friends and I were climbing on the radiant, mountainous face of a God. The head was made of glowing golden crystal rock. As we perilously ascended this huge Godhead, my friend who was a writer stopped and rested at the mouth, my friend who was a musician climbed into the ear, and I struggled to the eye. At our separate stations, we could no longer see each other, but we were united by the same illuminated Godhead, having placed ourselves at the spiritual sensory gates that governed our art.

This dream points to the task of mystic artists. It is the artist's uphill journey to behold creation with the senses of the Creator and carry divine light into his or her work. If our art

is to be a lamp of spirit, it is our task to create sounds, words, and visions that transmit penetrating rays to the hearts of receptive people.

The spiritual radiance in our hearts and the presence of God in our artworks are detectable with the mystic eye. God is all there is. God has never been separate from us. We are always climbing or resting on the Godhead. God's light has condensed to form this phenomenal realm. God's light is an ocean

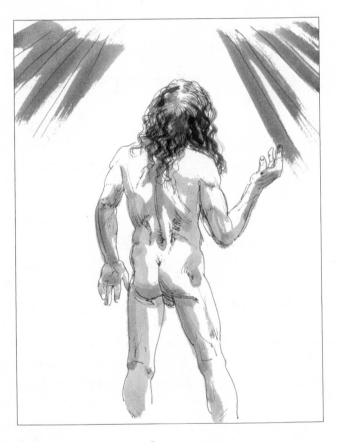

CONVERSING WITH THE LIGHT

of incandescence animating all forms, and God's dark light is a vast empty presence that is the formless ground of all forms. Every spiritual path has identified light with spiritual wisdom. Christ said, "I am the light of the world, ye who follow me will not falter in darkness, but will be guided by the light of life" (John 8:12). The Hindu Upanishads contain many references to the equivalence of inner light and spirit, as in chapter 2 of the *Mundaka Upanishad*, "In the supreme golden chamber (of the heart) is Brahman indivisible and pure. He is the radiant light of all lights, and this knows he who knows Brahman . . . his radiance illumines all creation."

Throughout the history of art, representations of divine beings and realms have been filled with mystic light, from the petroglyphs of solarized shamans to the use of gold and sun imagery in Egyptian art and the portrayals of Buddha and Christ as sources of illumination. Cross-culturally it is recognized that holy people glow, and we seek "enlightenment" through these spiritual beings. God's sublime presence is awakened in us by viewing images of beatific light.

The icon painters of the seventh century used golden halos to portray the living light of Christ. The pre-Renaissance painter Fra Angelico was a master at portraying divine radiance. His frescos in the monastery at San Marco show the transfigured Christ as an auric white flame. Michelangelo uses a yellow light around the body of Christ to draw attention to the hub of his swirling cascade of flesh in the *Last Judgment*. The Baroque art of Bernini frequently alludes to rays of heavenly light, as in his masterpiece the *Ecstasy of Saint Teresa*. Bernini has sculpted Saint Teresa in pure white marble and caught her ecstatic grimace of peace, joy, and rapture as her heart is pierced by an angel and she is showered in golden rays of light

from above. Through the sacred symbolism of mystic light and Saint Teresa's closed eyes, Bernini has evoked her highest reveries: "In the orison of union, the soul is fully awake as regards God, but wholly asleep as regards things of this world and in respect of herself."[1] The source of heavenly light is hidden but pointed to, as is Saint Teresa's internal experience.

Light became a principle subject of van Gogh's paintings. His early landscapes and paintings of workers in Belgium and Holland were appropriately brown and black, a typically Dutch palette for his day. His brother Theo introduced Vincent to the color and energy of the impressionists. Initially Vincent resisted, then his letters showed his doubts: "Yes, these studies of mine are altogether too dark and dismal! And yet, what about the blacks in Frans Hals, Rembrandt and Velasquez? To me shadows seem definitely dull, if not black. Can I be wrong? . . . If only we had been taught the laws of color when we were young! But it is as though fate had decreed that the search for light must be a long one in most people's lives."[2] When van Gogh saw what Monet, Seurat, Pissarro, and other French painters were doing, and he absorbed the lessons in composition from Japanese prints, his palette brightened and his designs became more essentialized. He experimented with complementary colors to dazzling effect. The sun and its resplendent rays began to fill his paintings with chrome yellow. Vincent's seething stars remind us of both the particle and wave aspects of light, and the thick sinuous strokes filling his canvases seem to flow directly from the vital creative energy of the cosmos.

Mark Rothko's late work, as seen in Houston's Rothko Chapel, reveals a transcendent darkness and paradoxically makes him one of the great painters of light. Rothko spoke of

his kinship with some of the great painters of light, Fra Angelico, Turner, and Monet. As we have noted in the previous chapters, mystics have indicated that their most profound contact with the absolute has been in states of being that they called the "clear light of the void," states of boundless emptiness and clarity that were beyond form yet pregnant with all form. The profound silence and mystery of transcendental experience is evoked in Rothko's mammoth black paintings.

The strange thing about both van Gogh and Rothko is that each created profound and original painted testaments of mystic light, yet each committed suicide. Why? They were two of the most transcendental artists in recent art history, yet their art did not ultimately heal them or relieve their suffering. Art did not end their despair. Perhaps it did for a while, but not ultimately. Artistic genius is by nature incredibly sensitive, convinced of its own vision, and prone to taking action. In the case of the suicidal artist, these qualities are fatal. These are serious considerations if we wish to promote art as a spiritual practice. If art is therapeutic only for the amateur and leaves the professional or great artist bereft of hope, what kind of spiritual practice is that?

Both van Gogh and Rothko lacked a spiritual companion or loving life partner who could stay with them to monitor their dangerous depression. Both artists lacked a spiritual master, a true spiritual community, and devotion to an interpretive spiritual tradition that could help them psychically channel the creative ocean of energy that poured through them. Both painters intuitively grasped and evoked spiritual truth and beauty in their work, yet neither had the illuminating experience of his essential nature and the nature of the cosmos as infinite compassion and goodness. The deep understanding of

Tibetan Buddhist mysticism is that the dharmakaya, the dimension of absolute truth, is boundless emptiness, boundless awareness, and boundless compassion.

The self-destruction of the creative artist is a complex and compelling issue, never more so than in the twentieth century, when so many great musicians, artists, and writers have killed themselves. Creative people are driven to periodic symbolic self-annihilation and rebirth, much like the mythic phoenix. When the phoenix sensed death encroaching, it would build a nest of wood, which was then subjected to the full force of the sun's heat. The sun set the nest and the bird to blazes, burning them to ashes and charred bones. The mysterious miracle of the fire bird was that a new phoenix was born out of the ashes.

A Jungian psychiatrist named David Rosen studied survivors

CLEAR LIGHT

of suicide attempts who jumped off the Golden Gate Bridge in San Francisco. Very few people have survived such a fall, which is about 255 feet. From that height, a body hits the surface of the water at about seventy-five miles per hour. Of the more than two thousand people who have jumped to their almost certain death, about 1 percent have survived. Dr. Rosen interviewed ten survivors. They all reported that they had planned their jump while in a confused and demoralized state, and each experienced a profound spiritual awakening after the leap. Their suicide attempts became leaps of faith that convinced them that there was a higher spiritual purpose to their lives. They reported feelings of rebirth, of unity with all life, and none of them attempted suicide again. Dr. Rosen was astonished at the similarity of the survivors' experiences and came to coin the word *egocide* to explain the transformative process. He felt that most suicides are an attempt to kill a negative ego, a negative self-image. *Ego* in a Jungian sense means the center of conscious activity, the nucleus of our personal history, which we have become identified with but which is not our true self and is not usually integrated with the many forces of the unconscious. The suicide survivors committed egocide, dying to their old identity, and like the phoenix they went into the light of death and came forth reborn and renewed in their soul.

As is well documented in thousands of reported near-death experiences,[3] an encounter with divine light is primary. The light may take recognizable forms such as luminous religious figures, angelic presences, or departed ancestors, or the light may be completely abstract, from a sense of all-enveloping white light to infinite grids of spiritual energy. As in the case of the aforementioned suicide survivors, the light brings with

it a sense of rebirth, purification, and divine love and a renewed purpose to life.

There is a need for individuals to find ways of transcending their limiting identities, of periodically committing egocide. The submission to God by following transformative spiritual practices can more safely engage the death-rebirth transcendence axis. Some cultures have elaborate and cathartic rites of passage for every stage of life. Our culture has not fostered safe death and rebirth rituals. So people create their own, consciously or unconsciously. I have found that entheogens and other spiritual practices can provide ego-shattering, cathartic, yet reassuring encounters with inner spiritual light. Some people take workshops, go on meditation retreats, or live with spiritual masters. Some people ruin their marriages. Some people go crazy. Some people get diseases. Some people quit their jobs to pursue their creative lives. However we transcend and transform ourselves, let us be encouraged not to lose hope; the ground of infinite compassion and illuminating vision is everyone's rebirthright. Art can illumine the shadows and pains of ego's death, and art can midwife the soul's brilliant rebirth.

An appreciation for the rarity, good fortune, and impermanence of human life is the foundation of a spiritual path, and the ideals of truth, goodness, and beauty are its guiding light. The aspiring mystic artist yearns for divine illumination and is bound by the ideals that spirit requires of us.

Art and Idealism

The Belgian symbolist painter Jean Delville was a tireless champion of idealism in art. Consider his three principles of beauty governing the production of art:

1. *Spiritual beauty*: requires that the artist reach for the highest or deepest truth as his or her subject.
2. *Archetypal beauty*: requires that the artist intuit the perfect thought forms, at once universal and personal, that express the subject.
3. *Technical beauty*: requires the refinement of the artist's craft so that it may best express the subject.[4]

These principles impose no specific subject, yet they encourage the artist to approach creation as spirit expressed into matter. This applies equally to abstraction, symbolism, realism, or any formal approach. Some of the most abstract artists of this century considered subject matter a primary concern. The early modernists Malevich, Mondrian, and Kandinsky each believed he was depicting an essentialized spiritual world in his abstract paintings. The abstract expressionists Newman and Rothko each felt his subject matter determined the depth and meaning of his work. In a response to the formalist critic Clement Greenberg, Mark Rothko wrote:

> I am not interested in relationships of color or form or anything else. . . . I am interested only in expressing the basic human emotions—tragedy, ecstasy, doom, and so on. . . . The people who weep before my pictures are having the same religious experience I had when I painted them. And if you are moved only by their color relationships, then you miss the point.[5]

If an artist chooses a subject of the natural world, idealism demands a double inquiry, seeking to penetrate not only the external appearance but also the essence of its meaning. The

sculptor Rodin explains this dual inquiry in the following exchange with an interviewer:

> "I obey Nature in everything, and I never pretend to command her. My only ambition is to be servilely faithful to her."
>
> "Nevertheless," the interviewer answered with some malice, "it is not nature exactly as it is that you evoke in your work."
>
> Rodin stopped short, the damp cloth in his hands. "Yes, exactly as it is!" he replied, frowning.
>
> "You are obliged to alter—"
>
> "Not a jot!"
>
> "But after all, the proof that you do change it is this, that the cast would give not at all the same impression as your work."
>
> He reflected an instant and said: "That is so! Because the cast is less true than my sculpture! It would be impossible for any model to keep an animated pose during all the time that it would take to make a cast from it. But I keep in my mind the ensemble of the pose and I insist that the model shall conform to my memory of it. *More than that,—the cast only reproduces the exterior; I reproduce, besides that, the spirit which is certainly also a part of nature. I see all the truth, and not only that of the outside. I accentuate the lines which best express the spiritual state that I interpret."[6]*

The light of truth beyond external appearances is what artists evoke in their finest works. Here we come to the conjunction of the three harmonies of idealism: beauty, truth, and the good. By absorption into the beauty of sacred art, a person

may sense the presence of higher truth and its inherent goodness. Beauty is the visible doorway, the seductive gift of transcendental presence. Beauty is the radiance of spirit.

The spiritual vision is a gift. In order to receive this gift, an artist's open receptivity to inspiration is all-important. Many of my visions have come as I was already working on a painting, or during times that favored open-focused intuitive self-reflection, such as meditation sessions or driving a car on long journeys. Find time to be alone, and open to metaphysical insight. Taking time to commune with the divine is a necessity. This is the same point Jewish law makes about honoring the Sabbath. We need to set time aside to refresh the soul, to remember and reconnect with the inner light of spiritual truth. Meister Eckhart said that he had developed an inner solitude and inner Sabbath, so that he took the sacred space of Sabbath with him whenever and wherever he went. Cultivate positive expectancy without preconceived notions. Relaxation into the ground of creation will deliver the ideal and illuminating vision.

God is the spirit of universal creativity, both the transcendent emptiness and effulgent immanence of all dimensions of existence. Art can be a channel of God's creative light. The highest art reveals God, proves that God exists. Every work of art that does not cause God to be felt misses the true potential of art. The beauty of God, the Infinite One, expressed through art can be peacefully beautiful or terrifyingly sublime, intensely personal, revealingly ugly, awe full, and unobstructedly loving and embracing, cracking the limits of the ego shell, scrambling and uplifting the soul. The fire of God fills the artist with holy pressure to turn the coal of matter into diamonds of art.

The soul travels in a circle in its encounter with the sublime beauty of art. Spirit offers a numinous vision to the artist, who then impresses the vision into a material work of art. The beautiful art object attracts the viewer back to the original source of the vision. The circle of spirit and matter operates through the doorway of beauty. This circulation creates an aura of transcendent energies around and through the work of sacred art.

Visionary Art

Visionary art is the creative expression of glimpses into the sacred unconscious, spanning the most searing shadow imagery of tortured souls in hell, the mythic archetypes of demonic and heroically compassionate forces that seem to guide and influence our feelings, and the luminous transpersonal heaven realms. Visionary art offers bizarre and unsettling insights, convincing us by its compelling internal truth. The mystical experience of spiritual illumination, unity, wisdom, and love is the ideal of Visionary art. The sublime and primordial infinitude of terror and beauty is not separate from this ideal.

The visionary artist may inwardly apprehend, then uniquely transmit traditional sacred archetypes or recombinant hybrids of traditional forms, or create previously undisclosed forms, beings, and vistas. The covenant that visionary art makes with a viewer is to catalyze the viewer's own deepest insights by plunging them headlong into the symbolic mystery play of life, planting seeds for their future spiritual unfoldment.

My artwork relies on the realm of Vision. Artists receive visions just like musicians receive sounds and melodies. I remember a morbid vision that occurred to me after a period of intense adolescent despair and anxiety. Having just completed

high school and just broken up with my girlfriend, I was faced with the frightening prospect of "becoming an adult." My internal stress wouldn't allow me to sleep, exacerbating the depression, which assumed metaphysical proportions. After consuming a steady diet of existentialist authors, I lay in bed sleepless one night. A vivid image of myself with two heads appeared, tearing my body apart. The vision summed up my psychic condition of conflicting despair and hope. The powerful hopeful side was peering over its shoulder toward a light and also attempting to remove the sick shadow self who was laughing, in some ways wiser, the shadow knew that such an attempt would cause the death of both halves. By visually capturing my conflicted mental condition, this frightening image was paradoxically accompanied by a sense of peace. It was like placing a monster safely into a cage. After making a brief sketch of the idea, I was able to fall asleep, commited to later make a drawing and eventually a painting of the vision.

Later vision experiences came about not only in times of emotional stress, but also through dreams, peak moments of psychedelic experiences, after reading spiritual books, during meditation practices or chiropractic adjustments, or at no time in particular. While waiting for a New York subway in 1991, completely sober but exhausted after a day of teaching, I had a strong vision of the *World Soul* sculpture that would occupy me for the next two years. There are times when an endless cinema of images assault my mind and it's difficult to keep track of them and sketch them all. Other visions have gestated for years before translating a sketch into a finished work. Having never found much of a home in the world of contemporary art, I began to look into ancient and foreign art traditions and found a rich and colorful family heritage that has roots spread throughout the world.

A proper historical account of the Visionary art tradition and the remarkable individuals who made the work has never been written, but would have to start with the ancient human/ animal hybrids of cave art, like the sixteen-thousand-year-old *Sorcerer of trois freres*. Shamanic art and much "primitive" work from all over the globe has its origins in the sacred unconscious. Also included in a history of visionary art would be representations of the mythic deities and demons of various cultures, such as the Mayan feathered serpent, Egyptian or Greek Sphinxes, and Indian, Tibetan, Balinese, and Thai portrayals of many-limbed, many-headed beings housed in complex mandalas.

One of the earliest known western mystic visionary artists was Hildegard of Bingen, a twelfth-century Abbess from Germany. At the age of forty-two she began to have visions. While enveloped by a fiery inner light she was told to, "Speak and write not according to human speech or human inventiveness but to the extent that you see and hear those things in the heavens above in the marvelousness of God."[7] The icons created from her visions are direct and authentic gifts of spirit. Perhaps the most famous visionary artist was the fifteenth-century painter Hieronymous Bosch, who portrayed an extraordinary array of grotesque beings, tortured souls in hell, and angels guiding the saved to the light of Heaven. His *Garden of Delights* is one of the strangest paintings in the world, an encyclopedia of metamorphic plant/animal/human symbolism. Pieter Bruegel's *Triumph of Death*, an amazing landscape featuring a coffin go-kart and countless armies of skeletons herding the struggling masses, and his *Fall of the Rebel Angels* were touched with the same visionary madness as Bosch. Northern and Italian Renaissance artists like Grunewald, Durer, and Mi-

chelangelo delineated the revelations of Christian mysticism with gothic and searing realism.

Our historical sketch of visionary art would have to include the seventeenth-century alchemical engravings of Johann Daniel Mylius and mystics like Jacob Boehme and Robert Fludd, who detailed complex mandalic philosophical maps of cosmic symbolism for achieving union with the divine. The alchemists' flask and the transmutations of its contents were symbolic of the transformative power of consciousness in which the opposites: male and female, sulfur and mercury, matter and spirits attain a higher synthesis.

William Blake, the nineteenth-century mystic artist and poet, created from his divinely inspired imagination. He would converse with angels and the spirits of great philosophers. He received painting instructions from discarnate entities. To Blake, painting had nothing to do with copying from nature:

> Shall painting be confined to the sordid drudgery of facsimile representations of merely mortal and perishing substances, and not be as poetry and music are, elevated into its own proper sphere of invention and visionary conception? No, it shall not be so! Painting, as well as poetry and music exists and exults in immortal thoughts.

Blake published his own books of art and poetry that revealed an idiosyncratic mysticism, rooted in his own visionary perception of religious subjects. He resisted conventional religious dogma and proclaimed "All Religions are One." The characters in Blake's paintings and engravings seem to be the kin of Renaissance masters, Michelangelo, Raphael, and Durer, yet softened with a peculiar magic. During his life,

Blake's exhibitions were met with taunting ridicule and accusations of madness from art critics. He struggled for economic survival all his life, supporting himself and his wife, Catherine, as an engraver and book publisher. He died in 1827, at the age of seventy, disregarded as an artist, buried in an unmarked grave in a paupers cemetary.

I sometimes refer to visionary art as a bastard tradition in Western art because its proponents are so often reviled by their parent culture. William Blake is one of the finest cases in point. In the twentieth century, Blake's unique work has been resurrected and given the respect that it is due. His poetry is regarded as some of the most original in English literature. His visionary artwork exhalts an ideal realm of inspiration that he termed the "divine imagination." Blake's work lay the foundations for the nineteenth-century Symbolist movement that included such artists as Gustav Moreau, Odilon Redon, and Jean Delville among many others.

Pavel Tchelitchew was one of the great visionary artists of the twentieth century. His obsession with anatomy and mysticism relates to my own work. Tchelitchew's paintings evolved through metamorphic symbolism to X-ray anatomical figures glowing with inner light and eventually progressed to luminous abstract networks. During the 1930s and 1940s he was regarded as one of the century's premier artists. His career before and after his death in 1957 provides a recent twist on the tale of cultural ambivilence toward mystic visionaries. In 1942 The Museum of Modern Art in New York City gave him a full mid-career retrospective and acquired his most famous painting *Hide and Seek*. So powerful is the visionary force of the swarming "fetus tree" in *Hide and Seek* that it became one of the most popular works in the entire museum. For many years *Hide and Seek* was part of MOMA's story of Modernism,

a tale that progressed through galleries with such works as Van Gogh's *Starry Night,* Picasso's *Demoiselles d'Avignon,* and works by Matisse, Malevich, Mondrian, Magritte and Dali. Sometime in the late 1980s MOMA removed *Hide and Seek* from display. Many people, including myself, have protested its unjust hiding and seek its permanent rehanging. Throughout history the visionaries that express their "mystical madness" are often met by a simultaneous force within the mainstream that fears and suppresses such outbreaks of the unconscious.

One of the greatest visionary artists of the twentieth century, a Viennese painter named Ernst Fuchs, is a master of technique comparable to van Eyck, Bosch, and Dürer. His idiosyncratic and mostly Christian religious figures glisten with luminescent jewel-like surfaces. He is an artistic descendant of William Blake, yet informed by art nouveau and psychedelic mysticism. Although Fuchs's works are celebrated in Austria and some other countries in Europe, and other artists have enjoyed his art and sought his instruction for decades, he has never been accorded the international acclaim that many younger and lesser artists receive.

The imaginal realms of visionary art include surrealists like Dalí and fantastic art like the amazing work of Mati Klarwein and the morbid genius of H. R. Giger as well as idealist work like that of Blake and Fuchs. Fantasic and surreal art operate in a territory without clear moral order, a rudderless dream ship adrift on the unconscious waters of memory and invention, desire and fear, sex and violence, wherever the currents of obsession lead. Mystic visionary art by Delville or Tchelitchew includes but transcends fantastic and surreal visions because of a sense of order beyond chaos. Idealist visionary art reveals hidden spiritual truths. Fantastic and surreal art depend on no ground of ultimate truth, no reference to God. All is dream

from which there is no awakening, except to the realization that we are all dreaming. Idealist and mystical art evoke a positive altruistic force and a basis for appreciating the divine dream show we call reality.

The visions of the surrealists help to define a dream realm where any bizarre juxtaposition is possible. There is truth in the strangeness. A vision of strangeness can shock us into deepening our acknowledgment and appreciation of the Great Mystery. The mystery of existence is unpredictably odd and has unexplainable pathological aspects.

Artists from many cultures and historical periods have portrayed strange deities and demons, the inhabitants of heaven and hell. Beings such as angels and others that dwell in the shadowland project our good and evil nature. My view is that heaven and hell are the polarities of feeling and being in human consciousness, and the judge that sends us to either region is within us, our own free choice and intention. For the eighteenth-century clairvoyant Emanuel Swedenborg, heaven and hell were places that his power to maintain prolonged trance states enabled him to visit. His cartography was Christian but unconventional. To Swedenborg, after death the soul enters the spirit world, where one's "true affections" become manifest: "The world of spirits is neither heaven nor hell. . . . It is where a person first arrives after death, being, after some time has passed, either raised into heaven or cast into hell, depending on his life in the world." If our true nature is loving and seeking self-transcendence, we are on our way to heaven. But if our true affection is self-centered, greedy, and power hungry, we sink toward hell. Hell is a place of abominable stenches, insatiable desires, hunger, darkness, constant bickering, and torment. In Swedenborg's experience, souls in heaven and in hell lived in houses and cities. The heavenly dwellings

are radiantly beautiful, while "in some hells, one can see something like the rubble of homes or cities after a great fire. . . . In milder hells one sees tumble down huts, crowded together. . . . Within the houses are hellish spirits, constant brawls, hostilities, beatings. . . . There are robberies and holdups in the streets. . . . In some hells there are nothing but brothels that look disgusting and are full of all kinds of filth and excrement."[9] This world has been well represented by artists such as Hieronymous Bosch and the contemporary chronicler of inner hell realms, Joe Coleman.

Swedenborg's heaven had several levels. In the highest celestial heaven the angels are most ineffable, participating directly in the will or intention of the Divine. His heaven was made of angels, each angel belonging to a group of like "true affections," the whole host of them forming the body of God. Swedenborg's heaven was not filled with lackadaisical angels strumming on harps; his angels worked according to their nature and with the intention of being of helpful service to others. I think that with some elaborations, Swedenborg—not unlike Dante, the other great visionary architect of the inferno and heaven realms—describes to Westerners a familiar scenario.

The mystical visionary experience of the heaven worlds is often recounted as brilliant boundless light and as similar to the sparkling jewel-like nature of gemstones. Dante recounts:

> Thus round about me flashed a living light,
> And left me swathed around with such a veil
> Of its effulgence, that I nothing saw.[10]

Eventually his eyes adjust to the brightness and he sees rivers of living sparks flanked by flowers of ruby and gold. The

whole panorama unfolds as a cosmically vast "snow white ce-
lestial rose" with angelic beings "having faces of living flame
and wings of gold" swarming like bees in and out of the infi-
nite circular expanse of paradise.

The Revelation of Saint John refers to the Holy City as
"having the glory of God, its radiance like a most rare jewel,"
and all through the *Avatamsaka Sutra* there are references to
jeweled Buddha-fields, infinite translucent multihued vistas of
gemlike structures. They are alive. They are self-illuminating.
A jewel-like fire-fluid is the epidermis of angels.

The psychedelic or entheogenic experience has allowed
many people to access the visionary worlds described by mys-
tics. Havelock Ellis wrote one of the earliest reports of mesca-
line inebriation in the late nineteenth century:

> The visions never resembled familiar objects; they were
> extremely definate, but yet always novel; they were con-
> stantly approaching, and yet constantly eluding, the sem-
> blance of known things. I would see thick, glorious fields
> of jewels, solitary or clustered, sometimes brilliant and
> sparkling, sometimes with a dull rich glow. Then they
> would spring up into flower-like shapes beneath my gaze,
> and then seem to turn into gorgeous butterfly forms or
> endless folds of glistening, iridescent, fibrous wings of
> wonderful insects.[11]

Heinrich Kluver wrote *Mescal and the Mechanism of Halluci-
nations* in 1928. It's an early analysis of mescaline intoxication
and "form constants." One of the form constants, that is,
"constants" of psychedelic vision, was imagery of cobwebs and
grating, lattices, fretwork or filigree, patterns of interconnect-
edness. Kluver also noted spirals and imagery of tunnels, fun-

VAJRA BRUSH

nels, and vessel-like passageways. Other constants of visual change were increase of dimensionality, such as the inclusion of more perceptual dimensions, from two to three to multidimensional forms, and ontological dimensions of meaning. Colors increased in vividness, seeming more radiant and overwhelming. And there were dramatic variations in perception

of size, like the shifts of personal scale in *Alice in Wonderland* or *Gulliver's Travels.*

During the latter part of the twentieth century, technology enabled artists to visualize the visionary realms in new and fantastic detail. The film *2001*, created by Stanley Kubrick in 1969, brought visionary psychedelic consciousness to the big screen. Cyberspace luminous forms created on computer screens, seen in such far-out special-effects films as *Altered States, Brainstorm, Lawnmower Man,* and *Contact,* are some of the closest visual analogs to subtle visionary heaven and hell realms. It's part of the allure and the glamorous aura of these computer worlds. Fractal geometry, visualized in infinite detail on the computer screen, has been adored and absorbed completely by psychedelic culture because it mirrors the beautiful tapestries woven by the loom of the psychedelic mind.

The allure may come partially from the sense of light emanating from each computer-screen pixel. The screen is electronic and glows from within. Each pixel is a scintilla mirroring our own light of consciousness and potentially affecting the subtle energy bodies surrounding our physical body. Because a computer model is a mathematically based form that is protean, infinitely malleable through 3-D modeling and morphing technology, it points to the transformative capacity of form itself. Computer-modeling technology is a visionary tool. One of the purposes of visionary art is to show the transformative nature of reality. We all want to transform something in our lives or in our world. Any natural process or work of art that demonstrates transformation can be a metaphor that empowers one's own capacity to change. People in a jam, in a trap, in a polluted mess, need to know that there is a way out. Morphing cyberspace technoart offers some psycho-

logically loaded and potentially transformative special effects.

Just as the writings of the mystics are trails left by the voice of God, great musicians share what God hears, and mystical visions are trails left by God's eye. Holy places have always been filled with holy music and spiritual and visionary art. From the shamanic human/animal hybrids of cave art to the ornate deity-filled mandalas of Tibetan Buddhist temples, visionary symbols remind us of the divine order behind and amidst mundane or conventional reality. The delights and terrors of the visionary realm are more than amusements and curiosities. If we can access the transcendental realms, our visions and the art flowing from them can become important reminders of our highest nature. The Buddha said that a brief glimpse of the enlightened state is worth many years of scholarly study.

Constant Subjects of Visionary Art

The timeless transcendent mystery outside our framework of mundane consciousness lives in the deep and accessible imaginal realms and comes to life by power of symbol. The angel, a visionary symbol of our higher self, ascends to heaven, so our collective imagination gives it wings and a gentle beauty. The dragon symbolizes earthy vitality and unconscious forces; therefore our imagination gives it scales and snaky or fishlike lower-world qualities. The entire spectrum of visionary art opens a window to the multidimensional imaginal worlds. The following is a list of recurring symbols found in visionary art from many cultures and times.

1. *Transformative beings and realms*
 Animal-human fusions Linked with shamanic powers, these are externalized symbols of internal "beastlike" feel-

ings or connections with the powerful characteristics of certain animals fused with human forms: the regal ferocity of the lion, the sharp-eyed swiftness of the eagle, the sensitive beauty of the deer, the devotion of the dog. The Egyptian gods Horus and Thoth sport bird heads and human bodies. Christian angels have human heads and bird wings. The Hindu deity Ganesha has the head of an elephant and the body of a man. These kinds of divine mutants are found in most shamanic and sacred art throughout the world.

Multiplication and recombination of body parts In order to symbolize expanded powers of awareness, artists have added limbs, heads, and other attributes of the body. Shrinking, enlarging, or isolating body parts are other artistic strategies. The fierce guardians of Tibetan iconography have many arms, legs, and heads. Many heads and a microcosm of the world appear when Krishna reveals his divine form. Odilon Redon isolated a giant eye, placing it in the sky in his drawing *The Eye Like a Strange Balloon Mounts towards Infinity*. Mythic power beings and fantastic creatures such as the Chimera, the dragon, and the sphinx typify the recombining of animal forms. Trolls, fairies, and all sorts of little people are examples of shrunken beings.

Archetypal or mythic beings C. G. Jung denoted many recurring archetypes of the symbolic unconscious—the holy child, the crone or wise woman, the wizard, lovers, the hermaphrodite, death—many of these symbols of states of consciousness emerge in the dream unconscious and have been portrayed in Tarot decks, alchemical engravings, and surrealist paintings.

Animation of the inanimate Faces, eyes, or bodies emerging from rocks, trees, mountains, or inanimate objects propose the possibility of anything and everything coming to life or consciousness. This illustrates the dreamlike nature of the mind's interpretation of reality.

Heaven worlds Celestial architecture and furniture, jewel-like radiant, heavily patterned realms of ornate magnificence, are the vistas found in representations of paradise. Examples include Tibetan thangkas of mandalic palaces, Ernst Fuchs's psychedelic interiors, and Joseph Parker's luminous, unearthly panoramas. A sense of ecstasy and immersion in the good and beautiful characterizes the home of gods, goddesses, angels, luminous helper beings, cherubim, *dakinis*, devas.

Hell worlds Monsters and alien demons are grotesque beings who inhabit the shadowy nightmarish realm, where suffering and fear are projected as a dimension of threat, violence, and death.

Apocalypse and war between heaven and hell Titanic battles between angels and demons, and images of the Last Judgment, portray the emotional oscillations of hope and despair, good and evil, and final conflagration.

2. *Scenes from inspirational stories* The primary subject of most sacred art is the depiction of scenes from various classics of religious literature, yet it is also one of Blake's favorite subjects, stimulating somewhat heretical or idiosyncratic interpretations of those subjects. Redon likewise used religious story or poetry as a starting point for some of his most compelling drawings.

3. *Clairvoyant vision and portraits of the soul* In shamanic art cross-culturally, the visionary seer reveals hidden aspects

of the body. X-ray views, halos, and auras of subtle energy show supernal light, flame, or radiation in proximity to the body. The clairvoyant perceives an integrated dimension where subtle spiritual beings and forms cohabit with fleshly beings, and may also see life stories and influential scenes and people encircling a person as lingering thought forms.

4. *Visionary abstraction* Spiritual states of awareness and visionary aspects of feelings can be portrayed by visionary abstractions. Tantric and Jain artists created simple and complex abstract forms to recount visions of chakras or glimpses from yogic meditation. Sometimes dots, grids, or free-form brush strokes model divine energies and creativity; both Mark Tobey and Gordon Onslow-Ford provide examples of this approach. The early modernist Kandinsky and the surrealist Roberto Sebastian Matta painted colors and shapes as they may have appeared to a psychic able to view astral thought forms.

5. *Visionary inventions* Many inventors have claimed that they received their designs or had breakthroughs in their research as visions. Nikola Tesla was renowned for his powers of imagination and was said to be able to test his designs by building his machines in his head, turning them on, and checking them in a week for wear and tear or other flaws. The German chemist F. A. Kekule had a vision of the hexagonal molecular structure of benzene as looped-together snakes. John Keeley invented beautiful machines to be powered by thought alone. Paul Laffoley elucidated numerous inventions and fantastic architectural plans in his unique paintings. His *Levogyre*, a levitating gyroscope, and *Klein-Bottle House of Time*, a house

built upon the life-energy field of a tree and including a time machine, are examples of his unusual genius.

6. *Divine calligraphy* Luminous sacred letters or words, floating in the air or spread over beings or vistas, are frequently observed in the visionary state. Engraved letters on caves or temples may occur, and sometimes entire scriptures flow from visionary encounters. Revealed sacred text may or may not be interpretable. Shapes, sigils, hieroglyphs, or emblems that seem like type may be coded messages from Spirit.

7. *Infinite patterns of connectedness* Allyson Grey makes paintings of beautiful geometric grids that imply infinite expansiveness, which were inspired by a vision recounted in the first chapter of this book. Other complex interlacing patterns that mirror the boundless latticework seen in mystic reveries are found in the architecture and decoration of temples and mosques. Elaborate swirls of illuminated manuscripts such as the *Book of Kells*, and fractal computer art, are other examples of metaphysical ornamentation. The abstract expressionist Jackson Pollock flung large fields of drips and swirls of paint on his canvases with the intention of "making energy visible."

8. *Cosmograms and mandalas* The structure of reality has been mapped in mandalas using sacred geometry, visions of worlds inside worlds, and charts of the entire cosmos. The scale in these works links macrocosm to microcosm. Alchemical engravings of heaven and earth and the Tibetan wheel of life are examples in this category.

9. *Divine Light* The most transcendent visions leave definable forms and beings behind and engulf the mystic in divine effulgence. From the undifferentiated white light

and clear light of the void, mystics encounter a unity of space, time, awareness, love, and light beyond words and form. This is probably one of the most difficult states to evoke through art, yet examples would be the dark sacred space of the Rothko Chapel and some of James Turrell's light spaces or his Roden Crater project. There are ancient tantric paintings from India, described as paintings of pure consciousness, that have only a white overall surface and simple rainbow borders.

For those who do not trust the dogmas of religious belief, the visionary artist gives a personal glimpse of the spiritual realm, based not on external authority but on the internally experienced revelation. The image of the Universal Mind Lattice (recounted and illustrated in chapter 1) came from a mystical experience that my wife and I shared in 1976. We intuited that everyone was connected in this network and had the potential to experience it. Subsequently, we have been contacted by people who have seen a reproduction of the *Universal Mind Lattice* and have had identical experiences. Once, at a party where some people were looking at my book *Sacred Mirrors*, a startled woman came over to me and said that she had never told anyone what she was about to reveal. When she was a child of ten, she began having spontaneous out-of-body experiences that deeply frightened her. She felt herself dissolving into the energy grid that she saw depicted in my painting. During her absorption into the light, she felt tremendous bliss and spiritual love, but when she returned to normal consciousness, she feared she was going crazy and decided never to tell anyone about it. She said that seeing it painted was a great relief, because it was proof that it was real and she was not crazy. A woman recently wrote to me describing her series of heart at-

tacks, her experience of dying, and her subsequent resuscitation by doctors. Some time after this event, a friend of hers showed her my painting *Universal Mind Lattice*, and she broke into tearful sobs of recognition. When I was in Japan recently, a young man pulled up his shirt and showed me a five-inch elliptical burn scar right over his heart center where he had been struck by lightning. He said that when he died, he had been in the Universal Mind Lattice until he was revived. I feel extremely lucky to have been able to serve these people with my art, and grateful that it evokes for them one of the most profound events of their lives.

Visionary art is beautiful for the truths it reveals and is not just art for art's sake. Transrational luminous forms of the divine imagination portrayed in art can introduce viewers to (or may confirm for them) their own spiritual worlds.

The Light of Idealism

Since the time of Plato, metaphysical idealism has played an important part in describing the mystical origins of art. Plato was a Greek philosopher of the fourth century BC who ran an academy to educate the young men of Athens. His writings feature his teacher, Socrates, as the main protagonist in a series of dialogues on the nature of existence, virtue, justice, and so on. Plato believed that reality consisted primarily of two realms: the realm of appearances and the realm of ideal archetypes. The transcendental ideal realm is the origin of the physical realm of appearances. The definition of the Platonic *idea* is related to the Greek word *idein* meaning "to see." To see, in the ideal sense, is to contemplate the causal spiritual realm beyond physical appearances.

The metaphysical doctrine that artists may obtain visions of

the ultimate reality, the universal ideas of Plato, and bring these insights to their artwork was first expounded in the West by the Neoplatonic philosopher Plotinus of the third century AD. Plotinus was one of the world's great mystics, who felt that the beauty of art can attract the yearning soul to return to the Primal Source of Illumination. The following points this out:

> Not all who percieve . . . art are affected alike by the same object, but if they know it as the outward portrayal of an archetype existing in intuition, their hearts are troubled and shaken and they recapture the memory of that Original.[12]

When people are profoundly moved by art, they recall from the depths their own intuition of spiritual truth.

During the Italian Renaissance, a resurgence of Neoplatonism tempered the cultural atmosphere of Gothic Christianity and influenced the artists of the day. As a teenager, Michelangelo hung out at the Medici Gardens where he absorbed the teachings of Marsilio Ficino, the great translator and interpreter of Plato's works. Ficino's philosophy held that the soul was the center of the universe, midway between the world of appearances and the realm of ideal archetypes. He also believed that the many religions were an expression of the infinite beauty of one true God. This relates his thinking to the perennial philosophy, the idea expounded in the twentieth century that there is a common mystical core to all religions. Ficino further believed that uniting with God through contemplation was the goal of existence. "Among all his contemporaries Michelangelo was the only one who adopted Neoplatonism not in certain aspects but in its entirety, and not as a convincing philosophical system, let alone as fashion of

the day, but as a metaphysical justification of his own self."[13] Michelangelo believed that true artistic inspiration is not derived from the material world, but has value only in reflecting the divine idea.

Idealist philosophers of various times and cultures show broad agreement about the process of mystical inspiration for art. German philosophers Friedrich Schelling and Arthur Schopenhauer believed that ideal archetypes, originating from God and perceivable to the artist through the inspired imagination, are the true subject of great art. William Blake wrote of the ideal visions that appeared to him as "organized and minutely articulated beyond all that the mortal and perishing nature can produce."[14]

Tibetan Buddhist teachings describe a realm filled with infinite deity forms, glowing linguistic symbols, and radiant jewel-like landscapes and architecture. This dimension of richly illuminated archetypes, known as the *sambhogakaya*, is described in Tibetan wisdom master Namkhai Norbu's autobiography, *The Crystal and the Way of Light*:

> The Sambhogakaya, or "Body of Wealth," is the dimension of the essence of the elements that make up the gross material world, a subtle dimension of light appearing in a wealth of forms which can only be perceived through the development of visionary capacity and mental clarity.[15]

Tibetan art, which symbolically describes different levels of awareness, derives its source from this realm. Much Tibetan sacred art is a depiction of the *sambhogakaya* or its interpenetration into the material realm, as human saints are shown surrounded by luminous deity forms.

Although William Blake may not have been familiar with

the term *sambhogakaya*, he was well acquainted with the territory he referred to as the Divine Imagination. The following passage is from Blake's *A Vision of the Last Judgment:*

> This world of Imagination is the world of Eternity; it is the divine bosom into which we shall all go after the death of the Vegetated body. This World of Imagination is Infinite and Eternal, whereas the world of Generation, or Vegetation, is Finite & Temporal. There exist in that Eternal World the Permanent Realities of Every Thing which we see reflected in this Vegetable Glass of Nature.[16]

Blake's comments on the imagination and its "ever existent forms" resemble the relationship of art to the ideal found in the German philosophers Schelling and Schopenhauer. Schelling wrote, "Nothing is a work of art which does not exhibit an infinite, either directly, or at least by reflection."[17] And further, "The archetypal ideas originate only in God. Art is the representation of the archetypes, hence God is the immediate cause and the final possibility of all art; God is the source of all beauty."[18] Schopenhauer further comments that when viewing a work of art,

> The object of aesthetical contemplation is not the individual thing, but the Idea in it which is striving to reveal itself.
> Therefore, if, for example, I contemplate a tree aesthetically, i.e., with artistic eyes, and thus recognise, not it, but its Idea, it becomes at once of no consequence whether it is this tree or its predecessor which flourished a thousand years ago, and whether the observer is this individual or

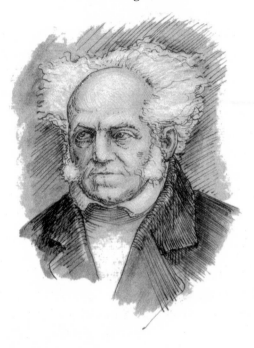

SCHOPENHAUER

any other that lived anywhere and at any time; the partic-
ular thing and the knowing individual are abolished . . .
and there remains nothing but the Idea and the pure sub-
ject of knowing . . . Genuine and immortal works of art
spring only from such direct apprehension.[19]

Schopenhauer was one of the first great philosophers of the
West to read the spiritual classics of Asia and integrate them
into his outlook. He predicted that such an integration of East
and West would bring about a renaissance of art and ideas.

The light of idealism shines through art from Tibetan *than-
gka* painting to the works of Michelangelo, Blake, Delville, and

Ecstasy

contemporary visionaries. These artists have accessed the luminous archetypal realms via contemplation. An artist's divine imagination, their soul, links the infinite presence of God with the finite physical world where the artist brings spirit to form.

What is any thing but spirit taking form? The dynamic evolution of appearances in the cosmos is the product of *lila*, the Hindu name for divine play of the creator. Stars are born, exist over billions of years, and eventually collapse. A fruit fly is born, lives for a few hours and dies. A thought arises during meditation and then disappears. Every existing form is part of the flow of God's boundless creativity. We and everything in the universe are God taking shape, a *theomorph*.

The visionary, archetypal realms of consciousness have dimensions that seem eternal, dimensions that evolve over millennia, and more dynamic creative terrains. Blake and the Neoplatonists describe the ideal archetypal realms as "eternal" with a permanence that sometimes seems static. I think this was based on the revelation that there is a realm beyond time. The ultimate ground of being is beyond all forms and archetypes, beyond birth and death, beyond time and space, beyond mind and the flow of thoughts. The Tibetan teachings of Dzogchen describe this perfect state as the primordial condition of emptiness, clarity, and pure creative potentiality. It is the context underlying reality, voidness pregnant with the potential to manifest all forms. This absolute primordial condition gives birth to the archetypal realm, a rich profusion of luminous forms perceptible to the visionary eye.

Just as we have a physical optical system that takes in the sensations of the light of our physical world, there is a metaphysical optical system growing from the open heart center that reveals the subtle light of the spiritual world. Emergence of this visionary anatomy will unveil the continuity and inter-

THEOLOGUE: THE UNION OF HUMAN AND DIVINE CONSCIOUS-
NESS WEAVING THE FABRIC OF SPACE AND TIME IN WHICH THE
SELF AND ITS SURROUNDINGS ARE EMBEDDED (DETAIL)

penetration, the infinite oneness of the material and spiritual
domains. This subtle tree grows as aspirants proceed along
their path, healing old wounds and transcending their limited
identity. When eyes become fruits of the spirit tree, they are
crystalline spherical mandalas, lenses to infinity—everything is

seen in its sacred dimension and everything that is created is good.

> All nature is but art, unknown to thee;
> All chance, direction, which thou canst not see;
> All discord, harmony not understood;
> All partial evil, universal good;
> And spite of pride, unerring reason's spite,
> One truth is clear, Whatever is, is right.
>
> —ALEXANDER POPE

Mystic art is a window to the transformed view, which reveals all phenomena as inherently sacred. Art is an illusion that can convey the truth. In the same way, the entire world of forms is a magical illusion, an exhibition of transcendental artistry pointing to a greater truth. All sounds and visions arise as artful beauty, a fountain of glory from the transcendent Creator. God's unrepresentable primordial state of clarity, awareness, and bliss underlies all manifest realms and can be recovered, remembered, reseen, here and now. The multidimensional holoverse we find ourselves in is creative spirit's magnum opus, a masterpiece that binds and liberates us. Our profane vision of life promotes anxious craving; the heart retracts in fear and dissatisfaction, remaining opaque to the light of spirit. Our luminous visions point to the sacred in every moment, transforming life itself into the ultimate work of art, and the art made by hand into rays of glory.

MUSIC OF LIBERATION

Chapter 6

Art of Goodwill

I consider human affection, or compassion, to be the universal religion. Whether a believer or a nonbeliever, everyone needs human affection and compassion, because compassion gives us inner strength, hope and mental peace. Thus, it is indispensable for everyone.

—TENZIN GYATSO, THE DALAI LAMA

It is not sufficient merely to be a great master in painting and very wise, but I think that it is necessary for the painter to be very moral in his mode of life, or even, if such were possible, a saint, so that the Holy Spirit may inspire his intellect.

—MICHELANGELO

THE FOLLOWING STORY DEMONSTRATES AN UN-usual transformation from juvenile self-absorption to service for the common good. Born in the flames of the punk era of the early 1980s, the Beastie Boys, a white rap rock

group, rolled out juiced-up hits such as "Fight for Your Right to Party." The popular success of the group did not impair their ability to mature and transform. In the 1990s, the Beastie Boys organized huge rock concerts featuring a spectrum of the world's finest and hottest musicians as a massive benefit for bringing attention to the injustice of the Chinese occupation of Tibet. The annual concerts spotlighted dancing and chanting Tibetan monks who demonstrated the threatened sacred beauty of Tibetan culture. The Beastie's Adam Yauch, who met the Dalai Lama and became a Buddhist practitioner, was the inspiration behind this bodhisattvic action. He skillfully brought the diverse and disorderly powers of rock music together to educate people and raise money for a just and good cause.

Another example of responsible and transformative art is the unusual collaboration between artist Mel Chin and environmental scientist Rufus Cheney. The artist initiated a sculptural earthwork called *Revival Field* that helped clean up a superfund toxic waste site. Cheney's bioremediation technique used special plants to leach heavy metals out of the polluted earth. This gesture toward healing the wounded earth is an inspiring act of creative kindness as well as a beautiful and inventive sculpture.

Steven Spielberg's films *Schindler's List* and *Amistad* focus on exceptional and redemptive acts of justice in the midst of two of humanity's most degrading moral blights, the Holocaust and the American slave trade. These films present the viewer with stories of true heroism and the difficult challenge of acting compassionately in hellish situations in which most people would acquiesce to the demonic.

Each of the art activities I describe above were accomplished

by collaboration and in service of a greater good. When artists work together, acting from their conscience about the problems and suffering in the world, they can bring the fire of creative transformation into the hearts of their audience. Art of goodwill sensitizes its audience with a longing for justice, wisdom, and healing compassion.

Only by their own free choice can artists make a work that serves the world beyond the studio. Conscience must arise from within and become alloyed with creative action. Artists must inquire of themselves, "What will be my work?" There are no standards to conform to. Artists are free to choose what they wish to do. Autonomous and individual, artists cherish their free condition. Liberated from external obligations, artists retreat into themselves. Artists are individualists of uncommon integrity, driven to be themselves and express themselves no matter what the cost. Attaining self-actualization is the goal of most artists; it follows that they should seek to be recognized. The artist-individualist wields a powerful ego and makes original creations, but may have only hints of the powers of soul and spirit. Individualist artists' wills are their own, for good or for ill.

Yet in the making and partaking of art, the boundaries of the autonomous ego dissolve on a regular basis. Musicians become one with their sound, painters become one with their subject. As Schopenhauer said, in the experience of high art the individual will is suspended and our hearts are elevated to a taste of the ideal, even if only momentarily. This makes the art experience akin to the mystical experience. Mystical experience is vision or consciousness of absolute perfection. And once the infinite light of love and perfection has dawned in our hearts, we naturally seek to come into greater contact with it. If we

have experienced the divine source of kindness, empathy, peace, and forgiveness, we will want to be guided by this highest and most noble intuition.

If—in addition to our physical, emotional, and mental nature—we are also spiritual beings, what is the life that spirit calls us to? The soul emerges with its own agenda. The soul calls individual artists beyond their sense of isolation into a life of love and deeper meaning. The soul demands that we experience our own divinity and find a way to express it in service to the wider world. The creative drive must come into alignment with the divine will. "Not my will but Thine." The soul—our greater, higher self—can work with the smaller egoic self through art. Art becomes a bridge to the spiritual in everyday life.

The soul inspires artists with visions, sounds, stories, and actions so that they might share them with their community. Artists of good will create their work as a service to spirit's presence and as an offering of insight, healing, and joy to others. Art is in essence a gift to the artist from spirit. The drive to share one's artwork with others is healthy and necessary. The gift must be given to the world. Sharing one's work completes the cycle of creative endeavor. Spirit is priceless and nonmaterial, yet it can be potently symbolized and accessed through contemplating great art. If artists' creations are purchased or supported financially, the money they receive is a symbol of their ability to bring satisfaction. It is a reward for their efforts that allows them to continue making their own unique contribution and empowers their ability to create their best work. Money exchanged for an art object is an offering to acknowledge the gift, a payment to keep the artist or art system healthy so it can continue to deliver the free, unpossessable,

THE GIFT

unbuyable presence. We seek to have art around us for just this
unpossessable and unknowable quality. If we could understand
and clearly define everything about art it would cease to be art.
One can know art to a degree with the intellect and emotions,
but one returns to contemplate great works because in their
unfathomable mystery is a mirror for the soul.

Spiritual artists want their artwork seen and used in order to
communicate the state embedded in the work, that is, the state
of mystic union with their spiritual source. The bodhisattva

uses skillful means to awaken people and relieve their suffering. Art can be one of these skillful means. Creation from the source is an affirmation of life, good to share. Therefore, using the networks available to share work in the broadest way possible serves the spirit. Some may mistakenly regard this as self-serving egoic hustling for fame and money, but if artists stay rooted in good intentions, their work can be a gift to illumine and awaken a bewildered world. As Jesus said, If you have a lamp you don't hide it under a basket. Art is the lamp of the soul.

Art of Delusion

Materialistic desire for power, fame, and money can obscure an artist's higher calling, like clouds covering the sun. Ambitions to dominate, acquire influential friends, produce and sell more, tend to blind artists to the shining source of their own creativity. Conversely, artists who only stare at the sun and paint in their garret expecting the world to beat a path to their door are equally if not more deluded. The problem, once again, is achieving a balance of inner and outer needs. How do we work it out?

Artists are survivors. Where there is life, there is art. Some art reflects and serves the delusions of life. Three things that constantly get people's attention are sex, violence, and humor. The artist who can weave these subjects together creatively is probably assured an audience. Yet artists can become attached to powerful imagery of violence, sexuality, irony, cynicism, anger, and fear as a way of attracting their viewers. Much pulp or romantic fiction and many action and horror films mirror and foster such dystopian attitudes. Art need not serve only

the confused desires and pathologies of the ego. Art can serve and reflect the condition of the human soul, which includes but transcends pathologies.

As a young man, I was a billboard artist. I painted huge Coke bottles, politicians, silver dollars, ice cream, cigarettes, and bottles of liquor. I've also illustrated for pharmaceutical companies when I didn't trust their strangle-hold on the medical establishment, and I've prepared forensic courtroom art when I feared I was working for the wrong side. I accepted these morally questionable jobs in order to support myself and my family. When I did these jobs I always suffered from feelings that the greater good was not being served. I knew that my finest contributions could be made only through making my own art, but like a lot of artists, I felt stuck.

The messages of most television programs and corporate advertising revolve around the quest for status, money, and power. Advertising is the art of glamorous deception and bad will, par excellence. All too frequently, the myths and stories given us by popular culture, and even high culture, represent or stimulate greed, lust, cynicism, anxiety, and despair. These negative states are addicting and can excite viewers, but in the absence of an ethical context for violence, these emotions can erode the soul and inspire acts of nihilism. The children who watch violence on TV, much of it initiated by "superheroes" who are supposed to be role models, learn that violence is a fine way to resolve confrontations. Children get the profoundly confusing messages that hurting people is okay and is actually painless and that evildoers go unpunished. The implications of glamorizing such unethical behavior are easy to imagine. Yet many artists, enmeshed in today's culture industry, do not feel responsible for, or perhaps even capable of,

"feeding the soul" through their works, which can only be done by serving a cause higher than one's own or the corporate sponsor's ego.

The primary political art of America is commercial advertising that extols the benefits of free-market capitalism. Advertising art is our most frequently encountered art form. From billboards, posters, and magazines to television commercials and icons on the Web, an individual sees hundreds of ads each day. Some of the most brilliant and clever writers, filmmakers, comedians, and artists are able to make a living because corporations hire them to create stunning, beautiful, and entertaining works of commercial advertising. However, ads are an art form with built-in obsolescence by the nature of the relentless desire for novelty, the waves of new products, and changing styles. The seductive appeal of commercial advertising twists our desires for pure and sacred beauty into base and hedonistic cravings. A beautiful mountaintop is used to sell a car. An ad can never be spiritually liberating because its sole purpose is to create desire for material things. Glowing products such as perfume or a pack of cigarettes with an aura of "spiritual light" around them stir the unconscious archetypes and promise salvation by consumption. By cleverly using the masks of radiant or sacred beauty, the art of propaganda and advertising has coopted our visual trust and polluted our mind streams.

Advertising art and mechanical reproduction of art in general have conditioned us in new ways to visual information. In the Middle Ages, people rarely saw art; it was confined to castles and cathedrals. An icon was lovingly labored over for months. Now we have clip art. But no one wants to return to the Middle Ages. Today everyone has access to art-making tools and we experience all forms of art more frequently than

ever before. Yet we contemporary consumers are more suspicious of imagery and want to know the hidden agenda behind any art we view. It is rare that we feel complete trust in the artist, rare that we find an art of goodwill.

Political Art and Propaganda

Political propaganda is similar to advertising because those with money and power tell creative people what to make art about. There is no freedom of intention for the artist. Although the goal of politics should be to improve the conditions of people and society, this is rarely the case. Politics is often the arena of titanic megalomania and disregard for the common good. It is rarely the wise who rule but rather the ones driven to dominate others. Politics is the oftimes bitter interaction of powerful individuals who have their own agendas yet who also have the responsibility for the welfare of many people.

The propaganda of Nazi art and socialist realism promoted "high-minded" goals of cultural reform, but the ideology that spawned the art was fatally flawed—it was in no way spiritually liberating. It pointed only to "liberation" in an earthly materialist dimension and only for a chosen group. In Maoist or Nazi propaganda posters, we see subjects of the regime looking with uplifted faces and pride at the sufficiency of the harvest or the high level of industrial productivity. There are jobs and enough to eat, proving the superiority of their particular regime. These images still exist in the poster collections of various museums of art and are representative of their time. This art is idealistic, so why is it not a prime example of art with a positive mission? What's wrong with an image of a blond-

haired, blue-eyed family smiling and filled with pride? For one thing, state-sanctioned idealism usually lacks artistic innovation and spiritual depth. The "inspirations" of political systems are filled with kitschy sentiments, such as an emphasis on pleasant, sugar-coated feelings or rigid conventional expressions of beauty and heroism.

> The new Reich will call into being an astounding blossoming of German art. For never has art been presented with greater duties and opportunities than in this Reich.
> —ADOLF HITLER

Just as important, the specter of Nazism was auratically transferred to the art and symbolism of the Third Reich. The swastika was an ancient and widespread symbol of unknown origin. As a Tibetan religious symbol it represents ceaseless becoming, otherwise known as life. The adoption of this symbol by the Nazis profaned its original sacred meaning. The swastika has come to stand for unspeakable acts of hatred and genocide. In retrospect, the lies of Nazi, fascist, and communist regimes have become transparent. The stunning lack of freedom, moral courage, and compassion in the propaganda art and symbolism of those ideologies points to a failure of aesthetic nerve.

> Whenever a community or a powerful section of a community, or a government of any kind, attempts to dictate to the artist what he is to do, Art either entirely vanishes, or becomes stereotyped or degenerates into a low and ignoble form of craft.
> —OSCAR WILDE

Seldom does political art have the power to last or be relevant to the wider world beyond the currency of the regime that gave it form, except when the artist is personally moved by some political reality and weaves it into a great work of art. Goya's painting *The Third of May* shows a shadowy militia shooting into a crowd of terrorized unarmed people and his *Disasters of War* etchings detail many disgusting atrocities inflicted by soldiers. Goya wed a stunning graphic sensibility with an acutely sensitive conscience. Many people consider Picasso's *Guernica* his greatest masterpiece. The huge painting was inspired by a historical event, the bombing of a small village in Spain, but like Goya's works it has lasting value because it unites shocking and inventive composition with the universal message of moral outrage against political violence.

One positive example of the interaction of government and art is the Vietnam Veterans Memorial in Washington, D. C. designed by Maya Ying Lin in 1983. This monument in the form of a minimalist earthwork is one of the most visited sites in the United States capital. The viewer must descend into the earth via a long sloping embankment to read the names of thousands of deceased soldiers inscribed in black stone. When the monument was first commissioned, there was an outcry of protest from veterans and politicians who wanted a more conventional figurative monument of heroic soldiers. Frederick Hart's *The Three Servicemen* was commissioned and installed in 1984 at a distance from the "wall of names." In 1993, the Vietnam Women's Memorial by sculptor Glenna Goodacre was added to point out the contribution of female Vietnam veterans. Effectively, the figurative works give the veterans of this unpopular war a human face and the wall of names evokes in the viewer awe and dread at such terrifying loss of life. The government

supported a powerful work of public art and the monument's function was fulfilled, to provide a place where people can grieve and honor their loved ones and remember the horrors of war. These works of art are providing a way of confronting and healing a period of national emotional devastation.

The downsizing and potential elimination of the government-funded National Endowment for the Arts reveals a fear and cynical misunderstanding of the vital role artists can play in society. Art makes a difference in the overall quality of life and vision enjoyed by any nation. Freedom of expression is one of the rights that make America great. The tiny percentage of the national budget that went toward supporting artists and art programs was a mere token, but was at least a supportive gesture. In order to pay homage to the importance of creativity and vision in human life, countries should allocate funds and secure a place in public education for the arts, as long as the artist's freedom is guaranteed. We remember civilizations for their art. Artists will always create, but without encouragement and support from the community, creators can more easily become discouraged and alienated. An attitude of tolerance and respect for diversity should prevail. Artists cannot expect flagrantly disturbing and X-rated art to be publicly funded, but neither should government and society give in to the blunt fist of art censorship that insidiously threatens hard-won freedoms of expression.

Art and Healing

Violence, illness, or accidents can come out of left field and strike us down. Sometimes we see how we have contributed to our own condition; sometimes it's a total mystery. Our health

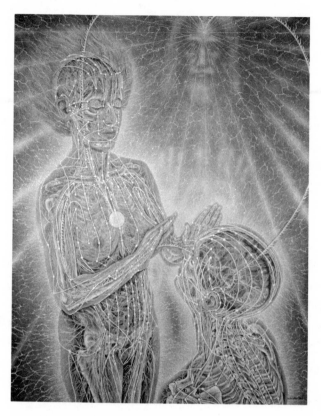

HEALING

often depends on harmonizing the complex demands of mind and body. Stress can trigger illness in people. The inner friction of despair and self-hatred can lower our defenses and allow sickness to take hold in the body. Illness can come as a wake-up call to slow down and examine whether we are on the right track with our life's purpose. Art can serve the alignment of soul and "smaller" self through creative expression and thereby play a role in the healing process.

An image of wellness and wholeness, the "picture of health" that a sick person aspires to, is an important aspect of getting better. Medical studies by Carl and Stephanie Simonton, Jeanne Achterberg and Frank Lawlis, and numerous other physicians and psychologists working in the field of visualization therapy have demonstrated that a patient's positive imagery can accelerate postsurgical mending. To bolster the strength of their white blood cells, cancer patients visualize them in relation to personally meaningful symbols of health such as Jesus, Mary, or a white knight. They might also visualize the cancer as weak and confused. Such intentional guided visualizations have also proven to be an effective mind-body treatment in reducing stress and working through psychological issues and a variety of life problems. Imagery can powerfully affect our nervous and immune systems. The observation and analysis of active imagery from the unconscious—such as dreams or other visions—can be sources of intuitive guidance. The arts are a way to externalize this healing imagery.

In the twentieth century the field of expressive arts has gained widespread use in psychotherapy. Patients have been asked to make art as a means of diagnosing their mental condition, and the healing potential of creativity is well recognized. Artists can make cathartic works to purge the psychic demons of sickness, the fears of mortality, anger, grief, guilt, and inner imagery of victimization. Some artists spend their lives portraying the demonic shadow, the vulnerable and pathological side of the mind. As long as artists remain true to their authentic experience and vision, there is healing value in their creative effort.

Just as important is the creation of imagery of hope and renewal, of the self transformed, radiant with life and already

well and whole. Art is a natural expression of each artist's unique life force. Our most meaningful creative work comes from deep inside and is an affirmation of the energy and flow of life. Art that affirms life seeds the unconscious of both artist and audience with the positive message: "Life is worth preserving and encouraging to achieve its highest potential."

Throughout history, art has played a role in providing a connection to healing spirits and forces. Native American shamans use the medium of sandpainting to create images of sacred healing archetypes on the ground. Healing spirits are called upon to occupy the imagery. The patient is then laid on the sandpainting and prayed over. All of these methods—strong positive healing imagery, prayer, and the trust between healer and patient—are proven to accelerate healing. The role of nonphysical helper beings has yet to be proven, but many healers and artists swear to their presence and effectiveness.

Whether art imagery purges pain and suffering or points to an ideal yet to be realized, almost any imagery can support the flow of healing energy and is of benefit. Artists illuminate their own worldview, an original vision that goes beyond cultural stereotypes. When a viewer enters an artist's work the viewer is enveloped, as if having landed in a strange but familiar dimension, both idiosyncratic and universal. By submitting to what is peculiar to themselves, artists attain originality and, paradoxically, express the uniquely universal. Norwegian painter Edvard Munch's *Scream* could only have come from him, yet in it we find a universal icon for the anxious twentieth century.

The case of Munch is extremely troubling to a simple-minded proposal that the best art should be uplifting or that an artist's mental wellness is his or her source of greatness.

Munch's most powerful art was inspired by his most negative states. His dark paintings *The Sick Child*, *Jealousy*, and the *Scream* exhibit deeply felt raw truth. Munch's gift was his profound anguish. He experienced and expressed transpersonal pain, collective torment. At the age of forty-five he sought help from a sanitorium for his alcoholism and mental distress and was hospitalized for six months. After his release, he felt himself to be a changed and healthier man. His paintings grew brighter, looser, and more conventional, reflecting his "adjusted" mental state. His posthospitalization paintings are universally regarded as weaker and less original than his earlier, "darker" work. Continuing to create from that negative state would perhaps have driven Munch to suicide. By taking his cure, he may have saved his life but diminished his art. There is one work of his posthospitalization period that I consider a true masterpiece. It is an exuberant, beautiful, and nearly iconic painting entitled *The Sun* with expansive rays flooding sky and earth. Munch made his choice to turn toward life and light.

Artists can influence their stream of consciousness by actively seeking images or content in their work that is positive and healing. I am not suggesting that artists delude or repress themselves but simply that they focus some attention on what makes life worth living and preserving. As an artist of eighteen, I felt assaulted by negative visions, perhaps fueled by my steady diet of depressing music and existentialist philosophy. It was 1973 and I had learned by reading art magazines that "painting is dead." America was still entrenched in the Vietnam War and it seemed that a foul political stench hung over Washington, D. C. I was painting billboards for a living and accidentally struck a dog on the freeway. Saddened, I took the dog's body

home in my car trunk. After calling the owners and finding they did not want the dog's body returned to them, I had to decide what to do with it. I found a remote place by a river-bank, placed the dead dog in a plastic bag, and left it there. I decided to come back every day to document photographically the decay of the dog. It was a warm summer, and the smell from the rotting carcass became very strong. This was my first "performance." I titled the action *Secret Dog*. After the dog had bloated and putrified and was no longer recognizable, I placed it in the nearby river.

My interests in the subjects of mortality and polarity grew, resulting in many events that could be classified as performances. I described some of my pieces from the morgue earlier in this book. My art actions bear resemblance to rites in that they mirror stages of my developing psyche. Art performance can include any material in any configuration—ketchup, ply-wood, yams, rocks, videotape, dead dogs—or any subject, from childhood memories to cosmic consciousness. Performance is the most open method by which an artist can make a state-ment. In retrospect, I can see that my performances present definite stages of transformation. The secret dog turned out to be my power animal leading me on a strange journey from a morbid existential view of life, through twenty-five years and fifty performance rites, to a more transpersonal perspective.

My wife, Allyson, our daughter, Zena, and I recently were invited to create a performance event in a hospital in Gaines-ville, Florida. The piece was held on Valentine's Day, 1997, and was called *Mending the Heart Net*. The event was intended to honor the special connection between healing, art, and the spirit of love. At their best, what links art and medicine is that they are both heart-centered offerings of service.

For five years the Shands Arts in Medicine program at the University of Florida has successfully united the creative and healing arts for the benefit of the community. Art has offered a creative way of working through the emotions and catalyzing the healing process of patients, family members, and hospital staff. The hospital's nine-by-sixty-foot *Healing Wall*, made of hundreds of ceramic tiles, is an example of the Shands program in collaboration with the pediatric oncology unit. Each six-inch-square tile was created by a child with cancer and/or his or her family during the child's stay in the hospital. The *Healing Wall* is a memorial of the courage and struggle to create beauty while coming to terms with life-threatening illness.

In front of the *Healing Wall*, my family and I erected a giant cloth heart–world map surrounded by dozens of outstretched fabric arms and hands. In the palm of each hand was a heart with an eye in the center. Emanating from the large heart was a net made of heavy red rope stretched to cover the wall. Visitors were invited to write healing prayers on a bandagelike cloth and tie it to the heart net. Hundreds of people visiting the hospital, patients and those who had heard of the event, joined with us to fill the net with good wishes. It was an elaborate sculptural valentine, an artistic offering and affirmation of the healing power of love.

I mention these two performances, *Secret Dog* and *Mending the Heart Net*, because they represent extremes, a sort of alpha and omega of my personal journey from an obsession with death to works based on nourishing the web of life.

By linking art and healing, we gather up fragments of our psyche and form a new whole. One mended mind and even one work of art from a mended mind can radiate a field of wellness to those around them. There is tremendous power

in the individual to positively or negatively affect the web of relationships. Art becomes a healing force to the degree that the artist can embrace and integrate the pathological shadow aspects of our collective being and still clearly point to the source of transcendent wellness and radiance that is our constant potential.

The revelation and acceptance of our identity emerges by the balance of artistic will between the polarities of light and dark, good and evil, and is the most delicate business of an artist's life. This is where artists integrate useful influences and purge unnecessary baggage, where artists "sell out" or attain self-actualization, where they find transcendent guidance and heal themselves or kill themselves. One may take the romantic position that artists have no choice and are driven to create by fate, by destiny, or by their own daimon. I partially accept this "fatedness" of artists and their vision but maintain that artists can influence or upgrade the connection to their creative source by examining and transforming their own artistic intentions. Everyone knows that they can become better than they are; in many ways art is founded on this principle. The transformative potential inherent in each person allows art to be a path of self-knowledge and self-transcendence.

Bodhichitta

Each wisdom path points to ideals of ethical, even altruistic, behavior and communion with the Absolute. According to the Buddhist teachings, unless one has the proper motivation, one will never advance on the spiritual path or attain enlightenment. A person may do various higher meditational practices, but if he or she does not have *bodhichitta*, the altruistic inten-

tion to practice and gain liberation for the benefit of all beings, the practice will come to naught. Spiritual artists should have compassionate aspirations to benefit others with their art. Art becomes a service to the divine by being an uplifting assistant to a suffering world. By alignment of the artistic will with the divine will it is possible to make art with the intention of a bodhisattva. Buddhist texts describe the bodhisattva as an enlightened being who has chosen to remain in the samsaric world of suffering, the wheel of life, in order to help bring wisdom and happiness to all living creatures. This unreasonable vow distinguishes the mission and extends the intention of the bodhisattva beyond the limits of a single lifetime. If one wishes to work with the bodhisattva intention, then one internally scrutinizes: "Is what I am doing solely for myself and my own benefit, or am I seeking to benefit as many beings as possible while attaining my own needs?" Can this altruistic motivation be applied to art without corrupting the internal freedom and creativity of the artist?

The last thing painter Robert Williams would want to be called is a "nice guy." He is famous for his wild and prolific transgressive cartoon surrealism. Some years ago a group of artists and a publisher recognized that Williams's extreme imagination was an inspiration to many artists outside the mainstream. Their collaboration led to the creation of the 1990's art journal *Juxtapoz*, which serves an energetic community of diverse artists who may not otherwise have any knowledge of each other. The magazine also puts some unusual and underseen art on record for anyone who cares to look, and many folks inside and outside of the art world do. For each issue Williams writes a column giving some insight and unvarnished truth about the difficulties and rewards of being a con-

temporary artist. The quality of Williams's art and character exhibits a humor and generosity of vision that gives more back to the world than it takes.

Albert Schweitzer provides an example of an extraordinary amalgam of priest, artist, scholar, medical doctor, humanitarian, and philosopher of world peace. As a young student at the University of Strasburg, it struck him as incomprehensible that he should be happy in a world full of misery. He awoke one morning with a conviction that he would give something back to the world that had brought him so much happiness. His decision was to devote himself to the study of art and science until he was thirty, and after that to spend the rest of his life in direct service to humanity.

After completing his medical training, Schweitzer and his wife went to Africa and established a medical outpost in the poorest of regions in Gabon. He treated all who found their way to his clinic, regardless of their ability to pay. To many black Africans he was one of the first kind white men they had ever met. Occasionally Schweitzer would return to Europe and America to give organ recitals and raise money for his clinic. Some recordings were made of his Bach organ recitals from the thirties. I count this music as

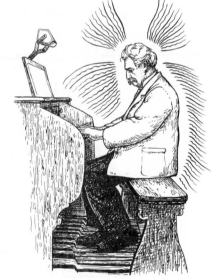

SCHWEITZER
PLAYING BACH

some of the holiest I have ever heard, because of the depth and heart of both composer and performer.

The central and most crucial insight of his life came as he was searching his soul and the philosophical tradition for a universal conception of ethics. In his own words:

> At the very moment when at sunset we were making our way through a herd of hippopotamuses, there flashed upon my mind, unforeseen and unsought: "Reverence for Life." The iron door had yielded: The path in the thicket had become visible. Now I had found my way to the idea in that life-affirmation and ethics are contained side by side! Thus, to me, ethics is nothing else than reverence for life. Reverence for life affords me my fundamental principal of morality, namely that good consists of maintaining, assisting and enhancing life, and that to destroy, to harm or to hinder life is evil . . . Reverence for life dictates the same sort of behavior as the ethical principle of love. But reverence for life contains within itself the rationale of the commandment to love and calls for compassion for all creature life. Reverence for life means being seized by the unfathomable, forward moving will that is inherent in all Being.[1]

Schweitzer wrote many books about religion and became the chief biographer of Johann Sebastian Bach as well as one of the great interpreters of his organ music. He was a supreme musician, philosopher, and healer who lived by his spirit of altruism. He discovered the ethical basis of concern for the common good in his own heart. It is no use demanding that artists find a moral basis for pursuing their work, yet in the

example of Schweitzer we find the encouraging and uplifting reminder that some people will discover it for themselves.

Art as Alchemy

Alchemy was the medieval craft of attempting to create the magically healing philosopher's stone, which could turn lead or any base metal into gold. Many chemical discoveries were made while attempting this "purification" of the base metals. Yet, as the modern science of chemistry was born out of the flask of alchemy, the arcane goals of the craft were dismissed as folly. It was not until 1914, when the Austrian psychologist Herbert Silberer published a study of alchemy as a psychodynamic mirror of the dream unconscious, that alchemy was again regarded seriously. Symbolically, alchemy can be understood as taking a lower materialistic level of consciousness (the base metal) and transmuting it into radiant spiritual consciousness (the gold).

There are many stages to the alchemical process. At the *nigredo* stage everything turns dark and rots. This is a necessary phase in alchemy, because "putrefaction brings regeneration." As a despairing existentialist at age twenty, I saw no meaning in life. Projected into my art were my own emotional wounds, gnawing at me and contaminating me with hopelessness and self-destructive behavior. When these emotions overwhelm an artist, it might be helpful to remember that even the darkness of nihilism may be an essential part of the alchemy of the soul. Although creative energy may be expressing itself destructively, it is inherently positive and can return to its causal, life-affirming nature through the transformative power of art. When an artist expresses fear, pain, anger, or other distressing

negative emotions, the catharsis can enable the artist and the viewer to transform stuck or hidden feelings by moving them outward. Negative art, if it tells the truth, can have a healing function. Making the monster visible acknowledges its presence in our lives and allows the artist to maintain sanity or move on to other emotional terrain.

The birth of spirit in art is a precious alchemical flowering—a redemptive calling. Shut your ears to the naysayers within and without. Open your inner spiritual ears and eyes. Inwardly ask for spiritual assistance in your task. Watch for arrows of vision that pierce your heart. The most tender and difficult artworks are done for God and for everyone else—for your universal self. The art you produce is a test performed for God's sake, as God's way of seeing whether you've understood and appreciated the special messages and visions you've been given. The art you produce is accomplishing your soul's task. Your art can be a step on the ladder of self-actualization and liberation.

The artist's mission is akin to the alchemist's task. The alchemist's great work was the transformation of gross material into spiritualized substance. Holding the goal of a soul-nurturing art in our hearts can sustain us through the trials and failures that are inevitable in the process of creation. Each object labored over can become a healing device, a clear transmitter of spiritual power, because it has been carefully handmade with devotional energies. The healing power channeled through the hands is renowned in Christian and Taoist traditions. Artworks that are labors of heart and soul become batteries of transcendental energy. The receptive, contemplative viewer is "charged" and renewed by these repositories of mystic power. The loading of art with such transformative power is the al-

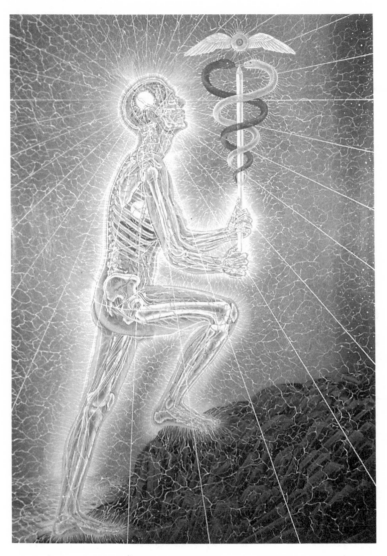

JOURNEY OF THE WOUNDED HEALER
(PANEL THREE)

chemical goal of art, the creation of the magnum opus, the great work.

The Art Covenant

The will to make art is the will to affirm life, to express our unique beauty and truth by devotional labor. This is a simple message anyone can appreciate: artists take delight in and care for their work, and we thereby are inspired to find delight in our own work. If the mission of art involves opening the eye of the heart so spirit can be seen and felt, this goal can only be reached when both artist and viewer observe art as a covenant.

Art that feeds the soul is a visionary covenant among Spirit, artist, and audience. The artist is responsible for outwardly manifesting the inwardly perceived transcendental source. By contemplative absorption in the artist's vision, viewers place themselves in the mind of the artist at the moment of inspiration. Viewers receive the same transmission and enter the covenant relationship. A viewer does not worship a two-dimensional image but the spiritual source the image mirrors.

When we trust that an artwork is sacred, it is a spiritual practice to open up and lose oneself in contemplation of it, immersing ourselves in an understanding that motivates us to become better people. The essence of all spiritual paths is to develop wisdom and kindness. In order that art may become a spiritual path, may it be an art of goodwill.

Omega 1997 Alex Grey

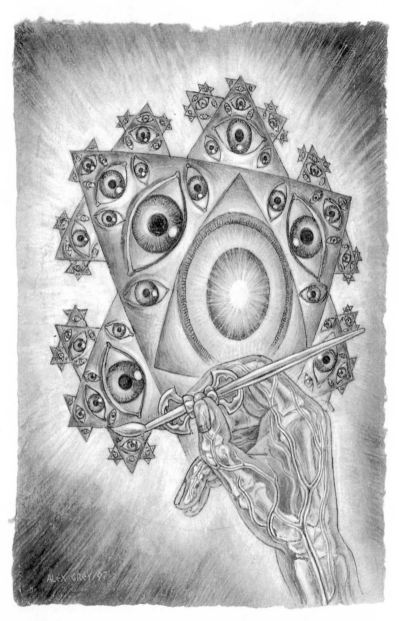

Vision Taking Form

Chapter 7

Art as Spiritual Practice

The artist enriches the soul of humanity. The artist delights people with a thousand unsuspected shades of feeling. The artist reveals spiritual riches until then unknown, and gives people new reasons for loving life, new inner lights to guide them.

—RODIN

"IT ALL COMES DOWN TO INTENTION," SAID Allyson, as she looked up from her painting. "Intention directs an artist's aim and mission. It makes the difference between whether artists recognize their own spiritual nature and whether they bring that spirit into their work."

I countered, "But you can't aim your paintbrush in a 'spiritual' direction unless you realize that a spiritual direction exists."

She admitted, "That's true, but you have to intend to realize that it exists . . ."

I added, "Some artists who accept the reality of spirit don't think intention much matters. They say that all art is equally spiritual, that no art is more spiritual than any other art, just like no person is any more spiritual than any other person or dog for that matter. The Zen master said that even the dog has Buddha-nature."

She had me now: "I can't believe we have to go through this again. There's a big difference between a dog and the Buddha, right? Both have Buddha-nature; the difference is that the dog doesn't realize it. Just like most of us don't realize we have an inner spiritual quality—or even if we do recognize it we're too lazy—so we don't intend to become enlightened or to practice in order to become a wise compassionate Buddha. A Buddha aims for and manifests a quality inherent but unrealized in everybody. With a work of sacred art, the artist aims for and manifests a spiritual quality inherent but unrealized in every kind of art."

I tried to sum up: "So artists need to recognize their own spiritual nature, find a way of manifesting it in their work, and then bring it out into the world so it can do some good. And that's all because of intention?"

Allyson went on, "Yeah, but it can't be boring or insipid. And really, intention is not enough; we sometimes hear artists explain the visionary experience they had that inspired their work, but their work just doesn't convey it, it doesn't move you. You don't feel the power of their experience. An artist has to find a way to adequately or amazingly convey spirit into their work. It has to be creative and filled with the real, scary fire of infinite love and beauty. But we're not saying that you

have to be a Buddha in order to paint something spiritual, are we?"

I concurred, "Obviously not. There haven't been very many painting Buddhas, but there has been some great spiritual art. The creativity of artists is nothing other than universal creativity manifesting through us on a microlevel. The trick for most artists is to get themselves out of the way and let the spirit do its work."

Art can be a spiritual practice. Not all artists consider this to be true, but with the proper motivation and focus, it can be so. A spiritual practice is an activity that enables you to develop the qualities of mental clarity, mindfulness of the moment, wisdom, compassion, and access to revelations of higher mystic states of awareness. A contemplative method, such as yoga or meditation, will stabilize and assist in the progress of spiritual awareness. An artist's craft can become a contemplative method and his or her creations can provide outward signs of an inner spiritual journey.

The technical skills of art making, such as drawing, painting, sculpting, rely on developing powers of focused concentration directed outward, making the hand respond to the mind. The perfection of artistic technique usually takes years of practice. The distinction between works of hollow skill and works of holy spirit are notable. The work of hollow art is a shell, a copy, a dead surface made more or less well. It is usually a work done to sell or as an egoic display of the artist. Hollow art is lacking the dimension of authentic spiritual engagement. During an artist's creative work period, many thoughts and states of mind are experienced, from the most base and distracted, including frenzied sexual and emotional outbursts, intellectual scheming and maze running, to obsessional con-

centration, and finally flaccid moments of tired inattention. If art is a spiritual discipline, then the attitude and approach to the creation of the work is central. The artist cultivates an attitude of prayerful devotion and union with the subject. In order to make holy art, artists let creative spiritual fire work through them. The technique of art needs to become meditation, a way of concentratedly "staying in the moment," allowing the hum and buzz of distracting thoughts to just arise and dissolve, bringing the concentration ever back to the mystery of art as spirit taking form.

Artists use their imaginations in unstructured and personal ways. Artists may rely on their dreams or some other promptings of the unconscious as the source of their ideas for work. Tantric meditations, which are more structured imaginal disciplines, are based on purified visionary encounters of wisdom masters and lead the practitioner to clarity and sensitivity of awareness, purification of karmic obscurations, and breakthroughs to boundless spirit.

With the correct method and motivation, artists can develop purified spiritual visionary capacities. Usually a good session in the studio includes both inspired moments and physical labor. During an artist's creative flow of concentration, he or she can be in a state of unity and integration with the subject and may also have breakthroughs of insight. Art is a physical trail left by the state of being that the artist attained and is driven to preserve. When art is a spiritual path, art objects become the reliquaries of insight.

There are some cultures in which the bond between art and spirituality is essential and unquestioned. Shamanic cultures such as those of the Inuit, the Native American, the Huichol; the Congo and Zulu cultures, the cultures of the Australian

Aborigines and islanders of the South Pacific, all produce art-work that portrays the interaction of the human and spirit worlds. The shaman journeys to imaginal visionary realms, the lower, middle, and upper worlds, via methods such as drum-ming or sacramental drug use, and there makes contact with palliative or antagonistic spiritual forces. In trance the shaman receives assistance from strange luminous helper beings and makes deals with or purges afflicting shadow demons. Usually the journey is undertaken for the sake of healing an individual or some aspect of the community. Signs and visions tell the shaman what to do. The shaman is the culture's most psychi-cally sensitive person. Shamans are also the performers of ritu-als that bind the community to-gether. Art can become a record of and a way of sharing the heal-ing story or a way to honor a mythic cosmology and the spiri-tual forces with which the sha-man works.

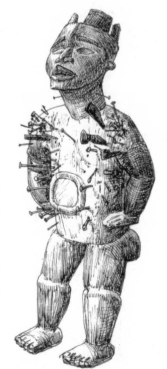

Frequently in these communi-ties, the artist and the shaman are one and the same person. Masks, headgear, and specialized ritual dress are used to enhance the shaman's power in trance or they are used for com-municating visions. Feathered headdresses or crowns, special garments, body painting or tat-

KONGO POWER FIGURE

too, and scarification announce to others the specialness of the shaman and prepare and protect the body during possession states. Shamans secure relationships to and become familiar with spirits that will work with them and through them. Many times shamanic artists have developed their imaginal powers by long and arduous apprenticeships that have brought them to the brink of insanity and back. Breakdown of the identity of the novice or initiate shaman can occur through vivid visions of dismemberment by animal and spirit forces. The shattered personality is eventually reassembled into the wounded and transformed healer. Wisdom and healing songs are transmitted to the wounded healer during the shamanic journey. The shaman's journey is a healing mission for the sake of the physical, mental, and spiritual welfare of their community.

The art of the shaman is not made for mere visual entertainment but has sacred and oftentimes ritual purposes. The totem, talisman, and fetish are imbued with magic power and are made for particular reasons to serve people or to appease and work with beings encountered in the visionary worlds.

In industrialized civilization, art has become a tool of commerce and fashion, draining much of its sacred functionality. Most mainstream art in galleries and museums today has neglected or camouflaged its role as a spiritual tool. Art-school graduates create cunning strategies that build upon and extend the latest art theory or contemporary style. Contemporary art has, at times, become a self-referential and intellectual game. In contrast, "outsider, insane, naive, folk, primitive, self-taught artists" do not pay attention to the contemporary art-critical agenda. These artists make art because God told them to, or because they are simply possessed or obsessed with their own vision. The intensely personal, sometimes crude energy that

goes into these works brings an aura of raw authenticity that is lacking in much contemporary art. Although the outsider art market can be just as prone to greed and exploitation of artists as the straight contemporary art market, the artist's purity of intent and compelling results should encourage all artists to embrace their own spiritual guides.

Two Approaches to Spiritual Art

There are two broad categories of spiritually transformative art. Each can function as an effective support for contemplation of spirit. The first type is based on a visionary glimpse into a higher mystic dimension, which the artist brings into form over a period of time. During the execution of the work of art, the artist's mind may wander, not maintaining meditational equipoise, yet in the end the work still points to the inspiring sacred reality. The second type of spiritually transformative art is rarer and more difficult. This approach engages artists in a more meditative discipline as they work and may result in greater spiritual progress for the practitioner.

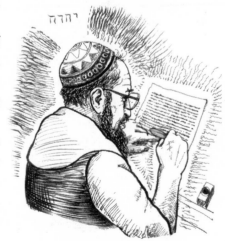

An example of this type of meditative art technique would be the practice of sacred calligraphy. Calligraphy demands that the artist-scribe maintain attentive, focused clarity as he or she works. The Torah scribe, or *sofer*, using a carefully cut goose

TORAH SCRIBE

212 THE MISSION OF ART

feather or reed pen, writes the sacred words in permanent ink on a valuable piece of parchment, prepared from the skin of a kosher animal. The proper intention and concentration, known as *kavanot*, must be in accordance with the laws that govern the writing of the holy words. Each word must be intoned before its inscription, and before one of the names of God is written, the *sofer* brings to full awareness the holiness of the name and writes with that knowledge. When the scribe is distracted, becomes drowsy, or is too agitated, he must stop his work and refocus; some even take a ritual bath of purification. There are rules about what errors are correctable and what errors constitute an irreparable flaw. When the artist-scribe wavers in his concentration and letters wobble or he makes a serious mistake, like misspelling the name YHWH, the parchment becomes nonkosher and is unfit for use. Thus the Torah becomes not only a scroll containing the holy words of God and the story of the Jewish people but also a sacred object made from pure meditative awareness.

Taoist and Zen Buddhist artists unite with their subject through meditation. "To paint the flower, one must become the flower." The artist recognizes the vast ground of truth underlying the flux of everyday life. Taoist and Zen arts are descriptive of these perfectly clear moments when the vastness percieves and expresses the vastness. As Lao-tzu said:

> To understand the all-changing-changeless is to be
> enlightened.
> Not to know that, but to act blindly, leads to disaster.
> The all-changing-changeless is all-embracing.
> To embrace all is to be selfless,
> To be selfless is to be all-pervading,
> To be all-pervading is to be transcendent.

Nature Study

The artist does not merely copy the surface of things. This is regarded as art of the lowest order. The artist does not merely master the techniques of brushwork and composition that allow full self-expression. The highest class of artist spiritually unites with universal energy, and the resulting art becomes a divine outpouring.

To take another example, the Russian Orthodox Christian tradition of icon painting loads each step of the preparation and inscribing of the icon with holy symbolic importance. First of all, a period of fasting and prayerful meditation on the subject of the icon brings the icon maker into personal contact

with the divine presence to be portrayed. Every material used in the process is prepared by hand with materials as natural as possible, materials that once had God-given life, no plastics made in a laboratory. Each material used has its own divine symbolic resonance. A thick wood panel is cut and sanded and painted with successive coats of gesso, a mixture of chalk and animal-hide glue and pure water. These materials literally and symbolically bring together the kingdoms of mineral (chalk), vegetable (wood), and animal (hide glue) on the "ground" or foundation for the icon. The layers of gesso must be repeatedly sanded smooth, a symbolic labor of purification of the self, or preparation of one's own unconscious ground for the arrival of the divine. The preparation of the gessoed panel can take up to twenty hours and must not be hurried. Any anxious fear, desire, or prideful hope will translate into the icon and must be avoided. The proper attitude of engagement is just to breathe, pray a mantric prayer such as the Jesus prayer, "Jesus have mercy on me," and be fully present. To apply gold leaf to the panel, one must first apply red earth, known as bole, and then finely sand and polish it. The imperfections in smoothing and polishing the red earth will be seen in high relief once the gold is applied, as spirit reveals our imperfections. In order to conjoin the gold (symbolically, the Spirit) to the red earth (symbolically, the material body) the icon maker must breathe on the red earth, warming and slightly moistening the bole and making it briefly ready to receive the gold. This procedure is a microcosm of the Creator's sanctifying breath of life, that force that subtly joins the spirit and body. Each step in the icon-making process, from the prayerful beginning to the blessing of the finished icon by a priest, is loaded with symbolic importance. The correspondence of icon making with

the psychospiritual process of the icon maker transforms a strict craft into a significant spiritual practice.

The sacred art traditions have incorporated prayer and meditative techniques to assist artists in making their creative work function as a spiritual practice. We have briefly examined some of these approaches. The Christian theologian Matthew Fox once said that the world's religious traditions are like a house on fire: we must run into each room and save whatever is most precious and essential, and leave the rest behind. Can we derive any instructive general advice from the approaches of traditional sacred art that would be relevant to the contemporary postdenominational sacred artist?

Toward Art as Spiritual Practice

In the past, sacred art traditions and even the modernists recommended that only certain kinds of imagery and styles could be used to make spiritual art. Today, as contemporary artists, our mediums and methods must be free to manifest in any way the spirit inspires us. However, there are many lessons to learn from the methods of the past. As artists work there will always be revelations as to how to deepen their own approach. The following are some steps toward a spiritual art.

PRELIMINARIES

Remembrance Remember we have only a limited time to live and do our art, so we should quit stalling and get on with our creative spiritual work. Remember the source of your inspiration.

Forgiveness Forgive yourself and others for coming be-

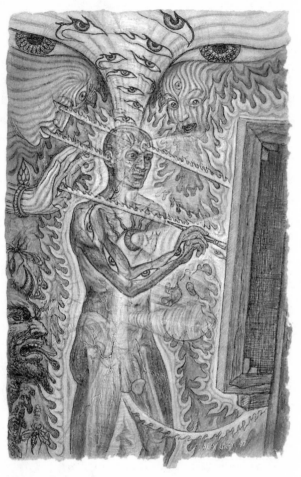

ARTIST AT WORK II

tween you and your creativity. Don't pollute your flow of creative energy with hatred and resentment.

Intention Intention is like a starter for the engine of creativity. Pledge to do your best work for the highest good, to practice your art as a way of spiritually awakening yourself and others. This can help purify or restructure your baser motives,

such as how famous you might become or how much money you could get for a work.

Consecration Offer yourself and your art tools to divine influence. Pray at the onset of your creative project. Pray prayers of wonder and appreciation. Pray for purification and release from negativities. Pray for inspiration, stabilization of the mind and body, and submission to the divine will. Ask for the blessings of spirit on your methods and materials.

Revelation Access the highest grounds of the divine imagination by whatever means necessary. Bring fresh insights and visionary imagery back to share.

Repentance The change of heart and mind that accompanies revelations must now be woven into your life by bringing them to form. Art becomes a vessel of this change of heart and functions as repentance, a way of getting right with the spirit.

PRACTICE

Creation as meditation Enter a state of clarity and connection with your artistic subject. If necessary, use a mantra, a shout, a sacred song, or breathing practice to disengage from conceptual thought. A free flow of art energy is not the prolongation of one single calm state but the recognition and integration of the freshness in the present moment. Disappear into the eternal now.

Possession Allow yourself to be possessed by your creative daimon, whether as a guiding angel or bodhisattva, or a healing or energetic force. Link up with the beam of creative light that Spirit has prepared for you. Use an affirmation like, "I am one with the Divine Ground of Universal Creativity." Visualize yourself joined with and transmitting the highest forces of love and wisdom while you are working.

Appreciation As a swimmer comes up for breath after many strokes, step back and appreciate the symbolic significance of your process and subject. Remember you are a creator creating, a microcosm of the great Creator, and get back to work.

Reflection At the end of a work period, see what you have done with your physical, emotional, mental, intuitive, and spiritual eyes. Listen deeply to your heart's truth and directives. Correct yourself and develop faith in the wisdom of your personal creative process.

INTEGRATION

Share your work. You have been given a creative gift; the success of your mission depends on sharing it. Listen inwardly and when you are ready, show the work to friends and relatives and artist associates. Find your artistic family and support, network with, and honor them. Have the courage to bring your work to the appropriate places for public display. It is your responsibility to find the ways your visions can positively influence individuals and your culture. If it is appropriate, offer your work for sale, and let it go.

The mere process of fixing imagery onto surfaces or forms does not ensure spiritual development. It is the intention and awareness from which artists create that determine whether their work will serve mammon, ego, or spirit.

Transformative Art

As previously discussed, there are developmental stages to the spectrum of consciousness, and art can come from any of these stages. As a person matures, consciousness unfolds in a sequence, from lower to higher, from the primal survival feelings

to the concepts of the ego self and on to the sociocentric or possibly worldcentric self. But these are not the stages from which transformative spiritual art is created. The higher spiritual stages of consciousness are revealed through the pure intentions of the seeker, through diligent practice and divine grace. A spiritual art transforms the artist and the viewer. In order for art to be transformative, its primary job is to undo the ego.

Just as the process of birth involves great pain and joy, artists have labor pains in extracting works from their inspirations. Birth involves the death of some limited conception of self. The spiritual artist dies to his or her egoic limitations and reaches beyond, to a higher level of consciousness and being. The great artists are seers who sense and transmit in their works that "something greater" toward which souls are compelled to move.

Artists face many limitations that threaten the accomplishment of their mission of art. Each person is a particular personality from a particular family, with emotional problems and intellectual blind spots. Then there are the limits of how long an artist can work every day. And when you finally arrive at the studio, with paper, canvas, or clay in front of you, you face the limitations between what your mind envisions and what your hands can accomplish. Ultimately, each of us faces the physical limitations of illness and death.

The suffering and struggle that our limitations impose can help us become more compassionate to others and bring that feeling into our art. The soul furnace that fires the clay of our creative efforts is heated with the alternating currents of joy and anguish. Michelangelo's sculpture *The Captive* has his huge arms bound behind him. He seems twisted in agony that

his face bears with noble resignation or emotional restraint. His eyes are lifted upward as though glancing at heaven or rather, as he is made of stone, as though taking a prolonged look heavenward. The straps that bind him seem flimsy, almost nonexistent; surely these are mental fetters. We are all bound by certain constraints—some of them moral, some intellectual, some emotional, some physical—but even with all our restraints we can still turn to God. We can endure our bondage with dignity while focused heavenward. This is not an individual portrait, but an excavation of the human soul.

Michelangelo's *Captive* simultaneously expresses the soul's torment and idealism, in a sculptural universal human.

We can wander through life bewildered by our limitations and buffeted by events, or we can approach life as a path to spiritual liberation. To hear Spirit's counsel we associate with realized teachers. We turn our eyes heavenward. During the Buddha's first sermon, in Deer Park, he spoke of the Four Noble Truths. Buddha's first noble truth, "Life is suffering," recognizes the struggle with the limits of our life, the way our minds are characterized by per-

MICHELANGELO'S CAPTIVE

petual unsatisfactoriness, the suffering of old age, sickness, and death. Buddha saw the wheel of life, the endless round of birth and death, as the wheel of delusion and suffering called samsara. The second noble truth is that suffering is caused by desire and attachment. If we didn't have so many expectations and desire so many things from our life, we would not be so disappointed and afflicted. The third noble truth points to nirvana as the end to the samsaric wheel of suffering caused by desire. The fourth noble truth outlines the way beyond suffering, to nirvana, enlightenment, through cultivation of a series of "right" approaches called the Noble Eightfold Path.

Right view (perfect knowledge) accepts the first three truths and establishes the spiritual perspective of total interconnectedness of all beings and things. *Right aspiration* means that the intention to become enlightened, and to thereby serve the world, passionately directs one's life. *Right speech* suggests that we hold our tongue if our words are boastful or spread ill-will or are not truthful and charitable. *Right conduct* is similar to some of the Ten Commandments: Do not kill, Do not steal, Do not lie, Do not engage in sexual misconduct, and Do not drink alcohol. *Right livelihood* recommends occupations that promote life, and the avoidance of professions that corrupt and bring harm to life. *Right effort* means a strong and steady spiritually inclined will. Buddha used the metaphor of a heavily laden ox marching through a muddy mire: "The ox is tired, but his gaze and movement toward the shore will never rest until he comes out of the mire." *Right mindfulness* encourages the right meditation each day, directed at realizing the essence of Buddhahood, along with the vigilant watchfulness and avoidance of our habitual hindering tendencies. *Right integration*, also called right absorption or collectedness, refers to the

totally relaxed mind, without stain of ignorance, craving, or hatred, absorbed into the emptiness that is the transcendental basis of all realms. Part of the effectiveness of our art as a spiritual practice is determined by the extent to which these right ways can be enacted in our art and life. Artistically, this means finding one's spiritual center and dwelling in alignment with the divine will creating through you. When creation is transformative, artists become better people through their artistic labors of love and spread positive fields of influence into their culture.

However, isn't the proof of a spiritual practice in the level of realization of the practitioners? Let's look at the accomplishment of the artists. Can we point to any great artists who were wise, compassionate, enlightened beings? Are there any artists who have exhibited the qualities of great mystics, saints or sages? Some of the greatest artists are known

Doi Butsu.
Great Buddha Nara Japan

DAIBUTSU

for precisely the opposite characteristics. Many have been selfish and megalomaniacal, using and abusing whoever gets in their way.

One may argue about the validity of ranking or classifying spiritual attainments, but there is no other way to find out how art measures up as a spiritual path. In the Taoist and Zen traditions we find examples of enlightened monks who were also

great artists. The earliest example of the famous Zen *enso* or circle brush painting was by Yoso Soi, an abbot of a Rinzai temple, in 1455. To make such a simple gesture was an act of sudden recognition that parallels the description of the Zen method by the first Zen patriarch, Bodhidharma:

> A special transmission outside the scriptures,
> No dependence on words or letters,
> Direct pointing to the mind,
> Seeing into one's nature, and attaining Buddhahood.

Next to the brush-drawn circle is an inscription that reads "Perfectly obvious." Yoso Soi's summary insight could not be more elegant. The technique of Chinese and Japanese ink painting required a meditative depth of union with the subject that is rarely found in Western art. Some of the drawings of Rembrandt display the same essential brushwork as Zen ink paintings, which attests to Rembrandt's profound capacity to unite with his subject and his perfection of technique. His paintings and etchings exhibit the impossible quality of living presence. The central figure of Christ in Rembrandt's so-called *Hundred Guilder Print* dissolves into perfectly delicate holy luminosity. If Rembrandt's alcoholism and strange business practices keep us from calling him enlightened, we can rest assured his hand was cradled by angels. In earlier Western art, Hildegard of Bingen, the twelfth-century abbess, was a case of an advanced mystic and visionary artist. Her visions and musical compositions were gifts of the spirit. Fra Angelico was a fifteenth-century monk who created frescoes and icons for his brother monks that display a high devotional intensity. To me, Michelangelo is the most fully realized artist, be-

cause of his profound accomplishments in drawing, painting, sculpture, and architecture. Accounts of Michelangelo's character reveal him to be brusque and intolerant, and he seems never to have resolved his profound melancholia. His contemporaries used the Italian word *terribilità*, which means "a terrifying, awesome power," to describe the effect of Michelangelo's work. Terror and awe are central characteristics of the mystical experience. Michelangelo's anguished struggle between body and soul may have been his strongest source of creative inspiration. Is this liberation and true enlightenment? No, but it gave him a compassionate sense of human tragedy that suffused each of his contorted works and made the struggle between flesh and transcendence palpable. He was a Catholic Neoplatonist, after all, blending the suffering of Gothic Christian imagery with the newly excavated idealist naturalism of Greek art.

The art saints Blake and van Gogh probably did not achieve a stabilized *samadhi* enlightenment, but their works display high levels of mystic reverie. Van Gogh trained as a minister before he threw himself into his art. He was relieved of his ministry caring for coal miners, because he was too zealous in his compassion. He did whatever he could to heal the sick and care for the poor by giving away his food and his clothing and taking in those whom the hospital turned away. He became so disheveled that the church refused to support his efforts. Though obviously troubled, van Gogh had a heart that places him among the holy.

Who was enlightened? Immediately we think of Buddha and Christ. These enlightened teachers never produced objects. They never wrote, composed, painted, or sculpted; they left that task for their disciples. Awakening the spirit was their art

form. What does enlightenment look like? The examples of saints and sages show that the highest wisdom and compassion manifest continuously. They know they are never apart from their spiritual essence. The consciousness of saints and sages is not turned outward, nor exclusively inward; it mysteriously hovers in grateful joy and infinite inclusiveness of all outer and inner dimensions, in the fresh aliveness of every moment. Their words and actions point to ultimate truth, beauty, and mercy. In the East there is a long tradition of enlightened Indian Vedic masters. They are the sages and gurus, such as Shankara and Patañjali, who transmitted the meditative methods of the various yogas. Garab Dorje and other Buddhist masters perfected nondual contemplation and passed down their teachings and methods through secret tantras and a lineage of realized sages. In the West, Plotinus, Meister Eckhart, Jakob Böhme, and others achieved higher states of realization and have left written accounts of their insights. They entered union with absolute truth, beyond relative perceptible forms. Their enlightened statements parallel those of the Eastern sages. Saint Teresa's mystic visions were clothed in the perceptible forms of luminous angels or Jesus and Mary. By the standards of these great mystics, you would have to place Blake and van Gogh at a high but intermediate level. Yet, such spiritual artists prove that art can be a spiritual practice. Who wouldn't want the level of vision and devotion of Blake or van Gogh? It doesn't mean that art can't be a powerful positive practice even if it hasn't produced artist specimens who are totally enlightened. Though the artists themselves were not enlightened beings, their visions and works point to profound states of realization, bringing happiness and insight to many people. Holy intensity is a quality of character that must be

brought to the practice of art. Such character can obviously be catalyzed or utilized in the art-making process, but it does not originate there.

Conventional art is an expression of the self or world as it is now. Kandinsky referred to such art as a child of its time. Transcendental art expresses something that you are not yet but that you can become. Kandinsky called this art the mother of the future. That's why you feel better after producing or viewing it. Transformative art expresses something beyond where you are. It demands that you recognize your higher nature and alter your life accordingly.

Spiritual art is driven by spiritual insight. All levels and depths of spiritual insight can find corollary expressions in art. The art is a carrier, a medium, a messenger of spiritual truth. In order for art to be sacred, it must refer to a sacred teaching or issue from a passionately realized spiritual truth. Art records the insight, but it is an object, created by mind and body. The seer, the witnessing awareness of all revelatory visions, is always primary. Uncreated presence is the source of all creation. The artist is a microcosm of universal creativity. Sacred artists need penetrating insight into their own true nature and devotional intensity in order to make art a spiritual practice.

As Emerson said, it all begins when the soul would have its way with us. Certain artists become channels of the zeitgeist, the spirit of the times. When this kind of force grabs an artist, he or she is possessed. Picasso, Pollock, and Warhol each transformed art in the twentieth century. Does this mean that their work is spiritually transformative? Not necessarily, but it does mean that their works express important insights into the state of the human soul. The onset of social psychopathology and/or transformative growth is foretold in their works.

Some artists encapsulate the spirit of the times in their work. Keith Haring was a recent example. His tribal graphic style synthesized the pictorial insights of modernism and brought together imagery from many parts of the world, yet it was deeply personal. In his brief life, Haring traveled the planet, making murals with children and people from various communities, which showed a spirit of collaboration and demonstrated an emerging awareness of global culture.

Scientific Icons

To my mind, it has been the astronaut "artists" of the 1960s who have yielded some of the twentieth century's most enduring icons. The NASA photographs of Earth, a blue-and-green, cloud-enswirled mandala, eloquently presents a sense of the unity and fragility of our collective home. A curious blend of pride and awe-filled appreciation arises when viewing these global portraits. There are no national boundaries visible from outer space, erasing our devisive planetary mapping just long enough for us to sense our perfect oneness. Humanity can now see our uniquely "living" planet within a system of other planets orbiting our sun. It is to be hoped that our earth icons can assist in awakening humanity to the harm we've done to our fragile web of life and will prompt ecological actions and inspire efforts of global cooperation.

Astrophysical observatories into the cosmos have given new scale to the imagination. We begin to grasp the place of the sun within the swirling billion-starred arms of the Milky Way, as we realize our galaxy is only one among billions. Outer-space telescopes beam back imagery of unfathomably huge galactic clusters from remote expanses of the universe and have

expanded our understanding of the terrifying vastness and strange beauty of the universe.

Science and technology have stretched human vision to the farthest expanses of space by the powers of the telescope and have allowed us to peer into previously unknown infinitesimal worlds by the powers of electron microscopy. Photography of cells, molecules, and atoms reveals pattern upon pattern of refined interwoven worlds and has given artists new vistas of the minuscule. Imaginal travel, from the farthest realms of outer space to the tiniest subatomic realms, can only leave one in a state of eye-bugging awe at the magnitude of our universe and our minds.

Super computers have given artists new tools to create vivid and realistic imaginal worlds. With 3-D modeling and texture mapping of surfaces at such a high level of sophistication, computer artists can seamlessly interject their fantastic worlds into films or photographic scenes of everyday reality. Hollywood and Madison Avenue have been quick to exploit such innovations, but these tools are also available for generating a new kind of sacred art. Fractal geometry, which is a tool for understanding the dynamic structure of chaos, has given artists a mathematics of clouds, flowing water, and trees, generating infinitely dense visionary images of spirally branching patterns. Benoit Mandlebrot may be remembered as one of this century's greatest visionary artists, for he was the premier mathematician who wrote the equations that generated the famous "Mandlebrot set," which led to a renaissance of computer-generated fractal psychedelia. The international Rave (all-night dance/party) scene uses the mind-bending potential of computer graphics and animation for light shows and banner art to enhance the psychedelic state that many trance-

dancing participants undergo. The worldwide technotribalism of Rave events is one of the most positive and innovative art scenes currently active.

As industrial technology spreads throughout the world, dialogues between nations increase, and the shared responsibilities of planetary preservation become more pressing. Industrial pollution respects no national boundaries. Everyone is "downstream." The radioactivity released over Europe during the Chernobyl disaster, the clouds of black smoke from the burning oil fields of Kuwait, the massive lead and CO_2 released from gasoline combustion engines, the dying of forests, the toxic waste dumps leaching into the earth and water throughout the world, the wearing away of the ozone layer, are just a few of the major problems that demand cooperation among nations. By continuing our irresponsible actions we jeopardize the destiny of life on earth. Humanity is reaching adulthood and needs planetary consciousness and planetary conscience to begin the cleanup and create a sustainable global community—or we will all die choking on our own filth. The new world spirituality will encourage personal responsibility for evolving consciousness, show reverence for nature, honor and celebrate diversity of cultures, and foster a vision of cooperation and interdependence.

Art of World Spirit

The artist wields a powerful instrument for personal expression, planetary healing, and spiritual awakening. New art forms emerge through technical innovations and when cultures collide. Today the simultaneous impact of so many technological innovations and divergent world cultures is spawning

a hybrid multicultural art. Popular music is filled with sounds from cultures sampled from all around the globe. Musicians from afar have collaborated with musical strangers and created a new World Beat sound. This trend can only increase.

We live in a time of unprecedented global culture. From cave art to the latest in contemporary art fashion, artists have access to the vast legacy of visual art. The art of every continent has been published in some form. Without too much effort on our part, the strange gods of all cultures can inhabit our imaginations, if not by our actually trekking the world, at least by viewing their images in museums, books, magazines, on television, or the World Wide Web. What lessons can we derive from this unique perspective? Lesson number one is that for nearly every culture, art has been a revelatory spiritual and unifying force in the human community.

Artists of the twenty-first century and beyond have the opportunity to create a universal spiritual art. This art will be born from visions of sacred archetypes common to all mystic paths. The spirit of the times will choose artists sufficiently prepared for this task. The challenge to artists today is to integrate the vast visual legacy of human culture with their own deepest and highest personal insights, distilling that into works of art and making a living at it. Artists need the generous support of patrons and collectors, dealers, curators, critics, and media producers of all kinds, each of whom must examine his or her own motives for being engaged in the field of art and see how the mission can best be supported.

The unearthing of Paleolithic paintings in the twentieth century reveals that art is a mighty instinctual force implanted in the hearts of people. Art is a people's collective mind. Art is not a mere amusement, distraction, or fashionable investment.

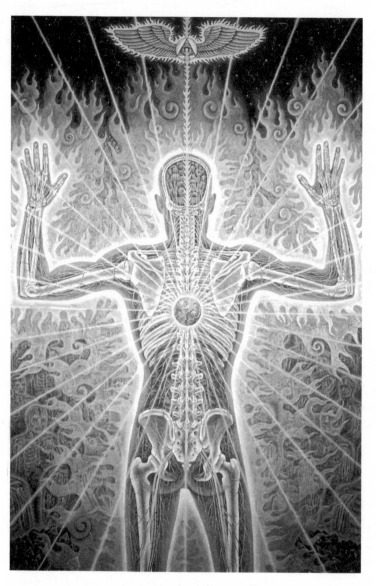

HOLY FIRE (PANEL THREE)

Though the artist, the art, and the viewer are all impermanent, art can provide evidence of contact with the universal creative force beyond time. Art has a function and a mission to interpret the world, to reveal the condition of the soul, to encourage our higher nature and awaken the spiritual faculties within every individual.

Art can be a form of worship and service. The incandescent core of an artist's soul, a glowing God's eye, infinitely aware of the beauty of creation, is interlocked with a network of souls, each one a facet of the Vision Crystal, part of one vast group soul. The group soul of art beyond time comes into time by projecting symbols through the artist's imagination. God's radiant grace fills the heart and mind with these gifts of vision. The artist honors the vision gifts by weaving them into works of art and sharing them with the community. The community uses them as wings to soar to the same shining vistas and beyond.

> Translucent wings teem with eyes of flame
> on the mighty cherub of Art.
> Arabesques of fractal cherub wings
> enfold and uplift the world.
> The loom of creation is annointed
> with fresh spirit and blood.
> Phoenixlike, the soul of Art,
> resurrects from the ashes of isms.
> Transfusions from living primordial traditions
> empower the artist.
> Shaman, yogi, devotional prayer,
> all break through with the visionary cure,
> Take the artist to the heights and depths
> needed to find the medicine of the moment,

A new image of the Infinite One,
 the God of creation
Manifesting effulgently,
 multidimensionally,
With the same empty fullness
 that Buddha knew
And the same compassionate healing
 that Jesus spread.
Krishna plays his flute
 and the Goddess dances
And the whole tree of life vibrates
 with the power of love.
A mosaic and tile maker inspired by Rumi
 finds infinite patterns of connectivity
In the garden of spiritual interplay
As the World Spirit awaits its portrait.

Afterword

IN 1995, WHEN OUR DAUGHTER, ZENA, WAS SIX years old, Allyson and I were discussing what makes an artist great. Zena chimed in that she knew how to be a great artist. We were amazed when she made three statements that we really couldn't improve upon. Then she made the following book illustrating her comments, which we are delighted to share with you.

May your mission be blessed!

Notes

CHAPTER I

1. Ken Wilber, *Up from Eden* (New York: Anchor Press/Doubleday, 1981); Jean Gebser, *The Ever-Present Origin* (Athens: Ohio University Press, 1985); Jurgen Habermas, *Communication and the Evolution of Society*, trans. T. McCarthy (Boston: Beacon Press, 1979).
2. Francis H. Cook, *Hua-yen Buddhism: The Jewel Net of Indra* (State College: Pennsylvania State Press, 1977); Thomas Cleary, trans., *Entry into the Inconceivable: An Introduction to Hua-yen Buddhism* (Honolulu: University of Hawaii Press, 1983).
3. Ken Wilber, *The Eye of Spirit* (Boston: Shambhala Publications, 1997).

CHAPTER 2

1. Piet Mondrian, *The New Art—The New Life: The Collected Writings of Piet Mondrian* (Boston: G. K. Hall and Company, 1986), 296.
2. Maurice Tuchman, *The Spiritual in Art: Abstract Painting 1890–1985* (New York, Abbeville Press, 1986).
3. Roger Lipsey, *An Art of Our Own* (Boston: Shambhala Publications, 1988).

4. William Rubin, *Frank Stella* (New York: Museum of Modern Art, 1970).

5. Rosalind E. Krauss, *The Originality of the Avant-Garde and Other Modernist Myths* (Cambridge, Mass.: MIT Press, 1987).

6. Georg Baselitz, *Paintings 1960–1983* exhibition catalog (London: Whitechapel Art Gallery, 1983). (A tip of the hat to Suzi Gablik who used this quotation in her excellent books *Has Modernism Failed?* and *The Reenchantment of Art*.)

7. Oscar Wilde, "The Soul of Man under Socialism," from *De Profundis and Other Writings* (New York: Penguin Books, 1986), 34.

8. Ralph Waldo Emerson, *On Man and God: Thoughts Collected from the Essays and Journals* (Mt. Vernon, New York: The Peter Pauper Press, 1961).

9. Michiko Kakutani, "Designer Nihilism," *New York Times Magazine*, (March 24, 1996), 30.

10. Robert Pejo, director, *Rest in Pieces: A Portrait of Joe Coleman*, documentary film, 1997.

11. "Albert Einstein," *New York Times* obituary, (April 19, 1955), 35.

12. Ken Wilber's numerous books, which describe various aspects of the transpersonal view, include *No Boundary; Spectrum of Consciousness; The Atman Project; Up from Eden; A Sociable God; Eye to Eye; Grace and Grit; Sex, Ecology and Spirituality; A Brief History of Everything;* and *The Eye of Spirit*. One can tell by reading Wilber's work that his authority on the subject of higher states of awareness is based on his own contemplative spiritual experiences as well as his in-depth knowledge of the world's scientific, literary, psychological, and mystical traditions.

13. Aldous Huxley, *The Perennial Philosophy*, in Roger Walsh and Francis Vaughn, eds., *Paths beyond Ego* (New York: Jeremy Tarcher/Perigree Books, 1993) 213.

14. Fortunately there are a few critics, authors, and organizations who are addressing this subject today. José Arguelles wrote a groundbreaking reframing of the historical unfolding of art's spiritual mission in his book *The Transformative Vision*. Suzi Gablik has consistently championed art that is socially and spiritually engaged in such books as *The Reenchantment of Art* and *Conversations before the End of Time*. In Roger Lipsey's *An Art of our Own*, he chronicles the modern era's most spiritual artists and challenges today's artists to

apply teachings and practices from the wisdom traditions. Julia Cameron and Mark Bryan have created powerful self-help books and workshops for soul-searching artists called *The Artist's Way* and *Vein of Gold*. Some gifted artists have written of the relationship of creativity and the spirit. One of the best is Stephen Nachmanovitch's *Free Play, the Power of Improvisation in Life and the Arts*. The painter and sculptor Audrey Flack collected some of her thoughts into the inspirational book, *Art and Soul*. *The Art Spirit*, is a text from Robert Henri's lectures and letters every artist should own. These books and others are an encouraging sign of sacred conscience emerging within the art world. As more artists pursue spiritual lives, the divine source of art will reward us all.

CHAPTER 3

1. Rollo May examines the phases of creation in his inspiring book, *The Courage to Create*. Betty Edwards has written a number of excellent books, including *Drawing on the Artist Within*, which is where some of the creativity research is discussed. During the nineteenth and twentieth centuries Herman Helmholtz, a physicist, Henri Poincaré, a mathematician, and Jacob Getzels, a psychologist, all worked on a theory of the stages of the creative process.

2. Ken Wilber, *The Atman Project* (Wheaton, Ill.: Theosophical Publishing House, 1980).

3. Harold Osborne, *Aesthetics and Art Theory: An Historical Introduction* (New York: E.P. Dutton and Co., 1970), 105.

4. Ibid.

5. Frank Elgar, *van Gogh* (New York: Frederick Praeger Publishers, 1966), 142.

6. Herschel B. Chipp, ed., *Theories of Modern Art: A Sourcebook by Artists and Critics* (Berkeley: University of California Press, 1973), 35.

7. Ken Wilber, *The Eye of Spirit* (Boston: Shambhala Publications, 1997), 112–113.

CHAPTER 4

1. William James, *The Varieties of Religious Experience* (New York: Collier Books, MacMillan Publishing, 1961), 326.

2. Roger Lipsey, "Mysteries of the Spirit, Then and Now," *Artweek*, v. 28, no. 1 (January 1997).

3. Keith Haring, *Keith Haring Journals* (New York: Penguin, 1997).

4. W. Y. Evans-Wentz, trans., *The Tibetan Book of the Dead* (London: Oxford University Press), 91.

5. James, *The Varieties of Religious Experience*, 317–318.

6. Ibid, 319.

7. Bernard Blakney, trans., *Meister Eckhart*, Fragment #42 (New York: Harper and Row, 1941), 248.

8. Sangharakshita, *The Religion of Art* (Glasgow: Windhorse Publications, 1988), 81.

9. Dalai Lama, Speech at an Interfaith Celebration of Religious Freedom, Episcopal National Cathedral, Washington D.C., April 24, 1997.

10. Evelyn Underhill, *Mysticism* (New York: Doubleday, 1990), 169.

CHAPTER 5

1. James, *The Varieties of Religious Experience*, 321.

2. Elgar, *van Gogh*, 71.

3. Raymond Moody, Jr. M.D., *Life after Life* (New York: Bantam Books, 1975); Kenneth Ring, *Life at Death* (New York: Coward, McCann and Geohagen, 1980).

4. Jean Delville, *The New Mission of Art: A Study of Idealism in Art*, Francis Colmer, trans. (London: Francis Griffiths Publishing, 1910), 14–15.

5. Selden Rodman, *Conversations with Artists* (New York: Capricorn Books, 1961), 93–94.

6. August Rodin, *Rodin on Art* (New York: Horizon Press, 1971), 30–31.

7. Hildegard of Bingen, with commentary by Matthew Fox. *Illuminations of Hildegard of Bingen* (Santa Fe, N.M.: Bear and Co., 1985) p. 28.

8. William Blake, *The Portable Blake* (New York: Penguin Books, 1974), 517.

9. Emanuel Swedenborg, *Heaven and Hell* (New York: Swedenborg Foundation, 1984), 33, 489–490.

10. Dante Alighieri, *The Divine Comedy*, trans. Henry Wadsworth Longfellow (New York: Houghton, Mifflin and Co., 1882), 147.

11. Havelock Ellis, "Mescal, A New Artificial Paradise," *Annual Report of Smithsonian Institute*, 1897, 537–548.

12. Plotinus, *The Enneads*, ed. John Dillon, trans. Stephen MacKenna (New York: Penguin Books, 1991), 129.

13. Erwin Panofsky, *Studies in Iconology* (New York: Harper and Row, 1972), 180. See also Robert Clements, ed., *Michelangelo, A Self Portrait* (Englewood Cliffs, New Jersey: Prentice Hall), 1963, 65.

14. Blake,*The Portable Blake* , 518.

15. Namkhai Norbu, ed. John Shane, *The Crystal and the Way of Light: Sutra, Tantra and Dzogchen* (London: Routledge & Kegan Paul Ltd, 1987), 130.

16. Blake, *The Portable Blake*, 655.

17. Friedrich Schelling, trans. Peter Heath, *System of Transcendental Idealism* (Charlottesville, Va.: University Press of Virginia, 1993), 231.

18. Friedrich Schelling, ed., trans. Douglas W. Stott, *The Philosophy of Art* (Minneapolis: University of Minnesota Press, 1989), 32.

19. Arthur Schopenhauer, *The World as Will and Representation*, Book III, (New York: Dover, 1969), 41.

CHAPTER 6

1. Albert Schweitzer, "Schweitzer's Struggle to Find Life's Meaning," *Midland Daily News*, Midland, Mich., (September 7, 1965).

Acknowledgments

I THANK MY LOVING WIFE, ALLYSON, WHO WAS THE FIRST PERSON to hear these ideas and edit the manuscript. She has been an unfailing friend and major influence throughout the entire process of writing this book. I also thank our daughter, Zena, for allowing her essential text, "How to Be a Great Artist," to be included in *The Mission of Art*.

My conversations with Ken Wilber about art and transformation, and reading his brilliantly insightful books have made him a most valuable spiritual friend and influence on my thinking. I am very grateful that Ken, whom I consider to be the world's greatest living philosopher, was willing to write a foreword for this modest volume.

Thanks to Sam Bercholz, president of Shambhala Publications, with whom I am honored to be publishing this book; to Emily Hilburn Sell for her editorial guidance; and to Shambhala's production staff for their hard work. I appreciate Peggy DeGraff's generous advice on my manuscript. Numerous

friends—including Dan Kirk, J. P. Harpignies, John Lloyd, Rabbi David Cooper, Karen Ellis, and Gary Speziale—brought insight to my thinking about art and spirit.

My friends Tom Gleich and Rebecca Wilkinson have been inspiring and generous in their support of my projects; for this I will always be grateful. Special thanks to all the artists who attended the Visionary Art Intensives at the Naropa Institute, Omega Institue, and the New York Open Center.

This book was inspired by a book *The New Mission of Art*, written by the Belgian Symbolist painter Jean Delville one hundred years ago. Called a "painter of astral light," Delville encouraged the artists of his time to embrace the path of art with soul. His theosophical subject matter articulated an outspoken idealist and occult vision. He understood the soul to be an immortal emanation of God, and felt that the soul reincarnates to fulfill its destiny. My strong reaction to and regard for Delville's work made me wonder whether I was recalling pictures and thoughts from a former incarnation. After a thorough reading of Delville's text, which I had hoped to republish, I felt that his historical references and florid style might not reach today's reader in today's art world. It became clear that I had to write my own book from a contemporary perspective. So, perhaps guided in some way by the spirit of Delville, this book emerged, a gift from a hidden source to an unknown friend. I offer these prayers for art at the altar of your inspiration.

Index

Abstractions, 164
Adolescence, art in, 7
Advertising and art, 97, 183–184
Albright, Ivan, 20
Alchemy, 199–200
Amistad (film), 178
Anamorphism, 36
Animals and humans, 161–162
Aquinas, Thomas, Saint, 73
Archetypes, 162
Art: alienation of, 46, 47–50; and community, 65; in context, 102–103; cultural integration of, 25–26; definition of, 19; development of, 8; history, 11–14; and idealism, 146–147; inspiration of, 80–82; meaning in, 104–105; mission of, 24–25, 202; possibilities of, 29; purpose of, 9; and society, 88–89, 180–182
Art and Culture (Greenberg), 43

Artists: responsibilities of, 30, 202; self destructive tendencies, 143–144
Attention. *See* Seeing
Augustine, Saint, 109
Auras, 92–94

Baselitz, Georg, 46
Beastie Boys (musical group), 177–178
Beauty, 73–74, 147, 148–149
Bernini, Giovanni Lorenzo, 141–142
Beuys, Joseph, 89
Bioplasmic body, 92–94
Blake, William, 153–154; divine imagination, 169–170; *Last Judgement*, 99; quote, 75; visions, 169
Bodhichitta, 30, 195–196
Bodhidharma, 223
Boehme, Jacob, 153
Bonaventure, Saint, 62–63, 73
Book of Kells, 165
Bosch, Hieronymous, 152

brain hemisphere polarity, 110
Bruegel, Pieter, 152
The Buddha, 21, 224
Buddhaghosha, 52
Buddhism, 52, 65, 206–207, 220–222;
and art, 100–101; and bodhisatt-
vas, 196; Dzogchen, 173; and
proper motivation, 195; Tibetan,
122–124, 129, 169; Zen, 100–101,
212–213, 222–223
Burnham, Linda, 25

Calligraphy, 165, 211–212
Carver, George Washington, 85
Cassatt, Mary, 98
Cave paintings, 12
Cézanne, Paul, 36–37, 39
Chakras, 94–102
Chang Yen-yuan, 101
Chartres cathedral, 100
Cheney, Rufus, 178
Childhood, drawing in, 5, 6
Chin, Mel, 178
Christianity, 124–125, 141
Coleman, Joe, 54
Commercial art, 97
Commercialization of art, 210–211
Computer art, 160
Conceptual mind, 104–105
Concerning the Spiritual in Art (Kandin-
sky), 41
Consciousness. *See* Human conscious-
ness; Transpersonal consciousness
Context in art, 102–103
Corpses, use in art, 50–51
Creativity, 19, 27, 75–79
Crick, Francis, 59
Cubism, 39

Dalai Lama, 129, 132, 178
Dalí, Salvador, 30
Dante Alighieri, 157–158

Darwin, Charles, 34
Death, 20–21, 50–51
Delville, Jean, 146, 250
Depth perception, 75
"Designer Nihilism," 48
Dharmakaya, 122, 123
Drawing masterworks, 86–87
Dreams, 109–110
Dzogchen, 173

Eckhart, Meister, 125, 149
Egocide, 145
Eightfold Path (Buddhism), 221–222
Einstein, Albert, 59–60
Ellis, Havelock, 158
Emerson, Ralph Waldo, 47, 139, 226
Energy systems, 92–102

Ficino, Marsilio, 168
Fludd, Robert, 153
Four Noble Truths (Buddhism),
220–221
Fox, Matthew, 215
Fractal geometry, 160, 228
Franck, Frederick, 73
Freud, Sigmund, 34, 59
Fuchs, Ernst, 155

Gangsta rap, 49
al-Ghazâlì, 124
Global culture, 229–230
Gödel, Kurt, 135
Goodacre, Glenna, 187
Goya y Lucientes, Francisco de José,
187
Greco-Roman art, 13
Greenburg, Clement, 43
Grey, Alex: adolescence, 150–151;
childhood, 3–6; works discussed,
6, 9, 50, 51–52, 76
Grey, Allyson, 21–24, 80–81, 90,
111–112

Grey, Zena, 234
Gyatso, Tenzin, 177

Hampton, James, 28
Haring, Keith, 119, 227
Hart, Frederick, 187
Healing and art, 67–68, 188–195
Healing Wall, 194
Heartfield, John, 26–27
Heaven and hell, visions of, 156–158, 163
Hildegard of Bingen, 99, 152, 223
Hillel, Rabbi, 114
Hinduism, 141
Hitler, Adolph, 26, 186
Holon, 102–103
Human consciousness, 59, 60; and art, 92–94; development of, 10–11. *See also* Transpersonal consciousness
Huxley, Aldous, 61, 63

Icons, 213–315
Idealism, 146–147
The Idea of the Holy (Otto), 114
Ignatius, Saint, 124
Imagery: and healing, 55, 190, 191; and spirituality, 117–118
Incompleteness, theory of, 135–137
Inspiration in art, 80–82
Islam, 41

Jakuchú, 20
James, William, 114, 124
Jesus Christ, 224
Jewel Net of Indra, 23–24
John, Saint, 158
Joyce, James, 82
Judaism, 41, 211–212
Judd, Donald, 89
Jung, Carl G., 162
Juxtapoz (magazine), 196

Kandinsky, Wassily, 41, 226
Kitsch, 97
Kluver, Heinrich, 158
Krauss, Rosalind, 44
Krishnamurti, 83
Kundalini yoga, 94

Lao-tzu, 10
Leary, Timothy, 119
Leonardo da Vinci, 103–104
Light in spiritual art, 141
Lila, 173
Lin, Maya Ying, 187
Lipsey, Roger, 115–116
LSD, experiences with, 21–22, 111. *See also* Psychedelic drugs

Mandalas, 100, 165
Mandlebrot, Benoit, 228
Marketing art, 90–91
Marx, Karl, 34–35
Maslow, Abraham, 60
Materialism, 35, 43–44, 182–184
Meaning in art, 104–105
Meditations, Tantric, 122, 208
Michelangelo, 83, 168–169, 223–224; *The Captive*, 219–220; *Last Judgement*, 84–85, 99; quote, 177
Microscopic photography, 228
Mission of art, 24–25, 202
Modernism in art, 34, 38, 42
Mondrian, Piet, 41, 42
Money values and art, 45
Morphic resonance, 130
Munch, Edvard, 98, 191–192
Museum of Modern Art, 154–155
Mylius, Johann Daniel, 153
Mysticism, 105–106, 113–118; and consciousness, 16–17; path of, 133–135; traditions of, 61, 122–125. *See also* Spirituality; Transpersonal consciousness

Mysticism (Underhill), 134
Mythic art, 12–13

NASA photographs, 227
National Endowment for the Arts, 48, 188
Native American sandpainting, 191
Natural Born Killers (film), 49
Nazi "degenerate art" exhibits, 26
Nazi propaganda, 185–186
Neoplatonism, 168
New York Times Magazine, 48
Nietzsche, Friedrich, 35
Nihilism and art, 53–55, 57
Nirmanakaya, 122
Norbu, Namkhai, 169

Ornstein, Robert, 110
Otto, Rudolf, 114
Our Lady of Vladimir, 115–116

The Perennial Philosophy (Huxley), 61
Photography, 227–228
Picasso, Pablo, 38–40, 187
Plato, 105, 167–168
Plotinus, 33, 168
Polar Unity Spiral (Grey), 111
Politics and art, 185–188
Pollock, Jackson, 91
Pollution, 229
Pope, Alexander, 175
Postmodernism in art, 15, 33–34, 38, 56
Primitive art, 11–12
Propaganda, 185–188
Psychedelic drugs, 111; in creating art, 21–22, 78, 118–121; experiences, 158; and religious practices, 120

Rap music, 49
Rationalism, 14–15
Rave scene, 228–229

Redon, Odilon, 162, 163
Religious traditions, 35; and art, 48; definition of, 64; development of, 130–131; reactions against, 131–132. *See also* Sacred Art; Spirituality
Rembrandt van Rijn, 223
Revelation of Saint John, 158
Roden Crater, 100
Rodin, Auguste, 148; *Gates of Hell*, 37–38; quote, 205
Rosen, David, 144–145
Rosenthal, Rachel, 99
Rothko, Mark, 42–43, 142–143, 147
Rushdie, Salman, 47, 48
Russian Orthodox tradition, 213–215
Ryder, Albert Pinkham, 3

Sacred art, 65–69, 125–129. *See also* Spirituality
Sambhogakaya, 122, 169
Samvega, 83
Sandpainting (Native American), 191
Sangha, 65
Sangharakshita, 126
Schelling, Friedrich, 169, 170
Schindler's List (film), 178
Schopenhauer, Arthur, 169, 170–171
Schweitzer, Albert, 65, 197–199
Science in society, 35
Seeing, 71–74, 82–83, 167
Serrano, Andres, 48, 132
Seurat, Georges, 37
Shamanism, 208–210
Shands Arts in Medicine, 194
Sheldrake, Rupert, 130
Shunyata, 124
Silberer, Herbert, 199
Simonton, Carl, 190
Smithson, Robert, 88
Society and art, 88–89, 180–182
Socrates, 81, 167

Sofer, 211–212

Space photographs, 227–228

Spielberg, Steven, 178

Spirituality: and art, 41–43, 105–106, 115–116; and art as practice, 207–233; definition of, 64; and imagery, 117–118; mystical traditions of, 61. *See also* Mysticism; Religious traditions; Sacred Art

Stella, Frank, 43

Stendhal, Marie-Henri, 83

Stone, Oliver, 49

Success in art, 89–91

Sufism, 124

Swastika symbol, 186

Swedenborg, Emanuel, 156–157

Symbolism, 154

Symbols in religion, 126–128

Taoism, 10, 212–213

Tchelitchew, Pavel, 154

Teachers of art, 65–66

Teresa, Saint, 141–142

Thangka paintings, 100

Theosophy, 41, 42

The Thinker (Rodin), 37–38

Thompson, Robert Farris, 39

Tibetan Book of the Dead, The, 52, 124

Tibetan Buddhism, 122–124, 129, 169

Tibetan thangka paintings, 100

Torah scribe, 211–212

Transformative art, 218–220

Transpersonal consciousness, 60–61; in making art, 116–117; and spirituality, 63–64; Universal Mind Lattice, 166–167. *See also* Human consciousness; Mysticism

Turrell, James, 100

2001 (film), 160

Underhill, Evelyn, 134

Universal Mind Lattice, 21, 166–167

Upanishads, 141

van Gogh, Vincent, 20, 45, 85, 101–102; career as minister, 224; and the Impressionists, 91; and light in painting, 142; suicide of, 143

Vietnam Veterans Memorial, 187–188

Visionary art, 130, 150–167

Warhol, Andy, 44

Watson, Ernest W., 72

Wilber, Ken, 61–62, 102–103, 249

Wilde, Oscar, 46–47, 71, 186

Williams, Robert, 196–197

Williams, William Carlos, 28

Wu Chen, 101

Yauch, Adam, 178

Yoso Soi, 223

Zen Buddhism, 100–101, 212–213, 222–223